FUTURE TENSE
A NEW ART FOR THE NINETIES

ROBERT HEWISON

methuen

John Ruskin: The Argument of the
Eye
Ruskin and Venice
New Approaches to Ruskin (ed)
The Ruskin Art Collection at Oxford:
The Rudimentary Series
Under Siege: Literary Life in London
1939–45★
In Anger: Culture in the Cold War
1945–60★
Too Much: Art and Society in the
Sixties 1960–75★
Irreverence, Scurrility, Profanity,
Vilification and Licentious Abuse:
Monty Python – The Case Against★
Footlights: A Hundred Years of
Cambridge Comedy★
The Heritage Industry: Britain in a
Climate of Decline★

★available as a Methuen Paperback

A Methuen Paperback

First published in Great Britain 1990
by
Methuen, Michelin House, 81 Fulham
Road, London SW3 6RB

A CIP Catalogue Record for this book
is available from the British Library

ISBN: 0 413 63430 2

Photoset by Rowland
Phototypesetting Ltd
Bury St Edmunds, Suffolk
Printed and bound in Great Britain by
Richard Clay Ltd, Bungay, Suffolk

Cover photograph of **Gaby Agis** by
Jessica Shaw, image by Robert
Hewison/Jessica Shaw.

Many people, sometimes unwittingly, have helped me to prepare this book, but I should like to thank the following in particular for their interest, criticism and conversation: Chris Barlas, Doug Branson, Helen Chadwick, Dick Hebdige, Ron and Jackie O'Donnell, Chris Orr, Jane Quinn, Jessica Shaw, Robert Sandall and Lisa Tickner. My editor at the *Sunday Times*, John Whitley, has been very understanding about the demands of book writing, and I should like to thank my publisher, Geoffrey Strachan, for backing the project and seeing it through.

The person who has done most, however, to keep both the book and its author going through a period of gestation even longer than the one she herself was enduring is my wife Erica. I only hope that the new life she has brought into the world has a calmer future than the one my title implies.

Fetter Lane

for
Vita

1. Guy Debord, The Naked City
2. Situationist Poster, 1968
3. Ronan Point, 1968
4. Josef Beuys, PLIGHT
5. Gaby Agis and Company
6. The Saatchi Gallery (Bill Woodrow installation)
7. Eric Fischl, The Old Man's Boat And The Old Man's Dog
8. Julian Schnabel, Humanity Asleep
9. Jeff Koons, Pink Panther
10. The Design Museum
11. Pat Steir, The Breughel Series (A Vanitas of Style)
12. Robert Rauschenberg, Almanac
13. Jean Baudrillard on TV
14. Derek Jarman, The Last of England
15. Derek Jarman, The Last of England, Final Sequence
16. Tobacco Dock
17. Richmond Riverside Development
18. Canary Wharf
19. Prince's Youth Business Trust Poster
20. Spitalfields Heritage Centre: Rodinsky's Room
21. Gilbert and George, Fuck
22. Gilbert and George, Gateway
23. Stuart Franklin, Victoria Station
24. Jamie Reid, Sex Pistols Record Sleeve
25. Michael Clark
26. DV8, Dead Dreams of Monochrome Men
27. Sue Coe, Romance in the Age of Raygun
28. Ambulance
29. Bill Woodrow, ENGLISH HERITAGE – HUMPTY FUCKING DUMPTY
30. Tony Cragg, Britain Seen From The North
31. Tony Cragg, Minster
32. The Bow Gamelan Ensemble, The Navigators
33. Ron O'Donnell, The Antechamber of Ramses V in the Valley of the Kings
34. Ron O'Donnell, The Great Divide
35. Jenny Holzer, Piccadilly Circus
36. Nigel Coates, NATO's Albion Scheme
37. Robert Mapplethorpe, Lisa Lyon
38. Rose Garrard, Flaccid Guns, from The Models Triptych
39. Leigh Bowery
40. Neil Bartlett, A Vision of Love Revealed in Sleep
41. Helen Chadwick, One Flesh
42. Helen Chadwick, Of Mutability
43. Helen Chadwick, Blood Hyphen
44. Derek Jarman, The Last of England: Tilda Swinton
45. Peter Howson, The Heroic Dosser
46. Ken Currie, The Calton Activist

INTRODUCTION

'Spending time devising the next confrontational culture is how the culture industry organises the time of the intelligentsia.'

RONALD JONES
Artscribe,
Summer 1988

T he title of this book is taken from the final sentence of my previous study, *The Heritage Industry* (1987): 'We must live in the future tense, and not the past pluperfect.' Readers of that book will find that *Future Tense* is complementary to, not a continuation of *The Heritage Industry*. This is, in fact, the book that I had intended to write when I began to investigate our contemporary obsession with the past, but, as is too often the case, the past took over, and it was only in my closing pages that I was able to suggest that there was another future for our culture.

Like *The Heritage Industry*, this is a book about contemporary culture in Britain, but, as the subtitle implies, the emphasis is indeed on the future. I believe that, as the next century approaches, we have to come to terms with a cultural crisis, of which the heritage industry is a symptom. It appears at times that we have nowhere to go but back. The solution I propose is that we develop that 'critical culture' whose existence I hinted at in the closing pages of *The Heritage Industry*.

Although the focus of this book is on Britain, the crisis that afflicts us is the crisis that afflicts the whole of Western civilisation: how do we maintain and evolve a living and progressive culture when the principal shaping force that has sustained cultural development for most of the twentieth century – that is, the culture of Modernism – appears to have been dissipated? It is because the great days of Modernism are over that we are now said to be living in 'the post-Modern condition'.

Such a statement demands a definition of what is meant here by 'post–Modernism'. But since the term, in one sense at least, means nothing at all – describing as it does only an absence – it is necessary first to define Modernism itself. Here, too, there is a difficulty. In its broadest sense Modernism can be used to describe no less than the entire thrust of technological, industrial and economic advance in the twentieth century. In a narrower sense, it applies to those new forms in art, literature, music and architecture which developed in parallel with the social, economic and political changes of the century, and which reflected both the liberation and disruptions that the experience of modernity brought in its train. The difficulty is that many Modernist artists – for instance T. S. Eliot – were opposed to the larger process of modernisation. The emergence of an urban culture in the nineteenth and twentieth centuries freed artists from aristocratic and church patronage, but this economic autonomy was gained at the price of marginalisation and a sense of alienation from the mass society

that was developing, as well as a need to satisfy the demands of the market that mass society represented. The Modernist doctrine of the 'autonomy' of art – that art exists for art's sake, and has no social responsibility, only a duty to achieve its own formal perfection – was developed as a form of opposition to the practice of mass production and mass communication that industrial modernisation demanded. It is only now that we see that this opposition is merely the other side of the same coin: that art for art's sake is a parallel to economic individualism, that the emphasis on aesthetic innovation is a parallel to technological advance.

There is a further difficulty within Modernist art practices themselves. The doctrine of the autonomy of art appears to explain the existence of the idea of an avant-garde, a small group of dedicated experimentalists marching ahead of the advancing forces of art. But while the various avant-gardes of the twentieth century have always offered new 'experimental' forms of art, many of them, from the Futurists before the First World War to the Situationists after the Second, had a political as well as an artistic purpose. Indeed, the purpose was not so much art for art's sake, as art as a means of offering a new vision of society in which there would be no difference between 'art' and 'life'. The failure of society at large to respond to such new visions meant that, instead of being the advance guard of a victorious army, the avant-garde tended to become an alienated, marginalised elite. After the Second World War, however, when both economic and artistic progress seemed most concentrated in the United States of America, the doctrine of the autonomy of art was heard more loudly than revolutionary proposals for social change. It should be remembered that this, the period of 'High Modernism', when the aesthetic principles of the movement had become an orthodoxy and their promotion virtually official government policy, was also the period of the Cold War.

Whatever Modernism had become by the end of the 1960s, its original thrust at the start of the century could be seen as progressive, optimistic, humanist, offering a religion of rationalism and economic improvement for the benefit of the whole of mankind. Where Modernism was critical of the process of modernisation, it was so on behalf of a more rational and enlightened society than the one that the contradictions within modernisation were bringing about. Two world wars and the effects of industrialisation on cities and the countryside alike called the supposed benefits of industrial progress

more and more into question. Linked as they were to this process, disenchantment with the fruits of Modernism also began to set in. The effect was felt in different countries at different times, but gradually the conviction spread that the period of Modernism was drawing to a close.

Beginning in America in the mid-1960s, critics and artists began to reflect this change by using the term *post*-Modern. The fact that the words Modern and Modernism acquired a prefix, rather than were abandoned altogether, indicates the extent to which the debate continues to revolve around the issues that the experience of modernity in the twentieth century has raised. To that extent, it is not possible to set a precise date on the shift that the acquisition of the prefix *post* suggests. Nonetheless, the term post-Modern has now come into general use to describe the cultural conditions of the present day. It is symptomatic of those conditions that there is no general agreement as to what the term means. It is used pejoratively, to describe a period of pastiche and parody where the progressive values of Modernism have been abandoned; it is used positively, to describe the liberation from the constraints of abstract Modernist aesthetics and the recovery of earlier styles of art and architecture which can now be used free-style, and at will, in a more 'popular' and appealing way.

I offer the further explanation of the significance of post-Modernism in my first chapter, but the key to my use of the term is that it is a negative, that it describes a void. As Suzi Gablik has written, 'to the post-modernist mind, everything is empty at the centre.'[1] This emptiness, together with post-Modernism's existence only as the empty space marking the place of a collapsed Modernism that had gone before, contributes to the pessimistic mood of my opening chapter. But, as the closing chapter argues, the post-Modern condition – that is, the condition we find ourselves in at the beginning of the 1990s – also has possibilities. One of those is the opportunity to develop a critical culture. As Andreas Huyssen has written:

If the postmodern is discussed as a historical condition rather than a style it becomes possible and indeed important to unlock the critical moment in postmodernism itself and to sharpen its cutting edge, however blunt it may be at first sight. What will no longer do is either to eulogise or to ridicule postmodernism *en bloc*. The postmodern must be salvaged from its champions and from its detractors.[2]

I approach the subject of post-Modernism as a condition, and not as a style. That condition, I argue in my first chapter, is a product of the arrival of post-industrial society and the development of what Donald Horne has called 'the public culture'. This is a managed, official form of culture, supported by public and private corporations alike, where government agencies and commercial organisations co-operate to promote a form of culture which is neither 'elitist', in the old aristocratic sense of a high culture enjoyed only by educated and privileged specialists, nor 'popular' in terms of a genuine folk culture that has been developed out of the social customs of ordinary people at large. While it contains both popular and elitist elements, this new, but essentially conservative culture is produced for mass consumption by the 'public', that notional entity constructed by marketing surveys and opinion polls. It is a guiding principle of this public culture that art and ideas should be immediately accessible, and therefore undemanding. Difficulty, in terms of art forms or critical concepts, is regarded with profound suspicion, although avant-gardes are allowed a protected place, so long as they do not disturb the larger order with genuinely subversive ideas.

The model and medium of this culture is television. The influence of television, as a communicator of ideas and in the way the medium itself shapes our perception of those ideas, underlies the twin themes of my first chapter: the growth of the information industry, and the ever-strengthening tendency for culture to be turned into a commodity. Two locations in particular frame aspects of my themes: the Saatchi Gallery in St John's Wood, and the Design Museum at Butlers Wharf, part of a new commercial development below Tower Bridge on the south bank of the Thames.

The medium of television has helped to turn information itself into a commodity, while the elision of culture and commerce becomes complete in television advertising. Culture becomes a matter of style, a commodity within the general circulation of commodities that in the end turns the individual self into a commodity among others. Television is fundamental to the process, not only because of what it presents in terms of imagery and values, but because of the way it alters and shapes our world view. As television functions at present, that view is both distanced and fragmented, where imagery overrides ideas, and where accessible images – not only in culture but also in politics – are offered as a substitute for thought.

In the process, reality is gradually drained of meaning, and we must

content ourselves with a choice of factitious images. Even our sense of identity dissolves, lost in a hall of mirror-images, and we float free on the thin surface of what has been called 'hyper-reality', a screen of images that present perfect copies of originals that never existed, projected by the global systems of the information industry. The ruling image in the void of post-Modernism is indeed that of a screen: the screen of the computer terminal, or of the television set that brings us our information and entertainment. The rhapsodist of this new nothing is the sociologist Jean Baudrillard, and I conclude the first chapter with an outline of his nihilistic position.

Since my first chapter argues that our culture appears to have no future, readers may well feel discouraged. But the crisis of the post-Modern condition is also an opportunity, and I have presented the position at its bleakest. We do, at the very least, have a choice about the possible nature of the future. My second chapter begins with two opposing visions of the future: Derek Jarman's in his film *The Last of England*, and the developers Olympia and York's at Canary Wharf. Paradoxically, Jarman's pessimistic vision has more to offer than the commercial optimism of the developers in Docklands. Jarman's work is a sign of resistance, not only to the commodification of culture, but also to the gradual draining of meaning from urban life by such environments as Tobacco Dock. The city – in its widest sense – is the site of a struggle between opposing visions of the future. In Docklands the contest is unequal, but in nearby Spitalfields there is an urban life that has not yet succumbed to the next wave of commercial development.

The reality of Spitalfields – which has its unpleasant as well as its appealing aspects – is not reducible to architects' plans or developers' site values. It is however captured by the artists and writers who have made the area part of their subject matter. The artists Gilbert and George have had an insider's view of the forces in conflict, and I argue that this has influenced the direction of their work. Novels by Iain Sinclair, Peter Ackroyd and Michael Moorcock have also described contemporary Spitalfields, and together with the London scenes in Salman Rushdie's *The Satanic Verses* I have used their work to evoke an idea of the city – what the Situationists called a 'psychogeography' – that is more profound than planners' plot ratios. These novels are examples of an urbanism – a philosophy of urban living – that is under threat from the steady privatisation of public space, and the increasingly rigid division between the interior, domestic sphere (with its television set) and the exterior, commercial realm of shopping and

work, a division that leaves no space for urban life as it is lived in the streets and formerly public places.

What these novels, paintings and films suggest is that the screen of the post-Modern condition has not yet become a perfect seal between the personal and the public realms, that there are gaps in the public version of reality through which new ideas may escape. The fragmentation that is a product of post-Modern social dislocation and alienation is an indication that the screen is cracked. It may still be possible to reassemble the fragments of identity and culture in a new pattern.

The evidence that there *is* resistance, not only on the margins, but right across the screen, is offered in my third chapter. To describe this evidence, which I find in many different art forms, I have had to coin a new term, 'Social Surrealism'. This is a combination of two terms which were evolved during the period of Modernism: Social Realism implied an art that was committed to revealing an external reality – previously ignored – in order to effect social change; Surrealism was an attempt to reveal an internal, psychological reality which did not correspond to the conventional appearance of things, but it too was directed towards social change.

The work of someone like Derek Jarman is clearly closer to Surrealism than Social Realism, but nonetheless his concern is essentially social. The extremes of anxiety and stress that many works of Social Surrealism portray are a product of social circumstances – not least the struggle for existence in the modern city. As I argue in the case of punk, a harbinger of Social Surrealism, such works are a kind of social metaphor. Fragmentation is rendered, both visually and verbally through the use of collage. Further, the previously separate disciplines of painting, sculpture, theatre and dance have been reassembled in new forms: as physical theatre, environmental constructions, performance art.

Collage, as in the cut-up, pixillated imagery of Jarman's film *The Last of England* or the multiple time frames of Iain Sinclair's novel *White Chappell*, is a means of conveying fragmentation and dislocation. But collage can become *bricolage*, a creative reassembly and recycling of materials that amounts to a reconstruction, a 'refunctioning' that, to quote one of the artists whose work I admire, can, 'release the hidden potential of things'. It is here that we begin to see some of the opportunities that the post-Modern condition affords. It is not just the discards and detritus of the urban landscape that are

available for creative re-use, be it to satirical ends, as in the sculpture of Bill Woodrow, or to poetic ends, as in the sculpture of Tony Cragg. The latest electronic technology can be used in a critical manner, and the devices of commodity culture turned against itself, as in the sign-writing of Jenny Holzer. Contemporary black music has reconstructed itself out of reappropriated sounds, recycled through reappropriated technology.

The transformation of materials is one of the hopeful signs that emerge from Social Surrealism. These point towards a new urbanism, and it is right that the architect Nigel Coates should here be the spokesman for this new approach to urban living. Coates and his colleagues in the Narrative Architecture Today group believe that both old and new technologies, both re-used and brand new materials, have the capacity to return control over urban space to those who have the most right to it: the people who live there, and whose creative and imaginative needs are most often ignored by the developers and planners who are trying to sterilise the poetry of urban living. Yet this poetry survives, in the cracks of the dominant system, to be nurtured by organisations like Welfare State, or to burst out in subversive celebration in the Notting Hill Carnival.

It is clear, however, that it is not enough to survive in the cracks and fissures of the official order. Social Surrealism, especially in its more apocalyptic and disordered moments, is more of a symptom of the crisis than a solution to it. But it points to continued creativity and future possibilities. In my fourth chapter I begin to look at the arguments for a more thorough transformation of our cultural attitudes. But the case for transformation can only begin with the given situation, which is the post-Modern condition. Readers will discover that, as I warned, aspects of this condition which in the earlier part of the book are viewed so pessimistically now begin to be looked on in a more optimistic light. This does not extend to the commodification of culture, or the slow death of the city as a livable space, but I do find centres of resistance, from which it is possible to move forward.

The city may be almost lost, but the individual body remains within our control. Since 1968 feminism in particular has developed a critique which is sited both in the body, and in the cultural context the body occupies. Feminists have forced a reconsideration of the way we describe the human body in words and in pictures, and of the way these representations of the body shape our intellectual perception. These perceptions in turn define relationships of power. Feminist

artists have sought to discover a new territory in which perceptions and therefore power relations will be different. Most of the artists and critics that I quote use the image of the gap or interstice to explain where this new territory may be found, or from where exploration may begin. I discuss some examples of these investigations, both in terms of theory, as in the case of Alice Jardine's concept 'gynesis', and in terms of artistic practice, as in the case of Mary Kelly and Helen Chadwick.

The creation, or revelation, of a new space in which new creativity may take place, however, is not simply in order to redress the cultural balance in favour of women. It may be possible in this new space to transcend the binary oppositions of sexually-defined identity altogether. As a step in that direction, homosexual artists and writers have found fruitful material in sexual ambiguity, as the work of Neil Bartlett shows.

One artist in particular, Helen Chadwick, has achieved something approaching the new territory as I have been trying to describe, both in formal terms and in the use of materials and subject matter, in her 'hermaphroditic' art. Chadwick's interest in ecology also points to a theme which I have not tried to develop here: the importance of evolving a new, unexploitative relationship to the natural world. The main subject matter of this book is urban, and the primary location is the city, but it is clear that a struggle, both economic and cultural, is developing in the future use of what is in fact an already industrialised countryside, as well as the city.

In my final chapter I move on from the question of the relationship between the sexes as a source of new patterns for a new art to the wider question of the possibility of new cultural relationships through which a new art might flourish. At issue is the possibility of a workable pluralism. Again, what looked in my first chapter like a bewildering condition of multiple uncertainties may yet offer opportunities to establish a new, undominating plurality of ideas. This would need a new critical approach, a new methodology that would encourage difference, without descending into general indifference and confusion. I argue not for a 'grand narrative', such as that of Modernist progress, but a 'grand dialogue', made possible in part by the information technology that otherwise presents a threat to individual identity. The fragments of post-Modern culture may yet be reassembled into a network.

Pluralism has political and practical implications, for democracy as

a whole, and for the administration of the arts in particular. But beyond that, in spite of the pessimistic outlook from which I began, I still believe that the values of culture have not yet been entirely reduced to those of a price tag on a commodity. The true value of art lies in its use as an activity and experience, not in its exchange as a commodity. The artists of the new decade, on the threshold of a new century, must adopt certain strategies to preserve that value. Definitions of reality must be constantly challenged, we must be prepared to reach for the sublime and to believe in the utopian. We need to look positively and critically at the past, and abandon the prevailing mood of nostalgia.

There are practical changes in the ownership of the information industry and the administration of culture that could help this process, but the fundamental change must be in outlook and philosophy. Artists – and critics – will have to change too. This is what I mean by a critical culture, one that conducts a constant, enquiring dialogue between its circumstances and its practices, a transmutation of the avant-garde engaged in the creative shaping and reshaping of culture, not according to commodity values, but to value in use. Culture must be treated not as an object, but as an activity; not as a dead past, but a lived present; not as an exclusive specialism, but as a process in which everyone from all cultures can join. From this process will emerge a new art: the art that comes after post-Modernism, an art for the Nineties that will open the twenty-first century.

Having given an outline of my arguments for a critical culture of the future, which will not be without its tensions, I should say something about my method, and my materials. Since my subject is, essentially, the future of British culture – though, like the heritage industry, the issue is not confined to Britain – all the material I have chosen to provide examples is British or, as in the case of Jenny Holzer or Robert Mapplethorpe, is well enough known in Britain to apply in a British context. The same is true of the critics and theorists I have referred to.

Although in the terms 'art' and 'artist' I include the verbal as well as the visual, much of the art discussed here is visual. In an age where the visual appears to be taking over from the verbal this is not surprising, but the choice has not been governed by a preference for any particular art form, and I have taken examples from performance art, dance, music, theatre, film and literature, as I think appropriate. Much of the work discussed is a crossover between the visual and the verbal.

It will also be noticed that much of the work discussed is very recent. This is for two reasons: one is that it is a feature of the post-Modern condition that even material from as recently as the mid-1970s now has an air of ancient history, such is the commercial consumption and rapid redundancy of ideas. The second is that much of the material is simply what I have seen and heard in the time that I have been preparing this book. I have not quoted every possible example of the genres I describe, only those which strike me as the most effective evidence of the case I am making.

The choice of materials relates also to the question of method. Since the late 1960s 'theory' has taken on a life of its own, as a form of cultural criticism and, to some extent, as a substitute for philosophy. It might well be said that literary theory has developed into a new form of literature, independent of poetry or imaginative prose. Critical theory has become part of the 'discourse' of the 1980s (a term whose significance I discuss in chapter four), and, as I explain there, it is impossible when writing about the present situation entirely to avoid entering into the complexities of that discourse, however demanding they are. But since a critical culture has to come to terms with the contingent, at the cost of theoretical purity, I have tried to write in terms of a narrative, and, at times, in anecdotal form. The material has been chosen because it is that which has struck me as important, and because I have been able to experience it, if only by chance and the vicissitudes of my job as a journalist, at first hand. To that extent, this is not a work of theory, but of practical criticism.

I am aware that there is a certain movement through the book that may strike the reader as paradoxical. The situation that evokes the deep pessimism of the opening chapter is shown in fact to have possibilities; there is a dialectical shift in the argument. There is an obvious progression in the imagery used, from the void, to the screen, to the crack, to the gap, to the new space, to the network. These individual ruling images recur with astonishing frequency in the quotations I make from a wide range of sources. Only the image of the network is more of a contribution of my own, though it has its origins in feminism.

The movement in my argument is, in one sense, ironical, and irony, as I argue in my last chapter, is both one of the features of the post-Modern condition, and a means of defence against it. (It is to be hoped that the use of the quotation that prefaces this introduction is recognised as ironical.) A specific event in London in June 1989 struck me as

having particular ironies for anyone interested in the future of what used to be called the avant-garde, and I have begun by describing it, as a narrative, and because the anecdote illustrates several of the themes that resurface in more theoretical form later. I have called it a parable, and it might be read twice, first at the beginning of the book, and then at the end. It is in itself an example of the *dérive*, that baffling theoretical term used by the Situationists, and which the prologue sets out in part to explain. Theory and anecdote can never finally be separated, nor should they be. I hope this makes a good story.

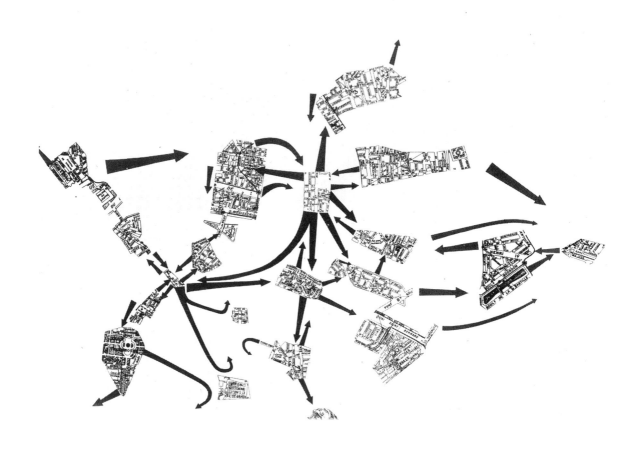

A PARABLE

'The "art"
offered us in
the galleries,
art schools,
lush mags etc.
cannot possibly
last much
longer.'

It's an angry little piece of paper, the text is badly typed, poorly reproduced by an elderly stencil machine. There is so much talk in the gallery that it is impossible to have a conversation. The declamations and denunciations on this and other faded sheets of close-printed, flimsy, ageing paper on display have difficulty in holding the attention of the guests at the private view at the Institute of Contemporary Arts:

Comrades: What we have already done in France is haunting Europe and will soon threaten all the ruling classes of the world, from the bureaucrats of Moscow and Peking to the millionaires of Washington and Tokyo. **In the same way we have made Paris dance** the international proletariat will again take up its assault on the capitals of all states, on all the citadels of alienation.

This is a hot evening in June, at the dead end of the Eighties. Many of the guests wear black, as though in mourning for these moribund times, but in a plurality of dress codes: suits – without ties; ties – without suits; a little cocktail dress; blue jeans cut off at the knee. Some have come styled as deserters from the Hitler Youth, others as their victims, with crew cuts (female), shaved heads (male). There is a white Rastafarian, an art critic in dark glasses. There are mandarin caps, panamas, babies, trick cyclists, baseball caps, and a pork pie hat as worn by aged jazz trumpeters in photographs from New Orleans. There are samurai hair knots, even a moustache *circa* 1972, and a skinhead in a faded green bomber jacket. The professional intellectuals lug their knowledge along with them in their briefcase-badges of office.

ART'S FINAL MASTERPIECE WILL BE ITS OWN DESTRUCTION

Attracted by this slogan, one of the spectators, a tall young man, his blond hair almost unfashionably long and wearing a dark cotton suit over a colourful Hawaiian shirt, decides to take a closer look. As he starts to lift the plexiglass

protecting the exhibit, custodians surround him. There is a dispute, and the Director of the Institute gently leads him away. The Director explains that the police are outside. They might appreciate a spot of trouble.

Out in the Royal Mall, the young man is introduced to a constable, who gravely discusses the concept of Semtex explosives hidden in bicycle frames. Back inside the gallery as the private view roars to a climax, he is given a drink and a cigarette. Tells his story.

Secure behind their plexiglass sleep the relics of an artistic movement that advocated the destruction of museums and the redistribution of masterpieces to cafés and bars. In their combination of revolutionary politics and artistic innovation, the Situationists were the last true avant-garde in a century of avant-gardes. The Situationist International never had more than seventy members. At its end it had four, one of whom was in an asylum. The illegitimate offspring of Dada and Surrealism, the movement came into being in 1957 as an alliance drawn from the pan-European avant-garde, shards of earlier formations in Germany, Italy, Britain, Denmark, Holland, Belgium and France. Almost immediately the pieces began to fall apart again. The original purpose, common to true avant-gardes, was to revolutionise society by revolutionising art, to change the perception of the world by creating a new vision through painting, sculpture, architecture, literature, argument.

The first issue of *Internationale Situationniste* supplied a useful set of definitions. ('There is no such thing as situationism . . . the notion of situationism is obviously devised by antisituationists.') The **situation** was something constructed, a 'moment of life' created as 'a game of events', a piece of theatre that would move participants and spectators to unexpected action.

'Theatre' is just a metaphor. Think in terms of a street theatre without actors or audience, but where the exploration of the city reveals the **psycho-geography** created by the physical and mental conditions of twentieth-century urban society. The Situationists were philosophers of city life, seeking to evolve a way of urban living, an urbanism, that found significance in the material

and psychological patterns of the city street. The significance was to be discovered through the Situationist practice of the **dérive**, literally, a 'drift', an apparently aimless wandering that nonetheless revealed the psychic undercurrents of the city.

Internationale Situationniste No 2 further explained:

a psychogeographical relief

One or more persons during a certain period drop their usual motives for work and action, their relations, their work and leisure activities, and let themselves be drawn by the attractions of the terrain and the encounters they find there. The element of chance is less determinant than one might think: from the *dérive* point of view cities have **a psychogeographical relief**, with constant currents, fixed points and vortexes which strongly discourage entry or exit from certain zones.

The Situationist would act on the aesthetic environment through the process of **détournement**, 'the integration of present or past artistic production into a superior construction of a milieu.' It is a method of appropriation and recasting that goes back to Duchamp and his recontextualisation of a urinal into an art object. The enemy of *détournement* was recuperation, the process that turns such assaults on the conventional canon of art into an aesthetic commodity, just as Duchamp's urinal has become a valued icon. Recuperation was a function of the **spectacle**, a term introduced by the French film maker Guy Debord as he, assisted by Raoul Vaneigem, gradually asserted control over the movement in a series of rows and expulsions.

By the time Debord's book *The Society of the Spectacle* was published in 1967 the function of Situationist art was reduced to that of propaganda. Artistic activity and cultural production was dismissed as part of the spectacle by which capitalism obscures the reality of domination and exploitation. Through the grand delusion of the spectacle the governments of the world, both capitalist and communist, sold back to the workers not only the fruits of their labours but the creativity of their leisure in the form of a social boredom that kept them lulled,

but sufficiently discontented to continue in their alienated slavery. Culture had become the opium of the masses: 'Culture turned into commodity must also turn into the star commodity of the spectacular society.'

The leaders of the Situationist International preserved the revolutionary purity of their avant-garde position with a zeal that left little room for other than internal politics. But in Paris in May 1968 the frustration of students and the boredom of Gaullist society led to 'a moment of life', a game of *événements* which stimulated similar protest in cities across the world. In Paris, cars, trees and café tables were 'détourned' into barricades, as students went on a month long *dérive* that rediscovered the revolutionary psychogeography of the city. The

posters of May 1968

Comité Enragés Internationale Situationnistes who ran the occupation of the Sorbonne could legitimately claim to have made Paris dance, but the students and workers who, with the co-operation of the forces of law and order had constructed a situation that became a general strike and almost a revolution, could not sustain the tune. The slogans and **posters of May 1968** (the last remnants of Situationist art): 'Power to the imagination'; 'Under the pavement – the beach'; 'Ideology tries to integrate even the most radical arts', attempted to unite art and politics in a cultural revolution that on the one hand was beaten down by the riot police, and on the other was bought off by an increase in the minimum wage. The society of the spectacle had won. In 1972, after final rows and recriminations, Debord dissolved the movement. With the end of Situationism, revolution in art and revolution in politics finally went their separate ways.

And now this, the last true avant-garde is in a museum; its objects and inflammatory statements treated as a backdrop to the spectacle of a private view. Launched at the Beaubourg in Paris in May 1969, after London the exhibition that assembled these relics of Situationism for the pleasure of the fashionable intelligentsia travelled to the Institute of Contemporary Arts in Boston. Its commercial sponsors included a bank and a brewery. The episode seems designed

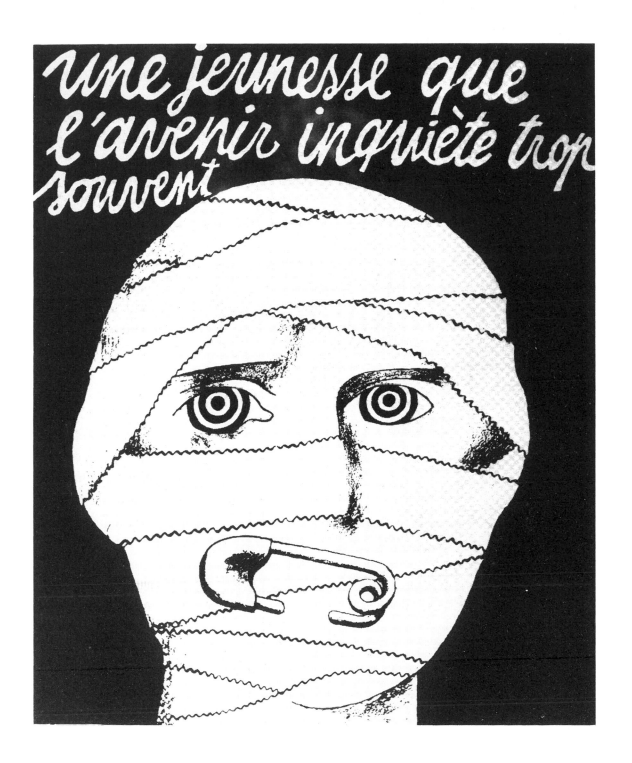

to illustrate the critic Andreas Huyseen's remark that, 'after '68, the imagination did not come to power. The Centre Georges Pompidou was built instead.'[1]

In 1988, as the twentieth anniversary of a pivotal year in the twentieth century brought out a raft of histories, documentaries and reminiscences, Guy Debord wrote:

The first priority in the spectacle's domination is to obliterate all knowledge of history, starting with just about all reasonable information and commentary on the recent past. . . . With consummate skill the spectacle organises ignorance of what is about to happen and immediately afterwards, the forgetting of whatever has nonetheless been understood. The more important something is, the more it is hidden. Nothing, in the last twenty years, has been so thoroughly coated in obedient lies than the history of May 1968.[2]

This statement, now recuperated as an epitaph, appears on the last page of the catalogue of the movement's embalming exhibition.

History repeats itself, only faster. In Britain the Situationists had their own illegitimate offspring, who replayed their ideology and imagery through the anti-spectacle of punk. Jamie Reid adapted the graphic style, Malcolm McLaren set out to subvert the entire music industry, by turning the avarice and the love of shock of promoters and record companies against themselves, and laughing all the way to the bank. In the process the group he created and managed, the Sex Pistols, for one brief moment of violent and offensive life supplied the ruling metaphor for Britain's social and economic crisis during the Seventies.

But by June 1989 the memorabilia of Malcolm McLaren's interventions in the music business and the fashion industry had already had their retrospective exhibition, at the New Museum of Contemporary Arts in New York. In London the Royal Academy was hesitating over offering him a similar honour. In London to promote his latest record this dropout and expellee of half a dozen art schools was invited to address the students of the Royal College of Art. Astonished by his

reception in a packed and eager lecture room he began, 'What is it that you want to know? I don't have any answers.'

What the art students of the 1980s wanted to know about was **style**. Why they wanted to know is one of the subjects of this book.

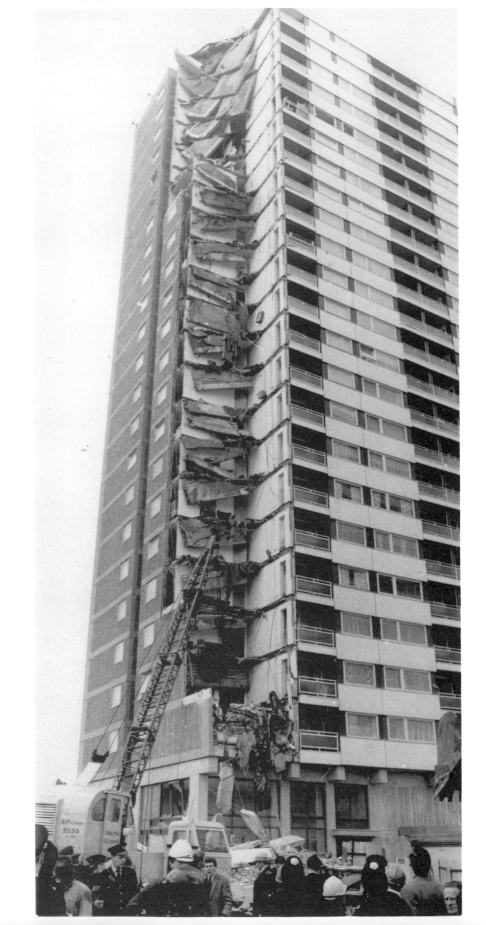

'Being good in
business is
the most
fascinating
kind of art.'

ANDY WARHOL

The turn of a century raises expectations. The end of a millennium promises apocalypse and revelation. But at the close of the twentieth century the golden age seems behind us, not ahead. The endgame of the 1990s promises neither nirvana nor armageddon, but entropy. The energies of the century are exhausted, the prospect of the future has reversed out into a negative image of the past.

That was not the feeling at the beginning of the century. The world was about to enter a new era: the modern age. A tidal wave of ideas had been released by the technological advances of science and industry. The idea of Modernism carried with it not just an optimistic faith in progress, but the belief that individuals and societies could benefit from and have control over the radical restructuring brought about by modernisation. Now, Modernism has lost its momentum; modernised no longer means improved. The process of modernisation continues with the remorseless yet erratic expansion of the world market. But it seems without point, as we come to realise that it is ultimately destructive of the environment that it has sought to control only in order to exploit. As the end of the century is reached there is a sense that further development will topple economies and ecologies into reverse. We are losing control of the present, and no longer believe that we can do much about the future. The culture of capitalism creates a sense of permanent crisis. The vision of Modernism has faded, gone the way of Romanticism and Classicism, to be replaced not by the new, but the neo.

Now, we live in the post-Modern. To be 'modern' has always meant more than to be contemporary. People have described themselves and their age as modern since the sixteenth century, and each time it has been in recognition of reaching a fresh stage in civilisation. The emergence of a new epoch always involves a changed perception of earlier periods, but until now people have defined their particular present against a positive idea of the past. In the Renaissance, where the idea of modernity began, the present was shaped in terms of a fruitful relationship with the ancient world.

But if the culture of any age can describe itself as modern, then a culture that thinks of itself as post-Modern must be thinking not in terms of a new epoch, but only in terms of a period that is *over*. Modernism has ended, and with no more to locate ourselves by than the prefix, *post-*, we stare into a void.

Into this void have collapsed the progressive ideals of the twentieth

century. The technocratic dream shared by mass societies, both capitalist and communist, that industrialism would lead to the emancipation of the individual, has proved false. The conflict between the interests of individuals and the state is as fierce as ever. As early as 1926 a caption in Fritz Lang's silent film *Metropolis*, which replays the legend of the Tower of Babel in terms of the construction of the modern city, warned, 'Those who toiled knew nothing of the dreams of those who planned.'

Those who dreamed and planned a socialist solution to the exploitation that industrialism – the economic context of Modernism – brought in its train have lost confidence in the possibility of creating a mass movement which would yet liberate the individual. In 1988 the historian Eric Hobsbawm drew a line underneath the history of the revolutionary movements to which he had devoted his life. 'Our movements, the classic socialist or communist labour parties, were born in a specific epoch which has now passed.'[1]

Those who planned were not necessarily of the Left, as the histories of pre-war Germany and Italy and post-war America have shown. Economic revolution is a social revolution in itself. In its final stages in the 1950s and 1960s the art of High Modernism, from the sculptures of David Smith and Anthony Caro, to the paintings of Ad Rheinhardt and Robyn Denny, to the music of Boulez and Stockhausen, was largely detached from any ideals of emancipation – except the belief that the practice of art itself should be left entirely free to pursue its autonomous, self-referring ends. In the spirit of *Metropolis*, Modernist architecture sought to achieve purity of form in concrete, steel and glass, but the skyscraper's earlier image of collective aspiration became transformed into a symbol of corporate power and domination. In the end, the twin drives of artistic Modernism, the urge to purify art by addressing no issues outside its own formal concerns, so distancing it from society, and the urge to revolutionise society through progress in art, came into conflict with one another. The final revolt of the avant-garde, expressed by the shambling protestations of the 'counter-culture', was against the official culture of High Modernism itself.

After 1968, neither Modernism as a social ideal, nor the idea of the avant-garde that wound around it, held out much hope for the future. Capitalism, which has carried both imperatives before it, experienced its first post-war crisis in the long recession that followed the oil embargoes and price rises of 1973. In Britain technocratic

Modernism experienced a symbolic collapse with the un-stitching of a systems-built public housing high rise, **Ronan Point**. By 1975 the revolutionary optimism of the counter-culture had evaporated, its heroes arrested, over-dosed or dead; their followers had taken their degrees, got their mortgages, moved to the country to sell antiques.

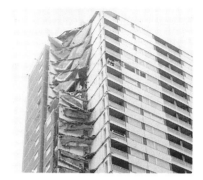

Ronan Point

The void became filled with a profound pessimism: the failure of the hopes of the 1960s embittered the radicals, in America and Europe conservatives looked to the past in order to contrast that idealised country with a decadent present. It is a sign of the cultural confusion of the late twentieth century that there is no one definition of the post-Modern. It began to be used in America in the 1960s on the one hand positively, to describe the break with elitist High Modernism by Pop artists and the counter-culture, and on the other hand negatively, to describe the fall from the principles of Modernism that these forms and attitudes represented. Either way, it was seen by artists and critics alike as a definite break with the Modern.

In the 1970s, the term migrated to Europe, and in architecture especially the break with Modernism appeared to offer new possi-bilities, in that there were no longer any rules to apply in a free market of styles. But where Modernism in art and architecture had implied renewal, post-Modernism has meant only the recycling of styles, including those of Modernism itself. Inevitably, in a period that perceives itself in terms of something that is over, post-Modernism is defined in terms of that which it is not, beginning with the absence of any single definition of itself.

In the post-Modern condition there is no longer belief in any grand system that will embrace and resolve all the problems of the world in a single account. No such 'grand narrative', such as that offered by Marxism, is possible, for there are no more large explanations to justify such a totalising – and thus totalitarian – system. There are no more utopias, though dystopias abound, from the Gulag to Cambodia to the American ghettoes.

The philosophical theories that have offered explanations of the world following the 1960s – Structuralism and post-Structuralism – are deeply pessimistic, for they seem to deny that it is possible to act upon what these explanations offer, by denying, in essence, that the individual will exists. We are either prisoners in a system of language, or castaways on a sea of ideology, and in neither case do we have any

control. Language speaks us; ideology shapes us in pursuit of its own ends. A great deal more than the Situationist International imploded after 1968. The critic Dick Hebdige has pointed out that the imagery of contemporary thought reveals a profound despair: 'The discourse of postmodernism is fatal and fatalistic: at every turn the word "death" opens up to engulf us: "death of the subject", "death of art", "death of reason", "end of history".'[2]

According to the philosophers of the post-Modern, philosophy is at an end, and so are philosophers. Not just individual will, but the very idea of individual identity is dismissed as an ideological construction, a necessary fiction during the emergence of nineteenth-century capitalism, but redundant in the age of the multi-national corporation. And that fiction is a construction of language, of the historic necessity of grammar. The French Structuralist Julia Kristeva sees the human condition reduced to the point where, 'individuals are no more than ephemeral variables in an eternally repeating machine of identification and rejection, of yes and no, of mimesis and aggression, that clearly presides over the phonological structure of language.'[3]

The prevailing pessimism is a sign of impotence. If no grand narratives are possible, there is no need to attempt to construct them. If no explanations can be given, there is no need to look for them – other than for those that explain why they cannot be found. By denying the identity of the self, the new theorists deny the possibility of thought leading to action. Submission to belief in the existence of an all-pervading ideology removes responsibility for our own lives, and for our social inaction. The pursuit of the autonomy of art relieves the artist of any social or political commitment. But then the artist, being an individual, does not exist.

Artists have been declaring the terminal condition of art for some years. Their final endeavours have been to record that state. Julia Kristeva's ephemeral variables in an eternally repeating machine of yes and no were first imagined by Samuel Beckett. Beckett's novels and plays achieve the utmost reduction in the materials and conditions of human life. In *Breath* (1969) drama is reduced to a single gasp and the waxing and waning of the light. Other artists have made similar gestures that take form and content to the point of disappearance: Ad Rheinhardt's all-black paintings, Sol LeWitt's instructions for lines to be drawn on a wall, Carl Andre's floorbound arrangements of sheets of metal or bricks. The composer John Cage has gathered his critical writings together under the title *Silence*. In 1952 he had written '4'33"

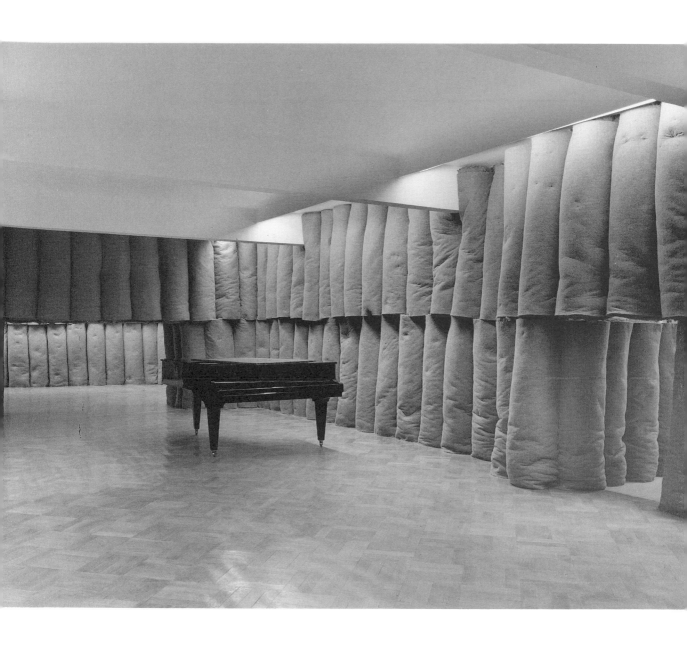

(tacet for any instruments)', first performed by a pianist who sat at the piano for precisely that length of time, without playing.

There are, of course, residual traces of content and performance in such works. The ambient noise in the concert hall was music enough for Cage.

PLIGHT

But these traces have not even a faint strain of Modernist optimism; their communication is limited to displaying the limits of communication. In 1985 Josef Beuys may have had Cage – he certainly had Beckett – in mind when he created his final London installation, **PLIGHT** at the Anthony d'Offay Gallery. The gallery walls were lined in thick rolls of felt, which turned the rooms into a tomb entered under a low, felt arch. The interior contained nothing but a closed piano with a blackboard and a thermometer on its top. The space was protected and warm (the felt and the thermometer) but, said Beuys, 'This room contains elements similar to those in Beckett's plays: everything is isolated, and knocking on the wall has no resonance. Communication is no longer possible.' He later said, 'People ask me what it means, and all I can say is, it means nothing.'[4]

three dancers

All that remains is the work itself. But that too is over. The installation has been dismantled, its powerful presence dispersed, and Beuys is dead. The past is post, we have lost the horizon of the future and must content ourselves with the evanescence of the present. At the end of their performance in a crowded art gallery **three dancers** breathe on a piece of glass fixed to the wall. As the faint cloud of condensation on the surface of the glass fades away, they walk quietly out of the room.[5]

The problem of our present is that it offers no secure image of the future. That comes to us out of the void, imagined as a horror film, a world peopled by mutant escapees from an experimental laboratory, or terrorised by gangs of warring *untermenschen*. The cities of Ridley Scott's *Bladerunner* or Terry Gilliam's *Brazil* are satirical images of the present where individual lives are the subjects of repression by an all-powerful technology of surveillance over which they have no control. Despite the current proliferation of images, the invisible links of the computer network and the microchip supply no adequate representation of the complexity and immediacy of the present, let alone the future. The potential destructiveness of nuclear

energy – as weapon or as accident – is so vast as to be inconceivable. We have lost the capacity to visualise or comprehend the technological processes that threaten to overwhelm us.

If Modernism in art was an attempt to understand and control the progress of modernisation in life, post-Modernism is an attempt to come to terms with what, in the developed world at least, has been termed post-industrial society. When Daniel Bell first published *The Coming of Post-Industrial Society* in 1973 he was writing at a time when world recession was developing into an economic crisis that placed the future industrial order in question: 'It used to be that the great literary modifier was the word beyond . . . but we seem to have exhausted the beyond, and today the sociological modifier is *post*.'[6] Bell argued that in the new economic system that was developing the ultimate determining factor would be neither raw materials, nor production, nor the surplus value created by the exchange of goods. In post-industrial society the key would be knowledge, science, technological research.

That new order has come about: the manufacture, distribution and exchange of information has created a new global pattern of industrial organisation. And as the new economic order has changed to meet these new circumstances, so has society. It is this that has led to the perception that a new epoch has begun. The new technology is itself a new form of perception. The VDU and the television set are the source of our information at the workplace, and our recreation at home. Their inner coils and reticulations of circuitry offer invisible connections to a network that holds the total sum of human knowledge, past and present. But when we try to access the future, the programme is unwritten – or we do not have the code. A distorted, shadowy image of ourselves stares back, as we confront a featureless blank.

Behind a row of shops in a modest north London street is a gallery, neither publicly funded, like the ICA, nor a commercial enterprise like Anthony d'Offay. The building is post-industrial, in that it is built like a factory and was once a motor repair shop, and then a paint distribution depot. Now it houses the collection of Charles Saatchi. The entrance is as discreet as its owner, who is rarely seen in public, never photographed and seems to make a point of not meeting his and his brother Maurice's clients. Behind the former factory gate, its wicket entrance marked by a buzzer and a humble card announcing the Saatchi collection as though it were any other household, is a

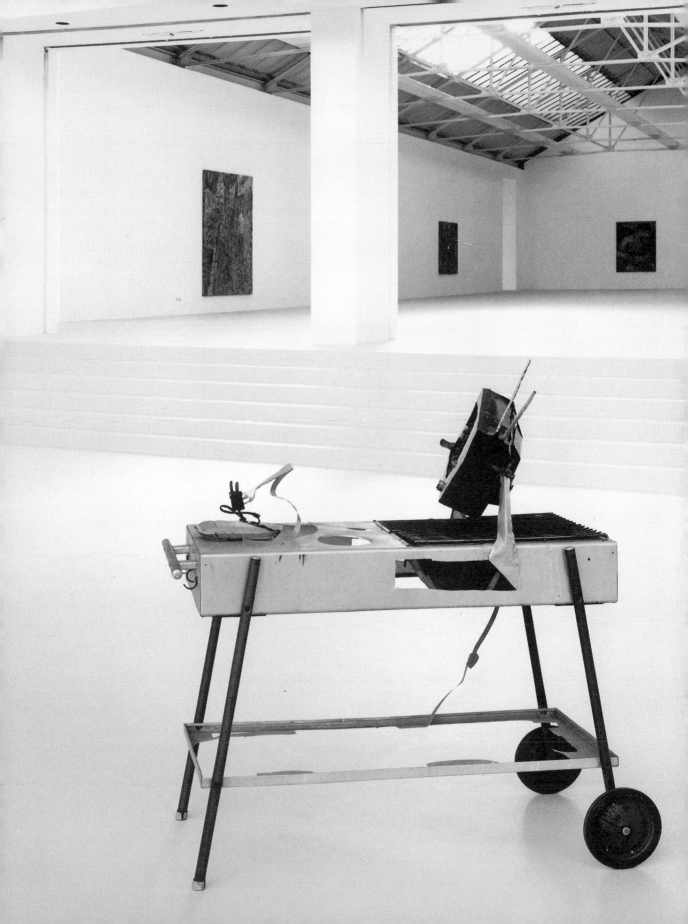

the gallery

pure white, completely empty access yard. To the left a further empty court leads to the door of **the gallery**.

This pure space marks the absence of Charles Saatchi as significantly as Michelangelo's library in San Lorenzo in Florence marks the presence of Lorenzo di Medici. Inside, the sequence of large rooms, three times the size of the Whitechapel art gallery, covers 30,000 square feet. It has been open to the public, on Friday and Saturday afternoons, since 1984. In the mid-1980s Charles Saatchi was spending £1 million a year on the collection, which has grown to more than 800 pieces.

The quantity of sheer space available is needed, for many of the works are very large, and the collection's strength is, paradoxically, its minimalism. The first piece to be bought, in 1969, was by Sol LeWitt, but the interest that began with a form of art that makes its presence felt by its absence has expanded to include the neo-Expressionism of Julian Schnabel, Georg Baselitz and Anselm Kiefer, a broadening range of British artists from Leon Kossof and Edward Auerbach to Howard Hodgkin and the sculptors Richard Deacon, Bill Woodrow and Tony Cragg. The multiple neos of the new New York School – neo-Geo, neo-Futurism, neo-Pop, neo-Conceptualism – are represented. The collection acquires work by each artist in depth, so that there are, for instance, a dozen recent works by the American figurative artist Eric Fischl. Through this collection it is possible to see most of the developments in contemporary art since the mid 1960s.

Fischl's narrative pictures

Because of its size, already too large to be displayed as one unit, and because Charles Saatchi sells as well as buys, the collection has a significant influence on the art market. It is one of the few private collections that can accommodate the large-scale works that otherwise are destined to go directly to public museums. It could be compared to the collections formed by the magnates of the nineteenth century, the Levers and the Tates, except that these are works of intellectual abstraction rather than Victorian grandiloquence. Fischl's nudes might have their parallels in the sublimated eroticism of Alma-Tadema, but **Fischl's narrative pictures** conceal rather than reveal a story, and evoke not luxury and pleasure but unease, morbidity and menace.

Charles and Maurice Saatchi are magnates, but they manufacture,

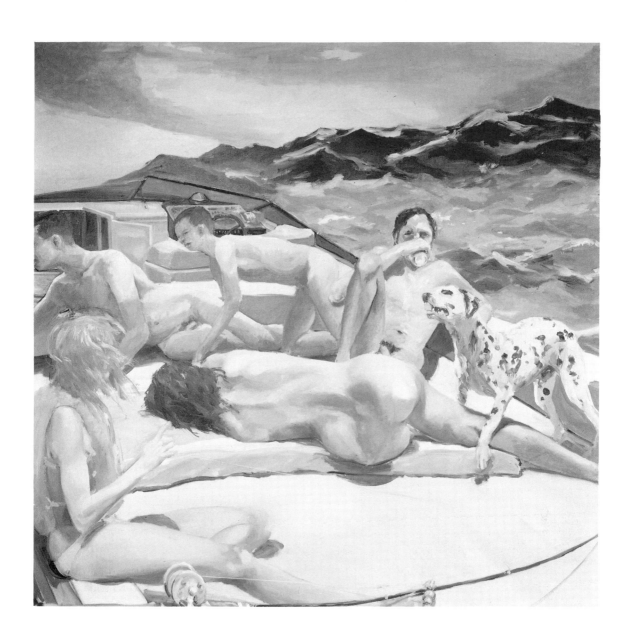

not things, but imagery. Since its foundation in 1970 the firm of Saatchi and Saatchi has grown to become (in 1989) the biggest advertising agency in the world, with 16,000 employees and offices in fifty-eight countries. Their progress has since faltered, but they are prime examples of the new economic order. Their commodity is information, and their operations are not merely multinational, but global. They have embraced the principle of dominance promulgated by Professor Theodore Levitt of Harvard Business School, which states that the only market is the global market, and the only viable position for a company is to be one of the top three in that market. The growth and globalisation of the information industry has had a profound cultural effect. In 1977 a statement by the American film, television and recording company Warner Communications declared:

The movement of information – at many rates of speed, to many kinds of people – is the business of Warner Communications. And the phenomenal growth of our company, along with other leaders in the field, reflects a marriage of culture and technology unprecedented in history, and a commensurate revolution in the human sense of self.[7]

Setting aside for the moment what that sense of self might be, the growth of Warner Communications was felt to be too slow for the principle of dominance. At the beginning of 1989 it sought a merger with Time Inc., to create the biggest communications company in the world.

The move was defensive, to meet the challenge of competition from Japan's Sony (who shortly after bought Columbia Inc. from Coca-Cola), from West Germany's Bertelsmann, from Britain's Robert Maxwell and from the international empire of Rupert Murdoch. These and companies like Xerox and IBM control 90 per cent of the world information network. Their power interlaces television, radio, newspapers, news agencies, cinemas and studios, record companies, magazines and publishing houses. The growth of the television industry means that not only is the same programme seen in eighty countries, but up to 30 per cent of the world's population can witness the same event at the same time via satellite. In Derek Jarman's film *Jubilee* the power of the media barons is satirised in the figure of Cardinal Borgia Ginz:

You wanna know my story, Babe, it's *easy*. This is the generation who forgot how to lead their lives. They were so busy watching my endless movie. It's power, Babe. Power. I don't create it, I own it. I sucked and sucked and sucked. The Media became their only reality, and I owned the world of flickering shadows – BBC, TUC, ATV, ABC, ITV, CIA, CBA, NFT, MGM, KGB, C of E. You name it – I bought them all, and rearranged the alphabet.[8]

Now, when money begets money with electronic purity, information is bought and sold in an economy, not of production, but reproduction. Its value is such that the philosopher Jean-François Lyotard fears that, 'the nation-states will one day fight for control of information, just as they battled in the past for control of territory.'[9] The development of information-seeking spy satellites has already moved the threat of global war into space.

The information industry is reshaping cities. In Turin, Fiat's redundant factory at Lingotto is being turned into a 'knowledge factory' where academic scientists and high-tech companies will share facilities for research. In Britain, in an economy afloat on invisible earnings, the London Docklands Development Corporation has read back its own image into the past: 'When the docks were first built they represented a massive revolution in communications as waterways became the chief means of transportation and communication. Today information is still the vital commodity for any business.'[10] And with the video screen and the fax machine, physical transportation is becoming as obsolete as the docks.

The coming of post-industrial society seems to mean not the end of capitalism, founded on the control of production and raw materials, but transcendent capitalism, which through the deployment of international finance capital not only is beyond the control of nation states, but has invaded the private sphere, where consumption has become the sole purpose of life. The information industry is the vehicle of this global capitalism. It circles the world, and as Warner Communications proudly boasts, provokes a revolution in the human sense of self: helplessness in the face of the overwhelming power that masters it.

The Saatchi collection, sustained as it is by profits from this system, frames the dilemma of the avant-garde. The gallery contains some of the most radical work of the late twentieth century, displayed to its

very best advantage. The stillness, the quiet, the chastity of the space that holds them has a spiritual quality: but it comes from the isolation of the works. Even the most demonstrative piece seems withdrawn, sharing the strange unrelatedness to the world outside the gallery, to the street, the shops, the housing estates that surround it.

The work has a purity which detaches it from life. It has that autonomy within its own sphere which much twentieth-century art has sought to achieve. But in doing so it has separated itself from that other impulse, to use art as a means of revisualising, and so changing, the world. The avant-garde movements committed to that second purpose – the Futurists, the Vorticists, the Constructivists, the Dada-ists, the Surrealists – included in their programmes a revision of the institution of art itself. It was not only necessary to challenge the conventional definition of reality offered by earlier styles of rep-resentation in art, it was also necessary to challenge the institutional framework within which art was contained. If it was to have any practical effect on how people led their lives, art had to be able to function in a different way. In essence, this revolution in art had to be achieved by destroying the conventional, bourgeois notion of 'art' altogether.

The attempted revolution has failed completely: from the moment Duchamp's common-or-garden urinal, signed by the fictitious R. Mutt, entered the permanent collection of an art gallery, the game was up.[11] Even the Situationists could not resist being recuperated into the system they attempted to subvert. Formerly dedicated to overthrowing the institutions of art, the avant-garde has become its own institution, and so negates its own purpose. As the critic Suzi Gablik argues, 'the steady displacement of radical consciousness by the forces of professionalism, bureaucracy, and commercialism has caused avant-garde art to lose its power of rebellion and crippled its impact.'[12] This has not meant the end of art as a self-referring activity, but it means that the avant-garde, as understood in the first half of the twentieth century, is indeed over. In its place, a neo-avant-garde lives on, incorporated into an official version of cultural production that reserves a special place for the new and the experimental: the sheltered accommodation known as the museum of modern art. With Modern-ism incorporated into the official culture of governments and insti-tutions, the oppositional role that an avant-garde might once have played has been absorbed into the world view to which it was opposed.

The avant-garde cannot resist the institutionalisation of the academy when the academy has adopted the posture of the avant-garde, as has been the case in Europe and the United States since the 1960s. Just as the fashion industry has to produce collections twice a year for their autumn and spring seasons, public institutions and the commercial infrastructure that supplies them require a constant renewal of imagery and ideas. And as in the cycle of fashion, moments of innovation are succeeded by the revival of old lines.

In these circumstances, genuine experiment by an artist is replaced by the reproduction of an avant-garde career. During the late 1970s the aridities of Minimalism and the non-visual nature of conceptual art seemed about to defeat the institutionalisation of art practice by causing art to disappear altogether. Museums of modern art in Europe and America filled the looming void by mounting a series of exhibitions devoted to the avant-gardes of the first decades of the twentieth century. The avant-garde entered the Royal Academy as history. In the early 1980s the rediscovery of the original, now 'historical' avant-garde was followed by the promotion, at the Royal Academy, of a 'New Spirit in Painting', the title of an international survey in 1981 which presented this new spirit, paradoxically, in terms of a return to traditional values: 'For all its apparent conservatism, the art on show here is, in the true sense, progressive. Consciously or instinctively, then, painters are turning back to traditional concerns.'[13]

The values, it appeared, were chiefly those of pre-war German Expressionism. The violence, distortion, morbid sexuality and the ultimate political destruction of the original Expressionist movement appealed to artists forming their ideas in the inflationary and socially disrupted 1970s. It meant a revival of the 'painterly' qualities associated with the marks left by an epic struggle between the artist and his materials. (The artist was almost invariably male.) The heroic gestures, broken surfaces, dense textures, the distorted figures, revived the style and rhetoric of Expressionism. But the *sturm und drang* of a neo-Expressionist like the American **Julian Schnabel** is an empty rhetoric. The critic Craig Owens argues that all that the signs of artistic heavy labour in such work reveals is not mastery, but its loss: 'In fact, contemporary artists seem engaged in a collective act of disavowal – and disavowal always pertains to a loss . . . of virility, masculinity, potency.'[14]

Julian Schnabel

The contemporary artist is caught in a ritual of excess, where only

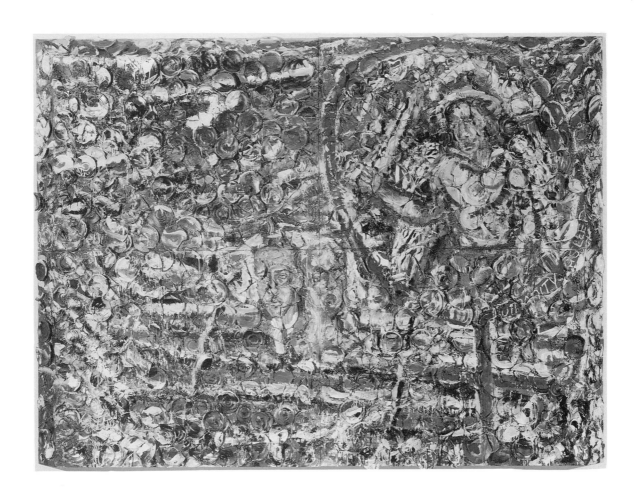

the most violent – or ridiculous – gestures are sufficiently rebellious to gain the attention of institutions and dealers alike. Even conceptual art, which attempted to escape the materialism of the art market by presenting ideas rather than objects, has been recycled in the banalities of **Jeff Koons**, whose artistic exploitation of the American art market was made possible by an earlier career as a commodities broker on Wall Street. Koons has moved on from Dadaist gestures of vacuum cleaners in glass cases and basket balls suspended in fluid to the use of craftsmen to produce limited editions of kitsch pottery sculptures. His career demonstrates what the English artist and critic Dan Cameron has described as 'the tyranny' of the avant-garde, where 'the artist who best flaunts his/her contempt for a decayed or outgoing style becomes the timeliest investment, the surest hedge against hard times ahead.'[15] Artists are caught in the contradiction

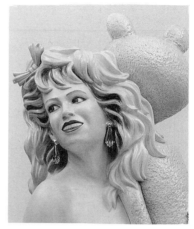

Jeff Koons

that the idea of progress in art is no longer progressive, when it is the only expectation that they are permitted to fulfil.

The institutionalisation of a neo-avant-garde in the 1980s may have created a double-bind for artists, but it has done well for the institutions that trade on them. The New Spirit in Painting was not unique; *Westkunst* in Cologne in 1981, *Zeitgeist* in Berlin and *Documenta VII* in Kassel in 1982, *New Art* at the Tate Gallery in 1983, asserted an international revival of 'traditional' painting, a theme taken up in group shows in the United States. The prophecy was self-fulfilling, and public galleries and private dealers benefited from the fresh interest that had been created. One of its creators, the exhibitions director of the Royal Academy, Norman Rosenthal, commented: 'Suddenly painting seemed to begin again internationally, particularly in Germany, Italy and America, and prices started booming and the market took off.'[16]

It has become a convention, following the Marxist critic Walter Benjamin, to say that art has lost its 'aura'. It is argued that in an age of proliferating mechanical reproduction, the individual work of art, far better known through its postcard image or catalogue illustration than as a unique object seen and revered in a single location, has lost the religious status that a painting once shared with an icon.

But that is not the case with the Saatchi gallery. Indeed, the reverent atmosphere it and other modern galleries evoke suggests not that art

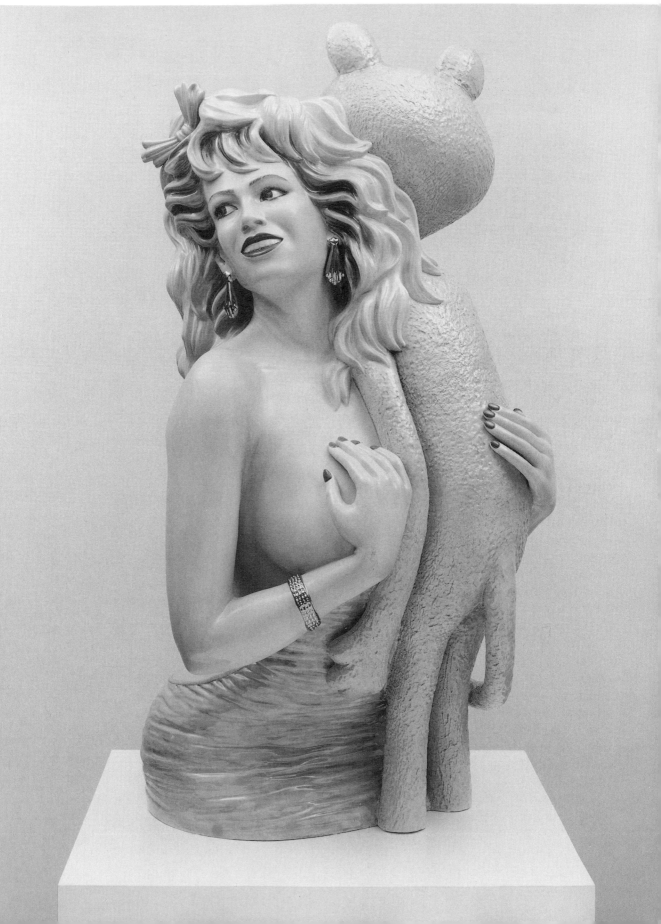

has lost its religious aura, but that it has become a substitute for the contemplative consolations no longer offered by religion. And as Norman Rosenthal's comment reminds us, art has gained a new aura: that of money. The law of supply and demand and the finite number of works available help to explain the phenomenal prices paid for the Impressionists and the old masters that preceded them, but the prices of twentieth-century works have followed a similar spiral. At a Sotheby's sale in New York in May 1989 paintings by Jackson Pollock, Francis Bacon and David Hockney fetched £6.9 million, £3.74 million and £1.3 million respectively. In London in June Christie's raised £1.2 million from a sale devoted to relics of the anti-capitalist Josef Beuys. In New York in November a new record price for a work by a living artist was set when a work by Willem de Kooning was auctioned by Sotheby's for £13 million.

The imagery of the market has penetrated the language of criticism so deeply that the great celebrator of post-Modernism in architecture, Charles Jencks, can describe the history of the avant-garde in terms of, 'an aggressive multi-national out to capture new markets, never content with what it has already done, always intent on the next challenge; "innovate or die", continually change or dry up, continually destroy in order to create.'[17]

The critic Robert Hughes argues more soberly that, 'there is no historical precedent for the price structure of art in the late twentieth century. Never before have the visual arts been the subject – beneficiary or victim, depending on your view of the matter – of such extreme inflation and fetishisation.'[18] Art is no longer appreciated for itself, but for the amount by which it will appreciate. The creation of the confidence that it *will* increase in monetary value, Hughes suggests, 'is *the* cultural artefact of the twentieth century.'[19]

This confidence is sustained – has to be sustained – by a range of institutions with a vested interest in the support of contemporary art prices. The market structure, says Hughes, 'resembles, and parodies, that of the multi-national corporations.'[20] Art dealers and gallery owners such as Mary Boone in New York and her husband Michael Werner in Cologne are themselves multi-nationals, as are the large auction houses. Banks and corporations – Philip Morris, Chase Manhattan, Prudential Insurance, Unilever, Deutsche Bank – have invested heavily. Public museums depend on the constant renewal of exhibitions and the discovery of fresh talent to sustain attendance levels and justify their funding. They maintain the glamour of

contemporary art through devices such as the Turner Prize at the Tate – sponsored by an international investment house. Critical discussion of contemporary art is conducted in magazines that rely on gallery advertising to survive. At one remove, a teaching establishment has its own interest in the cycle of critical production and destruction.

This process does not merely lead to a re-evaluation of artistic activity into purely monetary terms. More subtly, it leads to a shift in the way artists see – and value – themselves. And not just in the visual arts. The publisher Philippa Harrison, a former managing director of Macmillans, has observed the corporatisation and globalisation of the publishing industry, and its effect on writers:

'This thing must be good because it makes money.' 'I must be good because I make money.' And money is fashionable. The publisher must be good because he or she can afford to pay far too much money for top authors, the agent must be good because he or she gets his or her top author far too much money. It is not new for an author to want as much money as he or she can get – and often the author needs more than he or she gets – but the equation of money with talent is new and, I think, threatening for writers.[21]

As it is for any of the stars created in the new futures market of artistic reputation, for markets fall as well as rise.

On Wednesday 5 July 1989 the Prime Minister, Mrs Thatcher, sailed down the Thames through a London paralysed by a transport strike to

A new museum

open **a new museum**. Her government has not looked kindly on the public museums in its charge, freezing their purchase grants, allowing their buildings to fall into disrepair and the value of their budgets to be overtaken by the rise in the rate of inflation. But this was a museum that – with the exception of £100,000 from the English Tourist Board – was not built at public expense, and which will run – with the exception of £650,000 over three years from the Department of Trade and Industry – at no cost to the Exchequer. In her speech at the opening Mrs Thatcher dismissed the concept of a museum as, 'something that is really rather dead.' She preferred to call this new one an 'exhibition centre'.[22] And so it has proved to be, for the

ideology of this museum exhibits values that have come to dominate late twentieth-century culture.

The Design Museum at Butlers Wharf, on the south bank of the Thames just below Tower Bridge, is not a new shrine for art, but a temple of commodities. Like the Saatchi gallery, it is a post-industrial building, a 1950s warehouse cunningly converted into a pastiche of the white-walled, right-angled rationalism of Bauhaus design: a piece of retro-Modernism that imitates the style but lacks the content of the industrial idealism of the 1920s. For its purpose is not the manufacture of goods, but their fetishising display.

The argument of the Design Museum was set out in its first 'agenda setting' exhibition, *Commerce and Culture*. The future of design, it suggested, is more promising than that of literature and the fine arts. The reason is that commerce and culture are at last becoming the same thing. 'The distinction between life and art has been eroded by fifty years of enhanced communications, ever-improving reproduction technologies and increasing wealth.'[23] The very notion that a distinction between commerce and culture might exist is dismissed as a recent prejudice, a romantic and elitist response to industrialisation and mass production. Now museums, the repositories of art, and shops, the repositories of goods for sale, are becoming the same, 'committed to consumption, either of images, ideas or goods.'[24] This is no threat to civilisation. 'On the contrary, the synthesis of culture and commerce is a unifying process, bringing together the two appetites for consumption of knowledge and of goods which were once artificially separated.'[25] A wall notice declared in bold type: 'One day, maybe, stores and museums will become the same . . . with everything for display, inspection and sale.'

That day had not yet arrived at the Design Museum, for unusually, it opened without a shop. The only opportunities for consumption were the £2 entrance charge and the bar on the ground floor, where it was possible to view an exhibition of graphic design sponsored by Perrier, while holding a 75p glass of Perrier in your hand. But if the consumption of knowledge and the consumption of Perrier have become the same thing, there is no need for something as banal as a shop. By its own logic, the Design Museum itself is an object for consumption and sale.

The text of *Commerce and Culture* must be read in the context of the institution's foundation. Its £7 million capitalisation came from the Conran Foundation, a trust formed with part of the proceeds of

the public flotation of Sir Terence Conran's Habitat chain in 1981. The £1.5 million it is expected to cost a year to run will come from entry charges, the Conran Foundation, and business sponsors. The Design Museum is thus an extension of the forms of cultural consumption upon which its principal benefactor's fortune rests: furniture, fabric, household goods and clothing in the combination of Habitat, Heals, Mothercare and British Home Stores in the Storehouse group; architecture – the partnership Conran-Roche; publishing – Conran Octopus; and food – the Bibendum Restaurant. The display of goods on the shelves of the Design Museum is a stimulus to the acquisition of goods manufactured by its sponsors: Olivetti, Courtaulds, Addis, Apple, Kodak, Sony, Fiat, Black & Dekker, Perrier, Coca-Cola. Goods that will appear on its shelves.

The Design Museum building is itself a particularly attractive item on the riverside display of the surrounding £200 million development by Sir Terence's Butlers Wharf company, for whom the architects are Conran-Roche. The as yet empty space upstream of the museum will be filled by Spice Quay (a comforting label for an office block), the warehouse on the downstream side will be turned into a hotel. As the advertising for the scheme states, 'The Design Museum sets the tone for retailing at Butlers Wharf.'[26] The Design Museum serves as an advertisement for the new culture of consumption that has completed the elision of commerce and culture by turning all culture into a commodity.

The confluence of commerce and culture is brought about most effectively by advertising itself. Recognising that art and culture are the source of a society's symbolism, advertising inserts its imagery and the commodity values it bears into the cultural bloodstream by cultural means: by manipulated images, fictive words, thirty-second dramas, music and murals. There is an art of advertising – the dream states and disturbing juxtapositions of Surrealism are more familiar from hoardings than museums. The entire repository of visual imagery and cultural reference is available for exploitation. Derek Jarman noted of the television transmission of *Jubilee* that during an advertising break

Hitachi used Caravaggio's *Calling of St Matthew* for their commercial, symbolically replacing Christ with their latest television. The Light of the World usurped by a television

screen. . . . None of the critics of the violence in the film (one of the only films to *deal* with this area) noticed the violation in the Hitachi advertisement.[27]

Advertising, a £47 billion business in the United Kingdom, is the motor of the information industry. But, as commerce takes over culture, so manipulation succeeds information. Disinformation is as important a message as information in a system designed to promote consumption. We no longer acquire things because we have a use for them, but because we associate pleasure with their possession, or lack of them with pain. Need is replaced by desire, and the information industry itself becomes a commodity, the key commodity in a system where production has replaced consumption, and the purpose of economic activity the production of more consumers. Without the promotion of consumption, production will decline. The graphic designer Neville Brody has said that the direction of design, 'is towards the refining and *redefining* of techniques of manipulation. Design is no longer a creative process – it is being used to conceal a social system on the brink of collapse.'[28]

Design, as the Design Museum recognises, is no longer about the rational organisation of components or even the material appearance of things, it is 'the critical intelligence co-ordinating supply and demand'.[29] The very concept of design is the stimulation of trade. Its purpose is 'experience', and the source of that experience is advertising:

That ads for sherry nowadays read like text books, that Panasonic use Cubist pictures to sell office machines and Mercedes-Benz is pleased to compare itself to the eighteenth-century visionary architect, Claude-Nicolas Ledoux, are symptoms of an age demanding *value* and *meaning*, even in very ordinary, everyday things. In product design, functional excellence is now the baseline and to be successful consumer goods have to offer something more culturally seductive than mere efficiency. Customers demand what the advertisers call *shared values*.[30]

It is the shared cultural values of a view of the River Thames through plate glass windows from a marblised interior aping a modern Italian railway station bar that stimulates Perrier to sponsor the ground floor

gallery, as much as an opportunity to celebrate its own advertising campaigns, fetishised as 'graphic design'.

The elision between cultural and commercial values in the Design Museum's visual and verbal rhetoric marks the transformation of culture into style. The manipulation of style turns thoughts, feeling and associations into commodities for circulation by the information industry. Control of a product's appearance and associational context – eroticism, class status, power – is a means of controlling the thoughts and feelings of their purchasers. The critic Rosemary Betterton points out that the possibilities held out to women by the fashion industry, of changing identity by adopting a new style, in fact channel and limit their potential identities, 'by substituting a series of products for a truly different self-image. Women are sold their own images in the form of commodities.'[31] The logic of this inversion of social values is that a former Arts Minister, Lord Gowrie (who resigned in order to become chairman of the auctioneers Sotheby's) can tell the London Business School that shopping is one of the legitimate cultural pursuits of the late twentieth century.[32] Creativity is no longer what we make, or what we think, but what we buy.

The future of culture, according to the Design Museum, lies in teleshopping, which, 'could bring the museum and store into your own home.'[33] But the technology of television has already produced an important shift in cultural perception. It is not simply because advertising revenue is central to the information industry, nor that commercials have higher production 'values' (that is, they cost more per second) than the programmes that surround them. Television has changed our world view. It gives instant access to a thousand images, but each is narrowed to the small screen. The bemused narrator of Martin Amis's novel *Money* tries to come to terms with that alteration of perception:

Television is working on us. Film is. We're not sure how yet. We wait, and count the symptoms. There's a realism problem, we all know that. TV is real, some people think. And where does that leave reality?[34]

The reality of television is immediate, but we witness events (whether actual or fictional does not matter) rather than experience them. The mind and body are separated, just as viewers are separated, each in

their own homes, watching in private isolation. This domestic consumption allows the information industry to penetrate into the furthest recesses of our lives. John Hegarty, of the agency Bartle, Bogle and Hegarty, is determined to pursue us, even while television reinforces a sense of unrelatedness: 'As society fragments, we target more.'[35] Our world picture breaks up, splintered into clips and cuts, suspended on an unending flow of imagery, a single sequence of infinite variety, with only the passage of time as continuity.

Yet in the commodified culture of the late twentieth century the fact that art and literature supply society with its imagery and symbolism makes it more, not less important. With basic necessities provided for, the cycle of production and exchange has to be sustained by aesthetic innovation, by the manufacture of values and meanings. The very 'uselessness' of art and literature is what makes them most useful – the restlessness of experiment, the tyranny of the avant-garde that demands the constant renewal of imagery and ideas, supplies a steady stream of marketable associations from an apparently infinitely renewable resource. That is the – almost certainly unconscious, but quite logical – connection between the two forms of imagery that interest Charles Saatchi.

The conditions under which culture is produced and consumed (as opposed to created and experienced) are now such that even the most elitist high culture, which in its classical and Modernist forms constituted a form of criticism of twentieth-century industrial society, can become a product like any other. Traditionally, high culture represented the values of the rulers, the concerns of the aristocracy, the church and the governors of the state. The Australian cultural critic Donald Horne argues that now, the minority interests of those most concerned with philosophy, scholarship and the arts are no longer part of the culture of the rulers of modern industrial societies. 'The culture that dominates the public scene is not a ruling-class culture of triumphal display, but a fabricated "public culture" that purports to be the culture not just of the rulers but of all the people.'[36] This public culture, administered by governments and corporations, has absorbed the traditional values of high culture which it now deploys as a form of niche-marketing sustained by government agencies and private enterprises: museums, publishing houses, recording companies, art dealers, theatre owners and producers, 'quality' newspapers and periodicals, radio and television. In the process, even the most extreme statements of artists and writers who set out to challenge the

aristocratic and bourgeois views of the world have become acceptable subjects for recreation and entertainment. The fragmentation, anxiety and alienation revealed in T. S. Eliot's *The Waste Land* is now the familiar territory of the spy novel. Eliot's J. Alfred Prufrock has fathered John Le Carré's George Smiley. *Metropolis* becomes a musical.

Architecture, formerly the most assertive medium of twentieth-century Modernism, has most obviously absorbed the new values. The rules governing the conduct of the profession have shifted from those of the academy to those of the market place, as architects have become their own contractors and developers, like Conran-Roche. The architectural critic Richard Bolton argues that

the very basis of architectural practice has changed. In the past, architecture identified with religion, or science, or engineering; today another equation is apparent: architecture = advertising. For it is advertising that is the dominant form of discourse in contemporary life, and architecture and all other forms of cultural production have been recast by this fact.[37]

Advertising is the principal medium for the new, commodified, public culture.

'My buildings are a product,' says a developer, adopting precisely the language that Bolton deplores, but one that is used throughout the public culture. 'They are products like Scotch Tape is a product, or Saran Wrap. The packaging of that product is the first thing that people see. I am selling space and renting space and it has to be in a package that is attractive enough to be financially successful.'[38]

In Britain, the promotion of an enterprise culture by the Conservative government (which nonetheless has been steadily eroding the country's manufacturing base) has transformed the Arts Council from a disinterested institution committed to the expansion of artistic activity (albeit narrowly defined), and to making it as widely accessible as possible, into an aggressive instrument for marketing the arts. The Arts Council now promotes itself as an entrepreneurial bureaucracy. Under the chairmanship of Peter Palumbo, one of the wealthiest men in the country, a property developer and collector of contemporary art, it is at the government's behest placing more and more emphasis on 'incentive funding', a form of subsidy which is conditional on arts organisations transforming themselves into

commercial enterprises, rather than fulfilling their function as centres of experiment or creativity.

In both Britain and America the elision of culture and commerce has already taken place in many museums. The Victoria & Albert Museum, which in 1985 projected itself as 'the Laura Ashley of the 1990s' has become, in the words of its marketing manager, 'the Harrods of the museum world' – while shedding key curatorial staff.[39] Education is being taken over by the enterprise culture: the rector of the Royal College of Art talks of the institution as a business, and its students as 'product'.[40]

As the sponsors who have contributed £2 million to the Design Museum are aware, business sponsorship of the arts, now more than £30 million a year, is closing still further the gap between the arts and advertising. Sponsorship wraps the self-interest of the sponsor in a gesture of public largesse that appears to resolve the contradiction between the exploitation of the market and the imaginative needs of society as a whole. But business sponsors are already working in a system of commodity values, their sponsorship cannot be dis-interested. The 'shared values' that are sought by advertisers are modified in the exchange. The 'product' becomes a 'package'. And, since most of the shared values are traditional values, the emphasis is on those art forms with a predictable response. Arts programming suffers a gradual inertia, presenting only the least challenging music, the most conventional plays. When its reluctance to sponsor new work leads to imaginative atrophy, the information industry does not work in its own best interest.

In the new supermarket of culture 'with everything for display, inspection and sale', the conditions for the making and enjoyment of art, music and literature have so altered that many of the previous divisions between 'high' and 'popular' art have been dissolved, each has interpenetrated the other, as high art draws its subject matter from mass society, and popular forms like the cinema and television exploit the vocabulary of Modernism. Pop has its own version of the avant-garde, and the pop video aspires to the condition of the 'art' film. Television is the primary source of this 'levelling', which, while welcome as a form of democratisation of the arts, is a source of profound pessimism to cultural conservatives. But the instant access-ibility of high or low art through the same medium turns out in the main to offer only a choice of informational codes, not experiences.

Not only are all qualities equal, but all forms of art from all periods are equally available. There is no new, only the neo, and the artist may choose one style or another – or all of them, as in the case of Pat Steir's **The Breughel Series**, 64 panels reworking Breughel the Elder's *Flowers in a Blue Vase* of 1599 in 64 different styles, from Renaissance classicism to Baselitz's neo-Expressionism.

The Breughel Series

But if all styles are equally valid, no style has more authority or authenticity than another. We are left with a choice of superficial images, not of content. Under the bombardment of imagery made possible by the proliferating technology of reproduction the visual has replaced the verbal (spoken or written) as the dominant mode of communication. But words refer to ideas, images to sensations. Words are structured by the grammar of language that demands a rational ordering of ideas if the words are to make sense. The eye is free to rove promiscuously, accepting pattern or the absence of pattern, without the need for reason. And with so much imagery being produced by the information industry, there is, as Martin Amis's hero put it, 'a realism problem'.

The critic Angela McRobbie has said of television, 'It is no longer possible to talk about the image and reality, media and society. Each has become so deeply intertwined that it is difficult to draw the line between the two. Instead of referring to the real world, much media output devotes itself to referring to other images, other narratives. Self-referentiality is all-embracing, although it is rarely taken account of.'[41] But even when the image does refer to some real event, as in the nightly drama of the television news, it is shown drained of its content; the eye scans it, and passes on.

In this emergent image-culture, reality itself becomes drained of content. Susan Sontag has argued that the fundamentals of politics have become an illusion: 'Social change is replaced by a change in images. The freedom to consume a plurality of images and goods is equated with freedom itself.'[42] The point has been seized by politicians. Saatchi and Saatchi's former managing director, Tim Bell, said of their 1979 Conservative election campaign, 'We weren't talking about income tax policies, or tax cuts, or industrial relations legislation or public expenditure. We were talking about the emotional meaning of a Conservative vote.'[43] A colleague remarked, 'What we brought off was the concept of imagery, as opposed to words.'[44]

We are left with a world of pure surface, of face values. Dick Hebdige has pictured this world as Planet Two, the world represented by the style magazine *The Face*, which since its launch in 1980 has recorded the collapse of meaning into sensation. On Planet Two the organisational sense is horizontal, there are no fixed rules or systems, categories or laws. 'Because images are primary and multiple, there is, in this second world, a plurality of gods, and space and time are discontinuous so that, in a sense, neither time nor space exist: both have been dissolved into an eternal present (the present of the image). Because there is no history, there is no contradiction – just random clashes and equally random conjunctions of semantic particles (images and words).'[45]

The spatial organisation that Hebdige describes has been explored by artists who have sought to evoke its random nature in the collage: a collage of sounds as in Luciano Berio and Stockhausen – 'Collage is exactly what's happening in society,' said Stockhausen – or a collage of pre-existent imagery, reordered onto a single surface.[46] **Robert Rauschenberg**, a collaborator with John Cage, has transformed the use of collage from the original device used by Picasso and Braque, where 'real' objects such as newspaper cuttings were introduced to emphasise the material nature of the subject on the canvas (in other words, collage as a realist device) into one where a multiplicity of images float freely on the surface of the canvas, without any illusionistic reference at all. The illusion of depth, texture, indeed representation that the individual elements of a Rauschenberg 'combine' suggest, is denied, for they are silkscreened onto a depthless picture surface: images of images incompatible one with another, and offered by Rauschenberg as 'disparate visual facts . . . that have no respect for grammar.'[47]

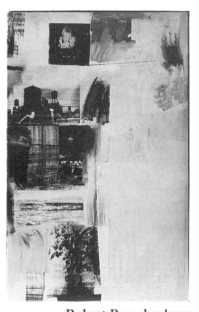

Robert Rauschenberg

The dominant characteristics of such works are depthlessness and indeterminacy. The only significance of the individual sections is derived from their juxtaposition; their unrelatedness ends only where one edge meets another on the single picture plane. There are no references except to what is contained across that plane. J. R. R. Christie and Fred Orton have made a parallel point about the most recent developments in literary theory, which they call 'superstructuralism'. According to this theory words no longer have any independent meanings, they refer to nothing outside themselves:

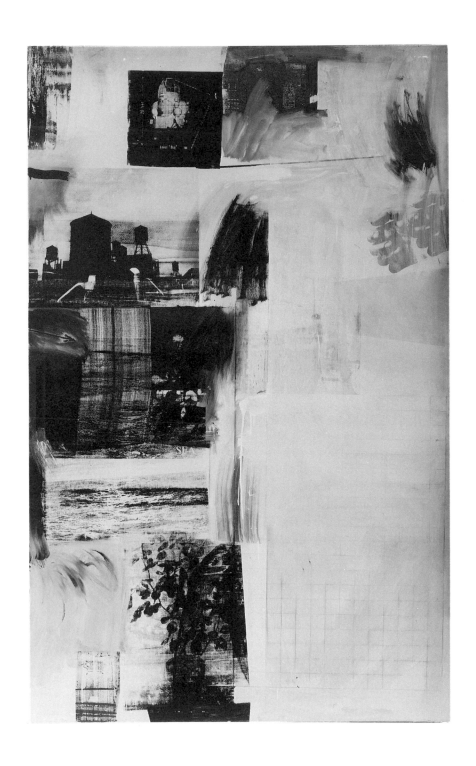

Meaning is only produced textually. There is nothing to the point
outside of the text . . . so that the distinction between text and
context, a work and its surrounding environment is dissolved; it is
all one surface, a portion of the intertext. The meanings residing
here are mobile, non-unitary and contradictory, because meaning
only exists in the particular differential moment of its textual
occurrence.[48]

Even words have lost their attachment to reality, as they jostle and
jumble against each other in a collage of ephemeral and relative
meanings. A realism problem indeed.

The art, architecture, even the literary theory of the late twentieth
century suggests that we are moving into a new form of spatial
organisation, what the art historian Fredric Jameson has called 'post-
modern hyperspace'.[49] It is a pervasive but shallow field of imagery,
registered in a culture without critical distance, reflected in an architec-
ture of surface whose mirrored glass denies its volume, and recorded
in a history without depth. The creation of this spatial organisation in
the built environment, he argues, has transcended 'the capacities of the
individual human body to locate itself, to organise its immediate
surroundings perceptually, and cognitively to map its position in a
mappable external world.'[50] But this bewildering environment – a
version of Hebdige's Planet Two – 'can itself stand as the symbol and
analogue of that even sharper dilemma which is the incapacity of our
minds, at least at present, to map the great global multi-national
and decentred communicational network in which we find ourselves
caught as individual subjects.'[51]

Unable to locate ourselves in a meaningful present, it is no wonder
that we have no image of the future. The present itself becomes not a
reality but an image, and that is not of the incomprehensible com-
plexity of social and economic organisation, but only of the surface
that facilitates and yet conceals it: the image of the video screen. 'All
the world's a screen,' says Nat West's *Dimensions: The Magazine for
Decision Makers*, without a trace of irony.[52]

On the screen reality makes its ultimate disappearance, to reappear
as simulation. The French sociologist Jean Baudrillard argues that,
'the very definition of the real becomes: *that of which it is possible to give
an equivalent reproduction.*'[53] Baudrillard's denial of the possibility of
there being any meaning in the post-Modern world includes the

denial of existence itself. Society is no longer a three dimensional space allowing the interaction of the public and the private, the individual and the mass. Social organisation is now an infinite pattern of 'switches, circuits and transistorised networks of millions of molecules and particles suspended in an aleatory gravitational field.'[54] The very idea of the masses is a conjuring trick, the 'silent majority' is a black hole into which sociology and everything else falls. Baudrillard would agree with Mrs Thatcher that, 'there is no such thing as society. There are individual men and women, and there are families.'[55] But Baudrillard doubts even the existence of individuals.

The reason for the disappearance of social space is that meaning itself has disappeared into the void. For Baudrillard there is no longer any distance between a word and the idea it refers to, there is no distance between image and reality, because even appearance has been replaced by its simulation. We live in an age of simulacra, perfect copies of originals that never existed, for this is the world of hyper-reality. Baudrillard has theorised the process by which the representation of reality has been replaced by its simulation:

These would be the successive phases of the image:

– it is the reflection of a basic reality

– it masks and perverts a basic reality

– it masks the *absence* of a basic reality

– it bears no relation to any reality whatever: it is its own pure simulacrum.[56]

In the new world of hyper-reality, where spectacle has replaced the real, we live in an 'ecstasy of communication', with an electronic network of imagery where the distance between the world and its reflection in culture has been abolished: 'Today the scene and the mirror no longer exist; instead, there is a screen and network. In place of the reflexive transcendence of mirror and scene, there is a nonreflecting surface, an immanent surface where operations unfold – the smooth operational surface of communication.'[57] Baudrillard's nihilistic ecstasy is such that not only does society and

the external world disappear in a single, depthless transparency of simulation, even the self is merged into the same screen. It is no longer possible to reflect on our own nature, or even to tell where our own identities begin and end: 'With the television image – the television being the ultimate and perfect object for this new era – our own body and the whole surrounding universe become a control screen.'[58] This is Warner Communications' revolution in the human sense of self. It has become a screen suspended over a void.

Baudrillard

Yet in spite of such demonstrations of his theoretical non-existence, **Baudrillard** continues as a sociologist – and television pundit. He is content to disappear into his own image, surrounded by multiple reproductions of Duchamp's urinal that is not, in any case, the original, but a copy. The lips moving on the screen say

Should we despair? I don't know – maybe art ends up as a kind of game, an eclectic game-playing activity? We have this notion of the history of art, with certain stages and so on – and we have to ask ourselves now – have we come to the end of the line? What is still possible? And we can't answer that question. We've come to a dead end. This might seem like a despairing position. But maybe this whole game will become a sort of ritual, where we'll carry on making images, but it won't be a question of fakes or originals anymore, it'll just be that all images will be possible at the same time. Everything will have the same value – the original, the copy, the fake. Everything will be on the market at the same time.[59]

The elision of commerce and culture will be complete, reality will have merged into illusion, and with no future, all we can look forward to is the repeat.

Yet, even as we appear to be reaching the degree zero of meaning and value, our response need not be despair. As Beckett's narrator states in the final words of his novel *The Unnamable* (1949), 'I can't go on, I'll go on.'[60] The collapse of Modernism leaves a space that need not remain a void. In every crisis there is

opportunity, and it is possible to reassemble the fragments of the old order in a new one. There is still a choice of futures, and there are still artists and writers whose work is a resource of hope.

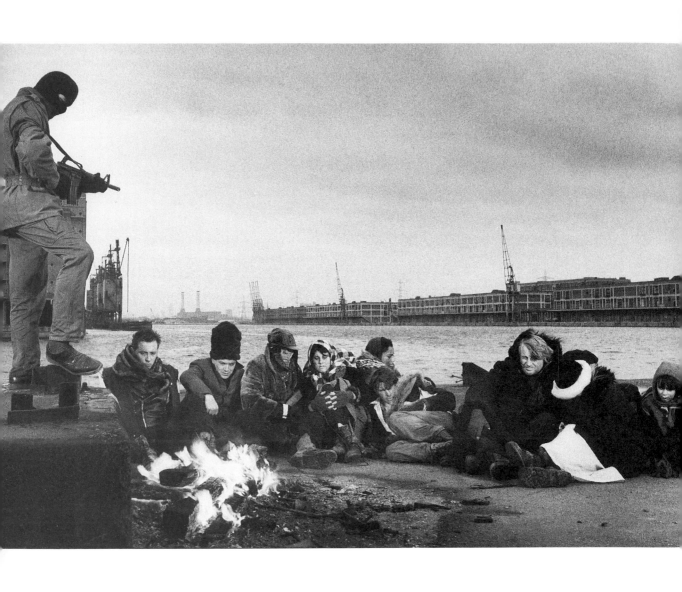

'No Future.'

PUNK SLOGAN

n his film ***The Last of England***, released in 1987, Derek Jarman presents an apocalyptic picture of the near future. There is no narrative, narratives having collapsed into the void of the imminent present. There is no dialogue. At most there is a situation, evoked by sounds and images that are constantly running into one another, across each other, against each other. The camera rarely turns

The Last of England

at its normal speed, the soundscape of music, radio and television voices, gunfire and explosions is sensed as overhead rather than listened to. Drawing on his parallel career as a painter, Jarman offers an artist's vision in place of the conventional naturalistic fictions of an orthodox film maker. He aims for a truth that will strike directly on the viewer's nerve endings: 'The film is a documentary. I've come back with a document from somewhere far away. Everything I pointed the camera at . . . had meaning, it didn't matter what we filmed. The film is our fiction, we are in the story. After all, all film is fiction, including the news, or, if you want to reverse it, all film is fact. My film is as factual as the news.'[1]

The film is bad news. England has become a vast scene of dereliction, of wrecked industrial buildings, abandoned wharves and boarded-up housing estates, a wasteland of rubble and polluted drains through which wander equally abandoned characters: a young junkie, a drunk, a man searching fruitlessly through the rubble, a naked destitute. The country has been taken over by armed men who are masked with the balaclava helmets worn by the IRA and the SAS alike. They use their guns to round up the few men, women and children surviving in the ruins of this collapsed civilisation. Some they shoot, others they guard at a wharf-side, where the refugees wait for transportation to an unknown destination. There are orgies as well as executions, and parodic reconstructions of public ceremonies – the Royal Wedding, a Falklands wreath laying – as though civic ceremonial has been preserved only as pantomime. Jarman has said, 'The terrorists in *The Last of England* are the establishment.'[2]

He calls the film a 'dream–allegory'.[3] He appears at its beginning in his favourite *persona* as a necromancer, working at night in his room above the Charing Cross Road. Early on in the film a number of authorial statements on the soundtrack give the images a social context: 'The household gods have departed . . . no one knows

where. Nature dies . . .'[4] The young men in the film are representatives of a generation that is helpless against state greed and a malevolent bureaucracy that through its own militarism has created this social breakdown: 'What were we to do in these crumbling acres? Die of Boredom? Or recreate ourselves, emerging from the chrysalis all scarlet and turquoise, as death's-head moths . . . not your clean-limbed cannon fodder for the drudgey nine-to-five.'[5]

Images and sounds of war recur, from Hitler ranting in German to British drill commands, sirens and falling bombs. The war is both metaphorical and actual, for Jarman has included in the film clips from home movies of family life shot by his father and grandfather. These extracts play an important part in the imagistic argument of the film: 'In all home movies is a longing for paradise,' Jarman has said.[6] The childhood sequences clearly represent the 'England' that is lost. But this nostalgic element is overlaid by another, for Jarman's father was a career officer in the RAF, and took his ciné camera with him on flying missions. The shots of airfields, a Wellington bomber, parading troops, represent the World War that intervened between an imagined England and the apocalyptic present where images of war titillate nostalgia.

As in his earlier film, *Jubilee*, Jarman shows an authoritarian official culture that has used war to bolster its position, and that is now bringing the war home:

Why did they turn the battle against us? Why did they have to introduce the rhetoric of poverty, of virtue through suffering? Very popular in England! Margaret the great flagellator. It's a terrible turning inwards, also a turning away, and a rejection, cold people drowning in wealth; yet in order to retain power they use this rhetoric of poverty. Bad news to keep us on edge, to maintain rank. They are the bringers of bad news, the fear merchants.[7]

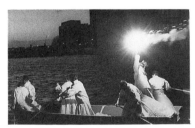

At the film's conclusion

Fires burn throughout *The Last of England*, purifying as well as destructive. There is a recurring image of a hand-held flare, borne aloft at times by a figure dressed as the heretic in Goya's *The Disasters of War*. These flares are held up as the light of the (heretical) imagination, and soon burn out. **At the film's conclusion** an open boat is guided out into the night by figures in white, beneath one bright flare.

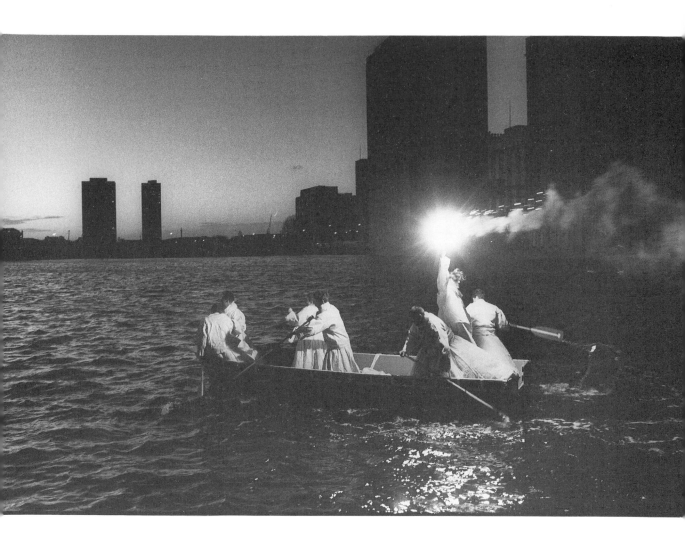

Jarman would be the first to stress the purely personal in *The Last of England*. The home movies are of his family and childhood, and the film began as an improvised home movie, shot, without script or casting, on amateur gauge Super-8 film stock. It is, at one level, entirely autobiographical: the young man who stamps, and then masturbates on a painting by Caravaggio, and who first lights a flare, disappears from the film because he decided to stay in New York after travelling there with Jarman during the time material was being gathered. The hatred of all authority is a persistent Oedipal theme in Jarman's work. The homosexual references have a particular resonance, and the apocalyptic note a particular pitch, for while he was making the film Jarman discovered that he was HIV positive.

The subject matter, implicit here, explicit in his previous feature film *Caravaggio* (1986), is the life of the artist and the conditions for making art. His view of the role and responsibilities of an artist was first stated in *Jubilee* (1977), a film that offered a powerful counter-image to the official picture of England in Royal Jubilee year. A woman artist explains softly:

Painting's extinct – art isn't. I started when I was eight, copying dinosaurs from a book – prophetic. . . . It's just a habit. Artists steal the world's energy. . . . They become blood donors. Their life blood drips away until they're bled dry and the people who control the world make it as inaccessible as possible by driving it into corners. They say it's dangerous. Our only hope is to recreate ourselves as artists, or anarchists if you like, and release the energy for all.[3]

Of *The Last of England* Jarman has said, 'I scrabble in the rubbish, an archaeologist who stumbles across a buried film. An archaeologist who projects his private world along a beam of light into the arena.'[9] But the private world of the artist exists in a larger context: his original title for the film was *Victorian Values*.

The starting point for this most personal of visions is the public world. Jarman was able to construct it out of found images, of the past and of the present, for the dereliction he records and transforms was simply waiting for him in London and Liverpool. Though the material is cut up, stained, recoloured, slowed down or speeded up into pixillated motion, it is still recognisable as the urban scene that informs Frank Clarke's film *Letter to Brezhnev* and even more so the

world of Stephen Frears and Hanif Kureishi's *My Beautiful Laundrette* and *Sammy and Rosie Get Laid*. The cityscape is the New York and London of Martin Amis's novels *Money* and *London Fields*. The near future is the England of Ian McEwen's novel *A Child in Time*, with its sham democratic government and licensed beggars. There are yet more extreme versions of the future in Snoo Wilson's comic novel *Inside Babel* and Kathy Acker's nihilistic *Empire of the Senseless*. The urban wasteland of Jarman's imagination finds its literary correspondence in the 'city, visible but unseen' of Salman Rushdie's *The Satanic Verses*:

The city's streets coiled about him, writhing like serpents. London had grown unstable once again, revealing its true, capricious, tormented nature, its anguish of a city that had lost its sense of itself and wallowed, accordingly, in the impotence of its selfish, angry present of masks and parodies, stifled and twisted by the insupportable, unrejected burden of its past, staring into the bleakness of its impoverished future.[10]

One significance of these and other contemporary versions of the present is that in spite of all the theoretical proofs of the impossibility of art, the terminus of this terminal condition is never quite reached. The screen that masks the void is, on closer examination, smeared and stained. But if reality is disappearing into the hyper-real, it is not enough to give a naturalistic impression of the external world as it might appear to be. Now that reality is done so much better on television, it is no longer wise for us to rely on appearances. There has to be a different approach to experience; the materials of the external world have to be used in a different way. Only then is it possible to recreate oneself through art.

It seems more than coincidence that much of *The Last of England* should have been filmed at a place called Milliennium Wharf, in the derelict Royal Victorian Docks. For it is in Docklands that a new city is being built, a denial (though it is unlikely that its sponsors are aware of them) of the visions of Jarman and his kind. Already the artists' colony that once occupied Butlers Wharf, and where Jarman made *Jubilee*, has been dispersed, after yet another of the accidental fires that prepared the old warehouses along the river for conversion to £750,000 flats. From Millennium Wharf will rise more of the brave

new world projected by the London Docklands Development Corporation. It is already possible to take the Docklands Light Railway on a scenic ride through a cityscape dense with cranes, not the cranes that once emptied and loaded ships, but those of the construction teams at work on a new metropolis.

When it was established in 1981 the LDDC took over control of 55 miles of waterside frontage, 8.5 square miles of land on both sides of the Thames, from the former Surrey Docks in Southwark through Wapping and the Isle of Dogs on the north bank, down to the Royal Victoria Docks beyond the Thames barrier. Parcels of land making up 25 per cent of the area of the boroughs of Southwark, Tower Hamlets and Newham passed into the hands of a government-appointed corporation. The assumption was that this land was empty: 50 per cent was officially derelict. Next to the heart of a major European capital lay a new Australia ripe for colonisation. But Docklands had its unseen aborigines, for the Corporation acquired 7 per cent of the three boroughs' population as well. Inside and outside the LDDC area lie the most glaring examples of the physical and social decline of Britain's inner cities. Southwark, Tower Hamlets and Newham have some of the worst statistics for poverty and unemployment in the country.

The government's answer to the problem of regeneration has been to make the development area an adventure playground for market forces. Normal planning regulations have been relaxed, and at the pivot of the scheme is an Enterprise Zone where there are no planning restrictions at all. Developers have been allowed a ten-year rates holiday, and 100 per cent tax-deductible capital allowances. The intention is that there will be 200,000 jobs in Docklands by the year 2000, but between 1981 and 1987 local unemployment actually rose. As many as 13,000 local jobs have disappeared, as the area's remaining industries have given way to the warehousing that was the first speculative building. The Department of the Environment estimates that 20,000 jobs have been brought into the area, but cannot say what proportion are new jobs, rather than jobs transferred from elsewhere.

The LDDC has no responsibilities as a housing authority: it expects that 60 per cent of the housing in its area will be privately owned. In an area with severe housing problems, 85 per cent of the housing built in Docklands since 1981 by developers and housing associations has been for sale. In spite of the subsidised sale of some new housing units at the 'affordable' price of £40,000 (average earnings in the area are £10,000 a

year) families are under-represented in the social mix. Up to 40 per cent of buyers have been single people or childless couples. A significant number of houses and flats have not been bought by people at all, but by companies for speculation, entertainment and stopovers. After a first speculative rush, when the price of housing in the area rose faster even than in the rest of the country, the bubble burst in August 1989, when the largest housing developer, Kentish Property Group, went into liquidation. Overall, the LDDC's emphasis on commercial development has led it to neglect its responsibilities for ensuring adequate housing and social facilities, as a House of Commons Public Accounts Committee report confirms.[11]

Two communities live side by side: the occupants of the flats in 'The Sanctuary' in Wapping High Street share their territory uneasily with the local authority tenants in the brick barracks that surround them. Neither the newcomers, insulated by electronic security and private transport, nor the Asian occupants of Garnet House have proper facilities in terms of schools, shops or recreation. The communications system is inadequate for both: more than £800 million needs to be spent on roads; roads that will destroy more housing. The Docklands Light Railway, opened in 1987 at a cost of £77 million, can only carry 6,600 people an hour, when the daytime population of the area by the mid 1990s is expected to reach 60,000. Extensions and improvements to the system will cost a further £140 million. The conclusion of the President of the Royal Town Planning Institute, Chris Shepley, is that this, the world's biggest urban property development, is 'an irredeemable failure'.[12]

The sums of money involved are a reminder that the private enterprise regeneration of Docklands is being achieved at public expense. The LDDC received £397 million in government grants between 1981 and 1987, and raised £83 million from the sale of land (which means each of the 20,000 jobs 'created' cost £24,000). It is to receive a further £436 million up to 1992. In addition the Department of Transport plans to spend £638 million on improving access to the area. In November 1989 a £1 billion extension to the Jubilee Line was announced. In September 1988 the Corporation was in financial crisis, projecting a deficit of over £400 million up to 1992. But with the firm political support of the Prime Minister, market forces will continue to enjoy their financially privileged playground.

Docklands represents the preferred image of the future, yet the LDDC's rhetoric masks the insecurity of the project and the profound

changes it intends to bring about, with an appeal to the reassurance of the past:

Careful to preserve the unique character of the area – while continuing to develop the business potential – the transformation of Docklands has taken place with an appreciation of the special qualities that the river, docks and distinguished buildings can provide.[13]

This rhetoric can be tested by a visit to Tobacco Dock in Wapping, one of the rare shopping developments – and therefore new public spaces – in the area. For once the building *is* distinguished, a Grade I listed warehouse built at the beginning of the nineteenth century. But within this historical structure the post-Modernist architect Terry Farrell has – at a cost of £60 million – created an entirely new environment: architecture for the primary cultural pursuit of the late twentieth century, shopping.

Where nineteenth and twenty-first century technologies meet is in the creation of defensible space. The warehouse retains its blank external walls, and a discreet modern portcullis protects the cavernous entrance from Pennington Street and the Highway. Guards carry portable radios like Uzi machine pistols, and matt black cameras survey the aisles of a 'shopping village' dedicated to the ideal objects of

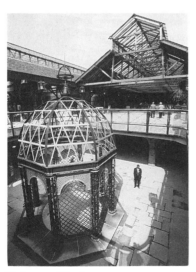

Tobacco Dock

twentieth-century consumption: the Filofax Shop, Next, Monsoon, Body Shop, Leather Dock, Cobra Sports Shoes, Graphite Clothing, Carducci Shoes, a temporary 'craft' market, and the pathetic optimism of an all the year round Christmas shop. In its first year, 1989, the unlet units threatened to outnumber the let ones, their raw concrete and breezeblock surfaces unveneered by shopfitters' make-up. These blank sections corresponded to the 2,000 empty speculators' flats stranded by the collapse in the property market, or the redundant trading floors mothballed at Billingsgate in the City.

The cast-iron columns, timber roofs, stone floors and brick undervaults of the original building have been preserved, but just as its original name, the Skin Floor, has been bowdlerised to **Tobacco Dock**, the structure has been hollowed out, with double voids broken into the roof to open out the under galleries. In these open spaces are the

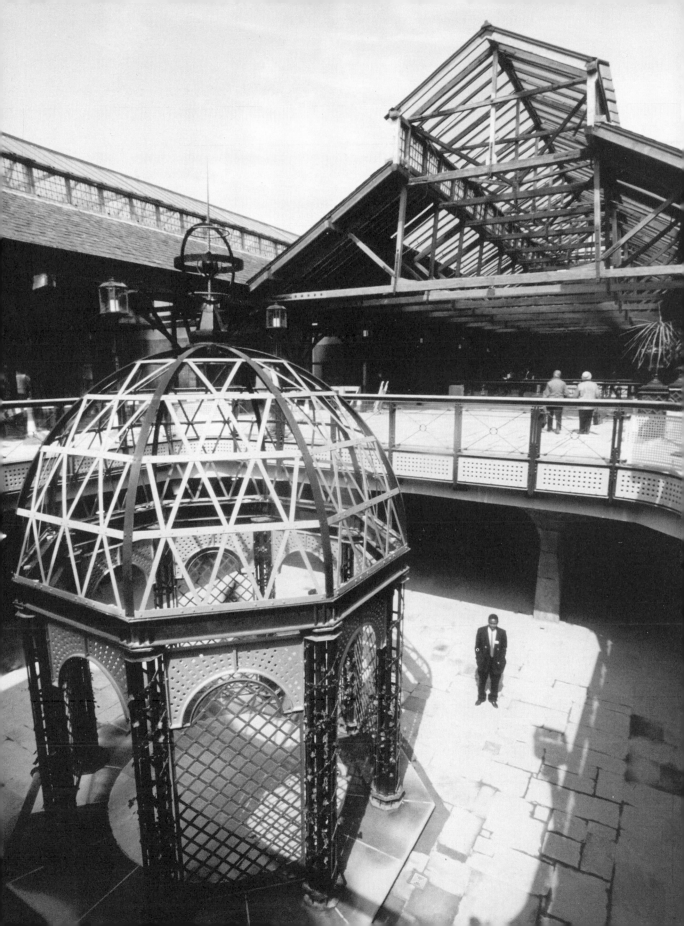

new constructions of post-Modern pastiche: an iron gazebo, a double staircase, a clock tower. In the early months most of the consumption was taking place at Henry's Bar. Here the decor does its best to pretend that it is neither in the present nor the past, but in the conservatory of some late-Imperial outpost, with wicker chairs, potted ferns, coloured glass partitions, brass ceiling fans. It seems the ideal setting for the new inhabitants of Docklands: aggressive entrepreneurial attitudes comfortably wrapped in appealing Victorian values.

The past evoked by Tobacco Dock becomes more and more imaginary as you move to the far end of the development. Beyond it are moored two sailing ships, reminders of the original trading purpose of the building. The *Three Sisters* is 'themed to depict the story of piracy down the ages'. The *Sea Lark* is 'a children's adventure ship'. But neither is sailing anywhere; they are steel replicas, built elsewhere, cut up and brought in by road. The canal they lie in is filled with concrete. Across the canal is Discovery Walk, a row of new Docklands houses, their pitched roofs intended perhaps to recall canalside houses in Amsterdam. But their semi-detached arrangement clings to the British mixture of claustrophobia and standoffishness. The 'picturesque' modernity of their façades is heightened by brightly coloured panels in primary red and blue, playful colours that recall toy bricks – and hint that their construction may be as flimsy as a doll's house.

Richmond Riverside scheme

Tobacco Dock and its environs are the product of a reactionary modernisation, an act of renovation which appears to be an act of conservation, but which denies the old by inserting a new fabric that itself denies that it is new. The way forward is via former glories of the past; imagined certainties camouflage the deep insecurities that change is creating. At times the conservatism which has revived Robert Adam in architecture and Adam Smith in economics appears to be a denial of the contemporary world altogether. In architecture, its most extreme statement can be found in the neo-Classicism of Quinlan Terry. Classicism, he argues, 'can and must replace modernism. I don't believe that modernism is art or architecture at all. It is a restless desire to do the opposite of what is right and good.'[14] But translated into buildings the argument is, literally, hollow. The façades of Terry's **Richmond Riverside scheme**

replicate the classical repertoire from the Renaissance to the nineteenth century. The interior spaces are those of a twentieth-century office block.

Such façadism is emblematic of the pastiche that in another form appears as the neo-avant-garde. But 'history' itself has become a façade. The critic Phillipe Hoyeau has described how in the public culture the lived past has become 'an imaginary object'.

The elements of what we may call 'open' history – conflicts, interests, resistance, illusions, specific sequences of events – fade into the unchanging landscape and become fixed in a temporality which is one of repetition. The pacified, neutralised 'past', divested of its residual burden of uncertainty may then be offered up for us collectively to identify with it.[15]

This authorised history, particularly in the commodified versions generated by the heritage industry, helps form the depthless surface of Fredric Jameson's post-Modernist hyperspace. But as a screen it does more than reflect the comfortable illusions of the imagined past: it imprisons a society and its culture in nostalgia, convincing us that we do indeed live in an age that is over. Further, it helps to conceal the uncomfortable realities of conflicts and resistance in the present. But while Tobacco Dock disguises its modernity with an imaginary past, Docklands' centre piece cannot mask the true scale of change. In spite of the example of Terry's Richmond Riverside offices, economics do not permit the concealment of all contemporary activity within a historic façade. The growth of the information industry, with its demand for buildings that can accommodate the new technology, has brought about the destruction and reconstruction of large areas of

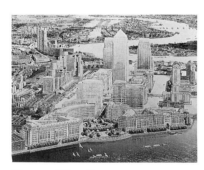

Canary Wharf

London, as the buildings of only thirty years ago are torn down to make way for even bigger structures. Developers have faith that the demand for new office space is insatiable. Rising at the centre of the Docklands Enterprise Zone at **Canary Wharf** is an 800 foot tower, topped with a pyramid like a blunt builder's pencil, and surrounded by twenty-four buildings containing up to 12 million square feet of floor space, and capable of accommodating 50,000 office workers. This, the biggest office and retail development in Europe, is expected to open in 1993, at a cost of £3,700 million. The watercolour drawings of the project when

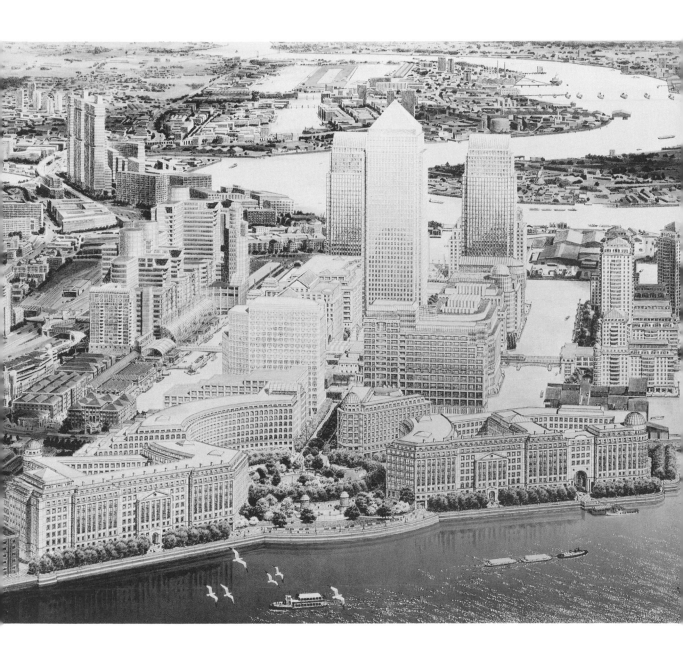

completed show fountains playing in tree-lined squares and avenues formed by turreted and pedimented buildings that suggest, with discreet historicism, pre-war Chicago or New York. The architect's model and the developers' illustrations underplay the true bulk and scale of the project. A more truthful idea can be gained from Battery Park City in New York where the same developers, Olympia and York, and the same architect, Cesar Pelli, have already constructed this new form of urban space, with the same, blunt towers.

The World Financial Centre – New York's equivalent of what Canary Wharf is intended to be – features a giant atrium whose curved roof recalls the Crystal Palace. It is public space, with shops and restaurants, but it is public space as defined by the corporation. Just as the original plan to include low- and middle-income as well as upper-income housing in Battery Park City has been modified to exclude the low- and middle-incomes, so the atrium offers an indoor park (with 45 foot palm trees) that excludes the more threatening forms of wildlife to be found on New York's streets. This space, and the esplanade which connects it to Battery Park City, provides a site for performances, concerts and exhibitions such as 'The New Urban Landscape' which celebrated its opening in 1988. But the corporate culture that this new urban landscape of defensible space promotes is simply another example of the aesthetic amenity as advertising, where the corporation (in this case Olympia and York, sponsors of the exhibition) has privatised the civic responsibilities that city government might be expected to undertake. The trade-off is lower taxes and controlled amenities for the corporation, but as the art critic Regina Cornwell points out, 'Where the city isn't willing or able to provide, an entity like Battery Park City grows. The blend of a more and more conservative liberal humanism in the museum/corporation alliance allows the presentation of an idealised lifestyle in keeping with the needs and goals of business – structured, class-bound and democratic at a distance.'[16]

Canary Wharf will be nearly twice the size of the World Financial Centre. The drawings of the project suggest that a similar pattern will be followed there. Sir Roy Strong, former director of the National Portrait Gallery and then the Victoria & Albert Museum, has been employed as an advisor: already Olympia and York have offered the National Portrait Gallery 200,000 square feet at Canary Wharf, with sculpture courts and restaurants in addition to gallery space. Such an institution would provide the cultural cladding that the enterprise

needs if the LDDC is to justify its claims that Docklands offers, 'a lifestyle unparalleled in the United Kingdom' in an area almost entirely without cultural facilities, other than the vast metal shed of the London Arena.[17] The cost to the developers would be small: the land was acquired on a 200-year lease at half the market price; the fiscal privileges of the Enterprise Zone are worth more than the entire government expenditure on Docklands. In truth, the offer to the gallery is another means of putting pressure on the government to solve the area's growing transport crisis, which threatens to strangle the project altogether.

The pattern of development that is emerging in Docklands sets in concrete and glass the restructuring of society that has taken place in the 1980s. The changes in employment and taxation mean that a faultline has developed between the 60 per cent of the population who are home owners, and those who have little chance of stepping onto the property-owning ladder. Around a shrinking core of those in full-time work there has developed a periphery of part-time and self-employed, and around them a further periphery of long-term unemployed. The writer Charlie Leadbeater argues that the government

is attempting to create a new political equilibrium based on stabilising the new economic divisions. This is not just a matter of satisfying the economic and material interests of various constituencies. It is a project to wrap them in a new political order which gives these groups a sense of legitimate place within society. At the core is a strategy to legitimise a society where roughly two thirds have done, and will continue to do quite well while the other third languish in unemployment or perpetual insecurity.[18]

Prince's Youth Business Trust

In Docklands the very rich will be able to afford to live there, the majority of office workers will have abandoned the city for the suburbs, and the poor are already on the edge, members of a growing underclass encouraged to be statistically invisible, culturally excluded from the privatised spaces of consumption. Martin Amis exaggerates only a little in his short story, 'The Time Disease': 'Pretty soon, they project, society will be equally divided into three sections. Section B will devote itself entirely to defending

Help us encourage him to create wealth. Not aggro.

THE PRINCE'S YOUTH BUSINESS TRUST.

section A from section C.'[19] The sense of threat is already there, in the posters produced for the **Prince's Youth Business Trust**: 'Help us to encourage him to create wealth. Not aggro.' The assumption is that the young man in the poster is dangerous in himself, and must be contained, just as the assumption is that the girl in another poster is bound to get into trouble: 'Help us to set her up in business. Before someone else does.'

The object of the rationalised commercial architecture of Docklands is to neutralise and compartmentalise the life of the city into work, leisure, shopping and the closed interior of the home, but the very process by which this compartmentalisation is achieved seems to heighten tension. The resulting disjointedness and fragmentation creates a climate of conflict as social groups battle for space in an increasingly unsocialised city, where the only answer to rising selfish-ness and brutality is closer surveillance for the disadvantaged and more sophisticated security for the privileged.

There are few areas of London where the struggle for space is more evident than in the streets surrounding Christ Church in Spitalfields, on the eastern edge of the City of London. An industrial suburb since the sixteenth century, it has been the focus for successive waves of immigration. In the early eighteenth century Huguenot silk weavers who had prospered built elegant town houses with weavers' lofts that still survive, though their original builders were succeeded first by Irish immigrants, and in the mid-nineteenth century by Eastern European Jews. Post-war the Jews, in turn, have been succeeded by the Bengalis who now predominate. The history of the area is summed up by the changing uses of the building at the end of Fournier Street, first a Calvinist church, then a synagogue and now a mosque.

In Princelet Street a voluntary group is attempting to convert a disused synagogue, built in the nineteenth century onto the back of a Huguenot house, into a centre for all the commu-nities with links to the area. The building was abandoned in the 1970s, and has yet to receive the gloss of 'presentation' that obliterates history when a building becomes a heritage centre. The synagogue, little bigger than a Victorian billiard room, is eloquently empty, **the upper rooms** of the house are still filled with the furniture, clothes and books left by its last occupants.[20]

the upper rooms

The rooms above the synagogue are like a rifled tomb. Below, the

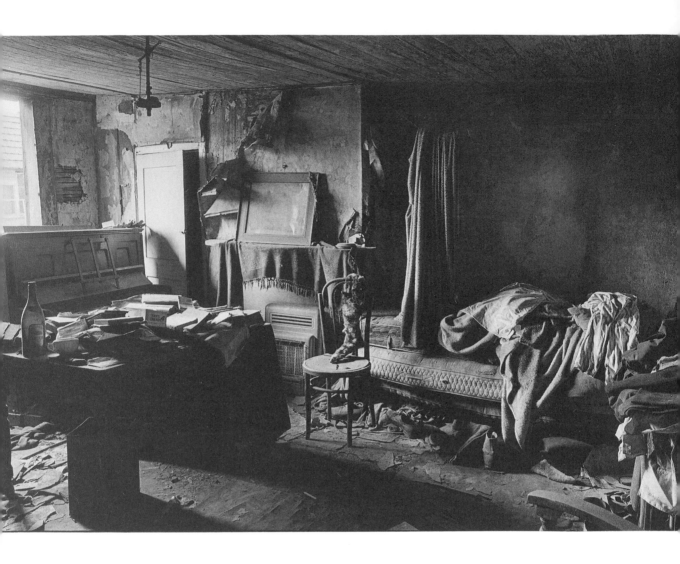

streets are vibrantly alive. Brick Lane is the spinal column for the multifarious activities of the rag trade, which is still the principal occupation of the neighbourhood. Business is conducted on the streets, the area is exotic with Asian music and spices. It is also a slum, strewn with rubbish, choked by traffic, and its inhabitants live in run-down tenements and work in overcrowded sweatshops. The Bengali community complains of racial attacks and police indifference. A banner that hung across Brick Lane in the summer of 1989, calling for demonstrations, 'To protect Islam and demand the ban of *The Satanic Verses*' defined the limits to cultural assimilation both the minority and majority communities will concede.

By the year 2000 this vivid space may not exist at all. The fine eighteenth-century houses are gradually being acquired by conservationists who have saved them from neglect and possible demolition by the local authority, and in the process are ending the multiple occupancy and multiple use that enabled successive communities to establish themselves there. Now, ruched curtains hang in Fournier Street, next to a sweatshop and the Bangladeshi Welfare Association. Some of the new Georgians have gone to elaborate lengths to reconstruct their eighteenth-century interiors, removing electric wiring and even plumbing. But this inward-looking activity goes on behind closed wooden shutters; gradually the Huguenot streets will become a private museum, occupied by fantasists of eighteenth-century life.

The slum houses will simply disappear. Looming over the whole area is the massive bulk of the Bishopsgate development at Liverpool Street. Sensing the competition from Canary Wharf, the City of London is hungry for more land: 45 acres in and around Spitalfields are scheduled for redevelopment. The vegetable market between Commercial Street and Bishopsgate is due to close, the rebuilding on its 11 acres will extend the City to the door of Christ Church. Truman's Brewery, the only large-scale employer in the area, which straddles Brick Lane, has closed and will be redeveloped. The eastward spread of the City has already changed the character of the streets and alleys west of Commercial Street. Ahead of the new buildings move the speculators, buying up properties and pushing up rents. Prince Charles's intervention to improve working conditions for the Bengali community, which has led to the construction of a few subsidised workshops, is unlikely to stem the rolling tide that will overwhelm the area.

The process of change in Spitalfields has been observed since the late 1960s by two artists whose initial aloof self-absorption has been modified into a bleak awareness of the transition their neighbourhood is undergoing. Gilbert and George moved into Fournier Street, ahead of the conservationists, at the time when they were making their reputations as 'living sculptures', an extraordinary double-act that declared the loss of creative imagination to be the subject of their art, and which solved the problem of the impossibility of originality by declaring themselves to be works of art. In his authorised study of Gilbert and George, Wolf Jahn explains, 'The individuality of the artist and the originality of the artwork then coincide exactly in a state of total vacuity and absence of content.'[21]

The emptiness, or rather the baffling impenetrability of their work, has a blank neutrality that is essentially post-Modern. It is in fact full of disturbing imagery, sexual, scatological, and replaying Christian and nationalistic symbolism in an ambivalent manner, but Gilbert and George have evolved a visual style that defies the normal process of emotional identification. Their subject matter, as in the early living sculptures, continues to be themselves, but their work has adopted the format of simple grids of separately framed photographic sections that add up to a single image. The black grid lines and the schematic, chemical colours, together with the floor to ceiling scale of the works, suggest large panels of stained glass. The smooth surface of the panels acts as a screen. They have said, 'Without the grid you look at the photograph and try to understand what it represents, the eye looks into it like a frame or a television set. With the lines, on the other hand, it becomes flat. You see it as a whole, as a work of art on the wall, instead of looking for its content.'[22]

The denial of content is an effect of the content, matched, from the other side of the screen, by the often blank expressions adopted by their self-images. But the external world appears to have forced itself upon the artists, who have constructed from the environment observed from the windows of Fournier Street an iconography of urban life that has taken on a mythical quality as they tackle larger and larger themes. 'Nature', in terms of any kind of pastoral landscape, has disappeared, surviving only in the form of sexualised emblematic flowers. The City is ever-present, notably in the looming shape of the NatWest tower, whose construction can be followed in the photo-works of the 1970s.

Jahn argues that the juxtaposition of frames showing hard, rising

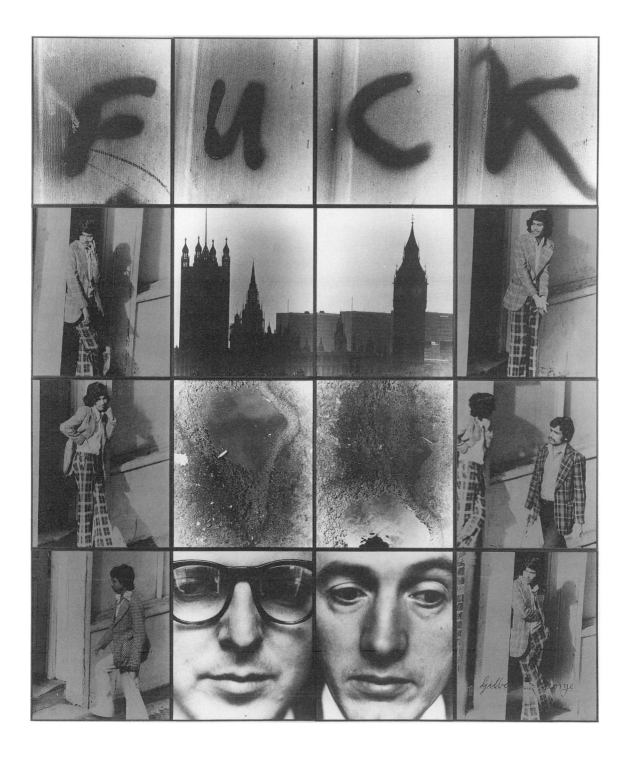

buildings and variations on puddles and mud represents 'the sexual polarity of urban space'.[23] The formless female principle is both menacing and potentially fruitful. (Apart from iconic figures such as

Fuck

the Queen, Gilbert and George have never shown female figures in their work.) Until 1977, Gilbert and George portrayed themselves as the only inhabitants of their alienated world, but in that year they began to include other figures, seen in the streets. The 'Dirty Words' sequence of 1977 took on the urban environment directly, by using as a motif its least decorative decorations, its rawest declarations of obsession and disgust. The graffiti of **Fuck** combines Jahn's sexualised environment – phallic Houses of Parliament, vaginal puddles – with the voyeuristic stares of Gilbert and George looking down on what appears to be a male prostitute.

While draining their art of conventional symbolism or social comment, Gilbert and George have been filling it with other meanings. The youths who at first were seen in images taken from the street now adopt studio poses, and whether naked or clothed have become emblems of a life force which may yet resist the crushing urban environment. Gilbert and George figure in such works as **Gateway** (1986) as commentators and instigators. The atmosphere is homoerotic (in works like *Tongue Fuck Cocks*, explicitly

Gateway

so) though the use of imagery from war memorials and churches suggests an attraction to young men similar to that felt by the 'Uranian' poets of the First World War, as though these East End boys represent another generation of doomed youth.

That Gilbert and George are erotically attracted to their subjects, while at the same time raising them to the status of spiritual symbols, creates a tension that gives the work a disconcerting force. Similarly, there is a contradictory relationship between the grimness of their themes and their attitudes towards them. They have said that, 'The true function of Art is to bring about new understanding, progress and advancement,' and that, 'our reason for making pictures is to change people.'[24] But their political attitudes expressed in interviews are conservative, they are admirers of Mrs Thatcher and 'traditional values'. Jahn interprets their position as being thus: 'One does not rise up against the State; one accepts it in order to be independent of it.'[25] The resolution, in so far as there is one, is trapped

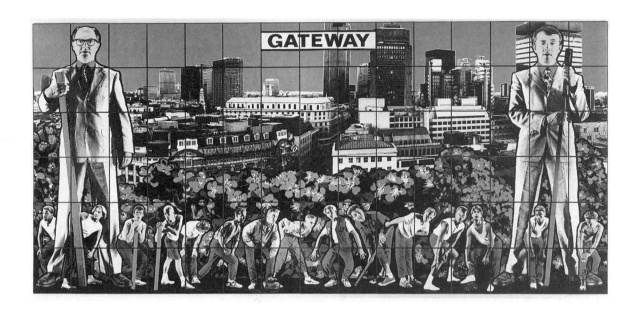

in the perspectiveless plane of the work itself, where the material presented is its own comment, and the appeal is to the personal rather than the social experience of the individual spectator. What is important here is that the spatial tensions on the streets of Spitalfields have contributed to the development of an urban realism of a specifically late-twentieth-century kind.

'"And down there . . . were the first houses." They peered in the direction to which she was pointing and at first could see only the outline of a large office building, the cloudy surface of its mirror-glass reflecting the tower of Spitalfields church.'[26] While Gilbert and George record the pressures of the present on their surroundings, novelists have found another theme in these same streets: the interleaving of past and present that disrupts the linear perspective of time. The tower of Christ Church, Spitalfields, dominates Peter Ackroyd's novel *Hawkesmoor* (1985), which moves between the present and the period when the church was being built as one of seven new churches for London in the reign of Queen Anne. In this earlier expansion the city spread over fields where the victims of the Great Plague that preceded the Fire of London in 1666 were buried in mass graves. Ackroyd uses this sinister, buried memory as an emblem for the dark side of the human consciousness, both in the character of his early-eighteenth-century hero, the architect Nicholas Dyer, charged with carrying out Wren's building programme, and his twentieth-century counterpart, the police detective Hawkesmoor, who has to investigate a series of murders in the vicinity of Dyer's churches. Post-Modern pastiche comes into its own in the eighteenth-century sections of the novel, written in Ackroyd's re-creation of Restoration prose. Dyer, we learn, is a member of a satanic cult which demands a human sacrifice on the site of each new church – Dyer's murders appear to recur in the twentieth century.

The mystery of this horror story remains unsolved. The implication is that time is circular, that Dyer and Hawkesmoor are one and the same. The novel offers the antithesis of classical sweetness and light, the purity and order which Quinlan Terry claims to find in its architecture is denied by the shadows cast by Dyer's designs. Both in its past and present form the city is shown to have a richer texture than eighteenth-century rationalism or twentieth-century rationalisation can contain.

Ackroyd, however, was not the first to investigate the dark side of

these streets, where the serial murders attributed to Jack the Ripper are also unsolved. He acknowledges the inspiration of Iain Sinclair's essays and poems *Lud Heat* (1975) which first pointed to the potentially occult significances in the layout of Christ Church and other East End churches. Sinclair lived for twenty years in Whitechapel – the name for the area that has now fallen into disrepute because of its association with the Ripper murders. In Sinclair's novel, *White Chappell: Scarlet Tracings* (1987) Spitalfields, and the City from the Farringdon Road to the Essex marshes becomes a multi-layered scrapheap of literary, historical and autobiographical references, where characters move back and forth in time, and narrative is broken and collaged into a pattern that matches the dissociated experience of the twentieth-century narrator, yet nonetheless is directed towards a transcendental unity:

We have got to imagine some stupendous whole *wherein all that has ever come into being or will come co-exists*, which, passing slowly on, leaves in this flickering consciousness of ours, limited to a narrow space and a single moment, a tumultuous record of changes and vicissitudes. . . . So it's all there in the breath of the stones. There *is* a geology of time! We can take the bricks into our hands: as we grasp them, we enter it. The dead moment only as we live it now. No shadows across the landscape of the past – we have what is coming: we arrive at what was, and we make it now.[27]

The mysteries that haunt *White Chappell* are no more solved than the Ripper murders that leave bloody traces through the novel. The fragmented plot aims at what Sinclair calls a 'presence': 'a template . . . more powerful than any documentary account.'[28] He celebrates earlier writers like Conan Doyle and Robert Louis Stevenson who, writing before the Whitechapel murders happened, sensed the visceral danger of the place: 'They got in on the curve of time, so that by writing, by holding off the inhibiting reflex of the rational mind, they were able to propose a text that was prophetic.'[29]

The invitation is to decypher *White Chappell: Scarlet Tracings* as a prophetic text: its construction suggests further breakdown and dislocation, but it also shows that the experience of the city cannot be limited to the present, nor can the past be confined to museums. The 'geology of time' is such that, if we will allow them, the resonances of the past can inform contemporary existence without having to be

turned into the simulacra of tourism. The city becomes a form of collective unconscious: exactly the metaphor that underlies Michael Moorcock's *Mother London* (1988). Here, the city shows a more benign face. Its survival of the Blitz unites an odd cast of characters who have all suffered mental disturbance of some kind as a result of wartime events. David Mummery, amateur historian, jobbing writer and author of *London's Hidden Burial Grounds* was nearly killed as a child by a V2 rocket; Mary Gasalee spent years with amnesia after falling victim to an air raid; Josef Kiss, a music hall mind reader, found his powers could lead him to survivors buried in the rubble.

All three are outpatients of the same mental hospital, and the text is interrupted by the unlocated chatter of disturbed minds, breaking in like radio interference: *'ghastly for them yet there's something horribly exciting my liver's still sitting there unless the bloody rats got it I wish it wouldn't go on so funny . . .'*[30] The narrative moves forward and back in time between 1940 and the 1980s, weaving a pattern of experience and memory that presents an image of London's deep imaginative resources. The character David Mummery writes a book on the 'lost' tube lines beneath the city, and discovers, 'there are, too, older tunnels, begun for a variety of reasons, some of which run under the river, some of which form passages between buildings. . . . I discovered evidence that London was interlaced with connecting tunnels, home of a forgotten troglodytic race that had gone under-ground at the time of the Great Fire, whose ranks had been added to periodically by thieves, vagabonds and escaped prisoners, receiving many fresh recruits during the Blitz when so many of us sought the safety of the tubes. Others had hinted at a London under London in a variety of texts from as far back as Chaucer.'[31] The novel (which turns in part upon the thwarting of a development scheme) concludes on this image of a London under London, modulated into the wanderings of an old woman tramp, following 'the city's old paths, many of them obliterated by fire and bombs, crossed by new roads, broken by tunnels or viaducts, yet as familiar to her as secret marsh trails existing here before London was built where the Thames was shallow and easily forded on swampland cut by myriad streams now all diverted, sewers.'[32]

These novels depict the city 'visible but unseen' of Salman Rushdie's *The Satanic Verses*. But to reveal the many layers, the psychic archaeology of the city, it is necessary to abandon mere surface realism. Time has to be presented free of conventional

perspective, the present of every moment is disrupted by the knowl-
edge of, even intervention by other moments. Narrative is as
fragmentary as experience, and mysteries are not explained. The city
and its inhabitants are in a constant state of transformation and
struggle: the battle for space is flaring in King's Cross, Brixton and
Notting Hill (the location of Martin Amis's *London Fields*) as much as
in Docklands and Spitalfields. The stress of change is such that
distortion and the grotesque are the only appropriate means of
expressing it. It is ironic, to return to Brick Lane, that its Muslim
inhabitants should object so strongly to *The Satanic Verses*, when the
grotesqueries of Rushdie's novel reveal the extremes of dislocation felt
by an immigrant community, cut off from its roots, and isolated
within an alien and semi-hostile culture. Rushdie's novel is about
people who have to invent themselves:

A man who sets out to make himself up is taking on the Creator's
role, according to one way of seeing things; he's unnatural, a
blasphemer, an abomination of abominations. From another angle,
you could see pathos in him, heroism in his struggle, in his
willingness to risk: not all mutants survive. Or, consider him
sociopolitically: most migrants learn, and can become disguises.
Our own false descriptions to counter the falsehoods invented
about us, concealing for reasons of security our secret selves.[33]

But it is not just the immigrants who have had to come to terms with
the stress of change. Everywhere the familiar patterns of cities are
being broken up, or wiped away. The gleaming mirror surfaces of the
new buildings deny a free space between the public and the private
worlds. The street is abolished, and we must choose between our
secret selves and the commodified masks of lifestyles projected by the
information industry. Our interior worlds become darker and more
desperate, the exterior more and more a pretence of a reality that we
have not even created for ourselves, for we have submitted to the
imagery sold to us. In the polluted environment of the late twentieth
century, we may all become mutants now.

In the post-Modern condition the perspective of Modernism has been
shattered, broken into scattered pieces that jostle and float above a
void. The decentred nature of existence is experienced as a series
of conflicts and crises, as logical sequence and narrative order is

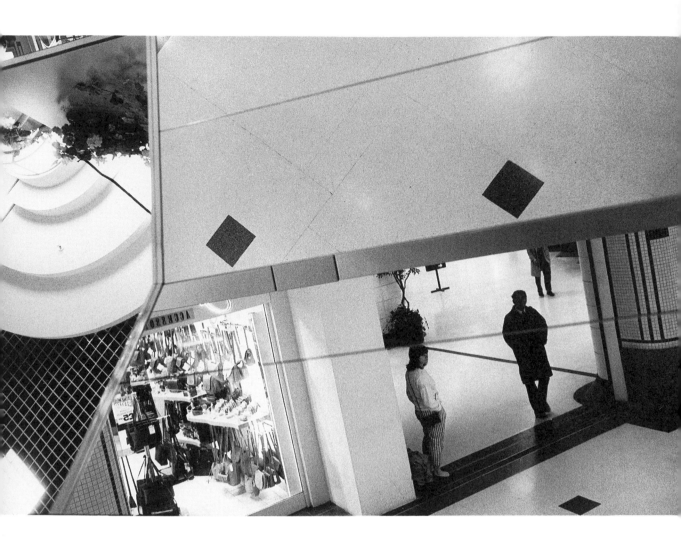

disrupted and the authority of representation breaks down. The fragmented imagery and incoherent storyline of *The Last of England* deliberately rejects the symbolic order of rationality so as to render the extremity of the dislocation that Jarman perceives. That dislocation is the product of the restless, relentless and ever more rapid economic and social changes – of the erratic drive of capitalism – that developments such as those in Docklands represent.

As an organism, the city is in convulsion, in a constant state of destruction and rebuilding. Where is the perspective, or even the horizon line, in Stuart Franklin's photograph of **Victoria Station**? Franklin has set out to record 'the frenetic activity' of contemporary London:

Victoria Station

The way Victoria has been redeveloped, how the hard sell aspects of consumer culture have been imposed on its stone façades and ironwork, has a desperate quality. There is a sense of fragmentation which is repeated all over London, in a mesh of building sites laden with scaffolding and heavy machinery.[34]

Marshall Berman, the American sage of modernity and philosopher of the urban experience, argues that the purpose of twentieth-century architecture has been to kill the living organism, the rich and complex human order that was the 'moving chaos'.[35] But, he argues, city dwellers do not wish to be driven into the suburbs, or live in post-Modernist hyperspace:

The contemporary desire for a city that is openly troubled but intensely alive is a desire to open up old but distinctively modern wounds once more. It is a desire to live openly with the split and unreconciled character of our lives, and to draw energy from our inner struggles, wherever they may lead us in the end.[36]

Struggle, fracture and fragmentation are counter-images to that of the smooth surface of post-Modernism. The very idea of the post-Modern began as a break with the Modern, a rupture that has left a gap only provisionally filled. But dislocation and fracture suggest that there are cracks in the surface, cracks that become faultlines, creating gaps that may yet prove fruitful openings for the emergence of new patterns and new forms.

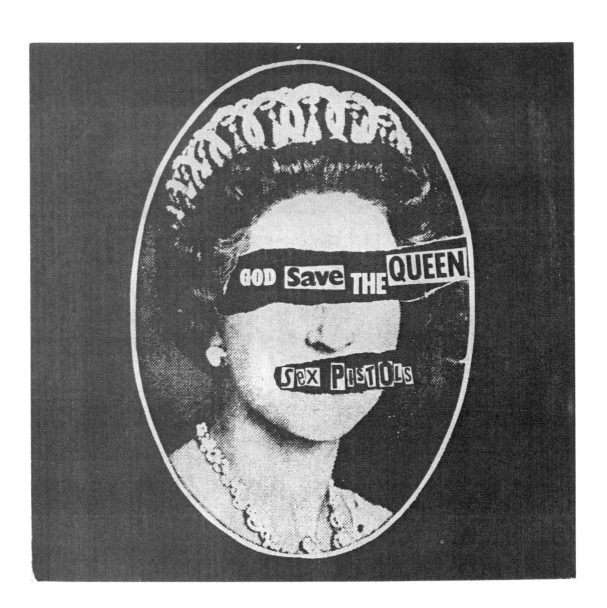

'Painting
relates to both
art and life.
Neither can be
made, I try to
act in the gaps
between the
two.'

ROBERT RAUSCHENBERG

G iven that we live in the post–Modern whether we like it or not, what is to be made of the prospect before us? The neo-classical façade of Heritage and the glassy surfaces of commodity culture are attempts to face down the conflict produced by the constant crisis of capitalism: neither can contain it altogether. If the cycle of production and destruction is permanent, then the place to find evidence of new life is not in the atrophy of Heritage nor the entropy of post-Modernism, but in the gaps inbetween.

The key to a new beginning must be the acknowledgement that a crisis exists, that the struggle is not merely a battle of styles in architecture, or even the competition for space in the urban environment, but what these symbolise for the individual, for what Marshall Berman calls 'the split and unreconciled character of our lives'.[1]

The struggle is personal, but it emerges in the social: those parts of contemporary culture that have not as yet succumbed to the pervasive process of commodification register the crisis in an acute form. Confronted by a void into which have collapsed the hopes of Modernism and the authority of all grand systems of belief and explanation, much of this culture will be decentred, schizophrenic and pushed to extremes. In the void, there are no limits to anything, nor is there a point of reference from which to begin. If we do not know what is real any more, how can we know what is right. In a world without values other than those imposed by the ruthless competition of the market, there are no certainties and securities of existence from which a structure might be built. The crisis extends even to the way we perceive the external world and order our experience of it. The evacuation of meaning from society ('there is no such thing as society') causes a collapse in verbal meaning: the breakdown of narrative contributes to the disorder and *anomie* of everyday life, which is reflected back by the confusing and disrupted states produced in contemporary art.

Yet fragments of the degenerating culture of Modernism, flashes of experience remain. In a condition of crisis, as the work of Gilbert and George shows, an art of pure, self-absorbed abstraction is unsustainable, except as a denial of the prevailing situation. On the other hand, with reality in question, a representation in words or images that merely reproduces appearances will not reflect the inner, psychic stress that the crisis exerts. Neither abstraction nor realism satisfactorily convey the inner and outer dislocation of contemporary life.

This dream-like, more often nightmarish state has long been the province of Surrealism. In 1924 André Breton described the Surrealist movement's purpose as, 'the future resolution of the states of dream and reality – in appearance so contradictory – in a sort of absolute reality, or *surréalité*.' Breton saw Surrealism as a means 'to express verbally in writing, or by other methods the real functioning of the mind.'[2] The fears, desires, absurdities hidden in the individual unconscious were brought to the surface by exchanging the 'reason' of narrative or mimetic representation for the happenstance of juxtaposition, by mixing the impossible with the possible, the seductive with the repellent, the violent with the comic, and by evoking just that dream-like state where there is no knowing what is fantasy and what is reality.

In spite of its social and political programmes, however, classical Surrealism focussed on liberating that which was repressed in the individual mind. Today's artists are trying to bring forth the repressed in the collective unconscious: the anxieties, lusts, and brutalities latent in society. To that end, one response to the post-Modern condition is not social realism, but a social *Sur*realism, that not only conveys the material and the psychological conditions that prevail, but offers a path towards changing them.

The 'dream allegories' of Derek Jarman use Surreal methods to reveal what is socially repressed: he is not so much a psychoanalyst, as a social archaeologist disinterring from the urban desolation the underclass of the dispossessed and the marginalised, homosexuals, blacks, the mad. The extreme conditions created by social violence are traced in the self-inflicted wounds of drugs and alcohol. The oppression of power is met by absurdity and alienation. For the playwright Howard Barker the established conventions of political theatre are too limiting to convey the urgency of the crisis: the collapse of the moral consensus in society is such that the corresponding conventions of naturalistic representation no longer hold. Traditional distinctions between good and evil, reason and unreason, between comedy and cruelty must be abandoned. The attrition that tragedy works on the dramatic characters that enact it must be brought to bear directly on the audience, so that a new relationship is established:

A theatre of catastrophe, like the tragic theatre, insists on the limits of tolerance as its territory. It inhabits the area of maximum risk,

both to the imagination and invention of its author, and to the comfort of its audience. It commands the loyalty and attention of those for whom the raucous platitudes of both left and right appear as aridities.[3]

The methods of this theatre – applied in Barker's *The Bite of the Night* – can produce pain and even resentment in the audience, for it involves losses of clarity and realism similar to that in Sinclair's *White Chapell: Scarlet Tracings* or in *The Last of England*. For Barker, 'these moments of loss involve the breaking of the narrative thread, the sudden suspension of the story, the interruption of the obliquely related interlude, and a number of devices designed to complicate and to overwhelm the audience's habitual method of seeing.'[4]

Thus Social Surrealism will delight in games, absurdities, illogicality: all are means to disrupt the symbolic order of rationality, that narrowing of absolute reality into conventional patterns of representation and thought. But the conditions in society which have provoked such an extreme response are not lost sight of. A precedent for this mood of apocalyptic despair and anger can be found in the sudden disruption of the symbolic order of popular culture by punk in 1976.

As the celebration of the Situationists at the ICA in 1989 sought to demonstrate, punk has a cultural pedigree that leads back to the classical Surrealists. But it also caught a particular moment of social history. The British economy was foundering between inflation and stagnation, and politicians seemed incapable of producing any solution beyond economic recession. The spectacle of post-war prosperity that had sustained the expansive mood of the 1960s was falling apart.

Malcolm McLaren, the manipulator of the primary punk band the Sex Pistols, claims not to have read the Situationist texts brought to his attention by associates like the graphic designer Jamie Reid – they were too full of difficult words – but, he has said, 'we were artists, we took the signs, and tried to make something of our own out of them.'[5] The principles of Situationism were commandeered without principle. McLaren certainly understood the principle of *détournement* and made a virtue of exploiting disruption. Here was an artistic practice that sought out the cracks: 'I kept busy constantly defining that hole in an industry, a fashion industry and a music industry, until they decided suddenly that it was cool to use the same notions

to sell their philosophy too. That's when things got very confused.'[6]

The Sex Pistols and The Clash were rapidly joined by a horde of new bands, liberated by the example of their violent energy and their rejection of the high musical style that rock'n'roll had become. Instead, their music exchanged virtuoso guitar solos for a frantic rhythmic drive that just about anyone felt they could play. Somehow they turned the utterly negative aspects of their situation and attitude – encapsulated by the group X Ray Spex snarling 'I am a cliche' – into a positive reworking of the broken and degraded materials of their environment. The speed and force with which they made music out of *anomie* belied the supposed listlessness of a defeated generation.

The messages of their songs of urban anxiety and their provocative appearance were rapidly taken up as a social metaphor. The sociologists of *New Society*, as much as the critics of *New Musical Express*, were looking for a symbol of the social alienation they detected in contemporary Britain, and the outrage that punks provoked more than filled the gap. Dick Hebdige makes the point:

The punks were not only directly *responding* to increasing joblessness, changing moral standards, the rediscovery of poverty, the Depression, etc., they were *dramatising* what had come to be called 'Britain's decline' by constructing a language which was, in contrast to the prevailing rhetoric of the Rock Establishment, unmistakably relevant and down to earth (hence the swearing, the references to 'fat hippies', the rags, the lumpen poses). The punks appropriated the rhetoric of crisis which had filled the airwaves and the editorials throughout the period and translated it into tangible (and visible) terms.[7]

The punks were anticipating crisis as much as enacting it. The punk warning 'No Future' proved increasingly accurate as unemployment rose to nearly four million in the 1980s, and the evidence of de-industrialisation accumulated. Ironically, the moment of the punks' rock-concert-as-riot-as-art-form had already passed when the real riots began in 1980.

That punk's assaults on received notions of good taste, its anarchic rebellion and articulation of *anomie* should be so instantly recognised by its fans and its detractors makes the authenticity or otherwise of its artistic roots irrelevant. As the cultural critic Iain Chambers argues, inauthenticity was almost the point: 'The Dadaist logic of sucking in

the trivia, the rubbish and the cast-offs of the world and stamping a new meaning on the chaotic assemblage was there in both punk's music and sartorial regime. Earlier subcultural styles, like earlier musics, were "cut-up", mixed and resignified . . . It was precisely the unnatural synthesis, the "inauthentic" collage, that was paraded.'[8]

The key to the historical moment of punk was, as Chambers has written, that, 'The poverty of the present was not so much rejected as regenerated.'[9] This is the spark of energy that still crackles through the Sex Pistols' 'Anarchy in the UK' or The Clash's 'White Riot'. The urban landscape and its wastelands of decay became a rich new territory, rubbish a resource, and the collapse of the old structures under the weight of their own repressive authority – a ruling image in Terry Gilliam's film *Brazil* – opened up new possibilities in the ruins. The free-form, collaged, ripped up and ripped off graphic design pioneered by Jamie Reid, Barney Bubbles, Malcolm Garrett and Neville Brody, says Brody, 'evolved from a breakdown of the traditional structure.'[10] There was no new structure, only a liberation from constraints.

Here, in draft form, was the combination of social anger and Surrealist practice that is still looking for a way forward from the black hole of post-Modernism. The cracks in the public culture revealed by punk have been enlarged by other artists. In August 1976 Derek Jarman, who identified himself with the nostalgic survivors of the 1960s, the 'glitteratti', 'the Andrew Logan all-stars' who then oc-cupied Butlers Wharf, dismissed the sudden irruption of punk as 'King's Road fashion anarchists' bank-rolled by the music business, and 'the same old petit bourgeois art students' exploiting the myth of working-class culture.[11] But less than a year later he made *Jubilee* starring McLaren and Vivienne Westwood's shop assistant Jordan, from their anti-boutique, Sex. The set was covered in slogans in the manner of the xeroxed punk fanzines *SNIFFin Glue* and *OUTrage*, and peopled by Toyah Wilcox, Adam Ant and the female punk band The Slits.

Though it put a boot through the pasteboard pageantry of the Jubilee celebrations as gleefully as Jamie Reid defaced Cecil Beaton's portrait of the Queen for a **Sex Pistols record sleeve**, *Jubilee* was not a punk film. Vivienne Westwood produced one of her sloganising tee shirts to attack the film and say how boring it was. As Jarman has

Sex Pistols record sleeve

pointed out: 'To sing of boredom is one thing, to show it quite another.'[12] As though in preparation for the techniques of *The Last of England*, the film was constructed as a collage, 'a determined and often reckless analysis of the world which surrounded us, constructed pell-mell through the early months of 1977', and intended as, 'a fantasy documentary fabricated so that documentary and fictional forms are confused and coalesce.'[13] In that respect Jarman more than achieved his aim, for like the songs of the punks, *Jubilee* anticipated what was to come: 'Afterwards, the film turned prophetic, Dr Dee's vision came true – the streets burned in Brixton and Toxteth, Adam was Top of the Pops and signed up with Margaret Thatcher to sing at the Falklands Ball. They all sign up one way or another.'[14]

It may be that the need to dramatise the self-destruction that punk perceived in the world they rejected, menaced as it was by nuclear war, environmental pollution, disintegrating cities and economic collapse, drove punk itself towards self-destruction. But the detonation reopened the options for popular music, and remains the formative influence for many bands that have succeeded the disbanded first wave. After punk, longevity is no longer necessarily considered success, but groups like The Fall have sustained and developed the original punk inspiration and its commentary on urban life. Since punk, pop is no longer thought of only in terms of the linear development of rock'n'roll. It has exchanged a vertical history for a horizontal bazaar of styles that exploit the full range of possibilities from reggae to synthesizers, from R&B to free jazz and every kind of cultural crossover inbetween.

Michael Clark

Traces of the energy and provocation of punk can be found a long way from their original source. The classically trained dancer and choreographer **Michael Clark** has torn up the conventions of ballet, mixing sound and image in a rapid collage of creation, quotation and reference that plunders popular culture with calculated offence. In pieces like *200% and Bloody Thirsty* (1989) the performance group Forced Entertainment enact urban rites of parodied sentimentality, drunken nihilism and repetitious boredom that are 'about human possibility in a cut-up contemporary UK, understandable by anybody brought up in a house with the TV always on.'[15]

The work of Forced Entertainment, like Jarman's concern to confuse and coalesce fiction and documentary, is part of a wider movement that has allied the social dramas enacted by punk to the aesthetics of performance art, creating new formal possibilities from the disruption of convention and the fragmentation of material. The evolution of performance art has broken down the old categories of painting, sculpture, drama and dance, and made fruitful exchanges between them. Forced Entertainment forsake the narrative conventions of theatre to draw on film and television imagery, mixing live and video-recorded performances in a semi-sculptural environment.

Monochrome Men

While visual theatre has begun to aspire to the condition of dance, choreographers have become dissatisfied with the abstract aesthetic to which so much contemporary dance has been confined. The members of DV8 have tried to rediscover the possibilities of direct statement in dance through 'physical theatre'. *Dead Dreams of* **Monochrome Men** (1988) is choreographed and performed by trained dancers, but their physically dangerous movements are calculated to appear natural and improvisatory, though in no way could they be mistaken for the replication of ordinary actions. The subject matter evokes the theatre of catastrophe, what DV8's artistic director Lloyd Newson calls 'the loneliness, desire and emotional death in men' as demonstrated by the career of the homosexual mass murderer Dennis Nielson.[16] The dancers in *Dead Dreams* inhabit the same violent and despairing urban jungle as the creatures in the collaged paintings of **Sue Coe**.

Sue Coe

Inevitably, work that enlarges the possibilities for dramatic expression feeds back into theatre itself. The territory defined by Howard Barker is already occupied by a younger generation of dramatists and performers, who have grown up without knowing any of the brief period of political optimism of those formed by the Sixties. In Jim Cartwright's *Road* (1986) the slenderest thread of narrative holds together scenes from a night in the living death of a slum street in a Lancashire town. As the play's narrator/guide remarks, 'This is the last stop. The "looked over and left out" we's all shovelled here, unsorted and slung up the side.'[17] The response to urban dereliction is a bitter mix of

drunken hilarity and desperation. The play culminates in a brutal and dispiriting party for a quartet of young people who try to blot out what passes for reality with sex, drink and music. They reach a transcendental state that might just avert catastrophe by chanting, 'somehow, a somehow, might escape'.[18]

The catastrophe has already happened for the derelicts, strays and walking wounded who inhabit Gregory Motton's

Ambulance

Ambulance (1987) and *Downfall* (1988). His characters wander through a city of dreadful night, their desperate lives illuminated only by flashes of blue light, and broken into shards of scenes less than a minute long. The audience has to scrabble for meaning in order to thread together these scraps of pain, guilt and anxiety into some sort of narrative, and it will almost certainly give up in the attempt, for Motton does not intend to create a pattern resembling reason:

Do you know what my wife told me once? The cosmos is chaos. You know what beauty is? Well there isn't any. You know what wisdom is? There isn't any. And form, there isn't any. Human ideas. Did you ever have an idea? About anything, the stars, for example. The Milky Way. That is an exaggeration. Look at it. I'm on the run, in a way, so are you. We've been too careless. But carelessness is an idea, an exaggeration.[19]

Such works dramatise a sense of social breakdown by breaking up the cultural forms through which ideas are expressed, and – to borrow a term from contemporary techniques in pop music – radically remixing them. They have, in words from the soundtrack of *The Last of England* addressed to the commodity culture, 'gathered everything you threw out of your dream houses, treasured your trashcans, picking through the tatters of your lives. We jumbled the lot and squatted your burnt-out lives.'[20] Central to the process is the classic Surrealist device of the collage and its three-dimensional development, assemblage. There is no better means of conveying a sense of fragmentation than to present the world as a series of fragments, in a deliberate discontinuity that can be disorienting – or playful. As was argued in chapter one (p.65) the spatial organisation of a Rauschenberg combine is a figure for the organisation of the post-Modern world. Found imagery or objects, torn from their original context,

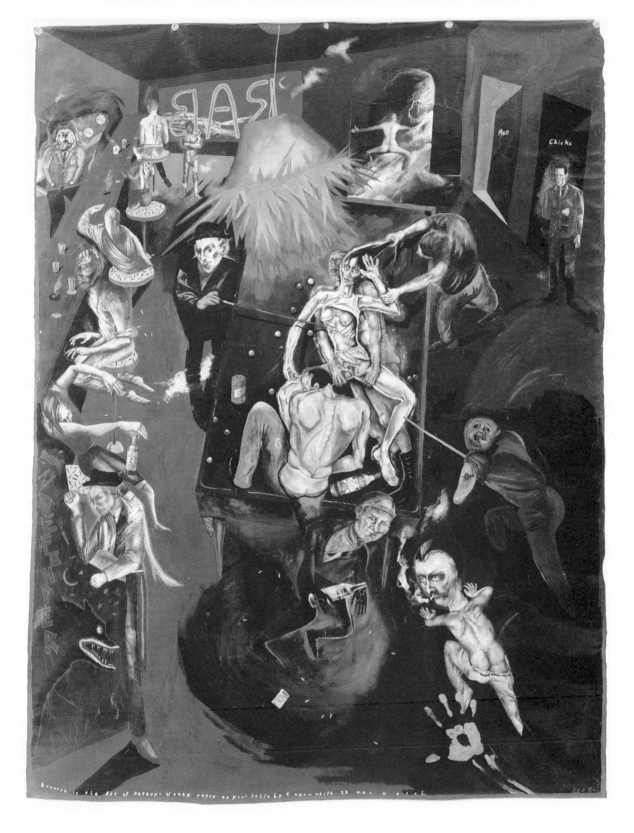

ENGLISH HERITAGE

and dislocated as much as relocated by their new surroundings, acquire a new eloquence. That this imagery and material is almost entirely man-made suggests a new relationship to the natural world, indeed to a world that is predominantly *un*natural, that is urban and industrial.

Sculptors in particular have taken to using junk and scrap for satirical ends. Bill Woodrow's **ENGLISH HERITAGE** – *HUMPTY FUCKING DUMPTY* (1987), made out of a dismembered school vaulting horse, cut up pieces of a hot-water tank, electric circuitry and a nuclear warning symbol, plays with the tradition of the equestrian statue as a glorification of authority and the nursery rhyme view of politics, to express his anger at the charade of contemporary pomp and circumstance. In **Britain seen from the North** (1981) Tony Cragg presents a bas-relief mural in which a plastic man surveys a Britain constructed of industrial debris: the point of view more than hints at the North/South divide.

Britain Seen from the North

As these examples show, collage and assemblage easily become bricolage: random elements are reassembled into patterns that give them a fresh coherence. Old meanings and significations are shaped into new. Tony Cragg has moved on from assemblages that make a point outside the material to transforming the material from within. The fundamental principle remains the same, but the effect is more constructive. The banality of everyday life celebrated in Pop Art and the reticence of Minimalism acquires an alchemical magic. Cragg has written,

Artists have liberated an immense vocabulary of materials, objects, environments, concepts, and activities from the non-art world, for use as parts of a rich language capable of expressing complicated ideas and emotions. The nomination of banal objects and actions as carriers of important information – the recognition that every object is accompanied by a world of associations and references – has been of great significance. Without this, a soup can remains a soup can, a fluorescent light bulb just a light bulb, and a chair with fat on it remains just that. But with this recognition, we find objects offering up meanings and emotions relating to their literal form, their metaphysics, their poetry and their emergence from the natural world, or from their origins in nature.[21]

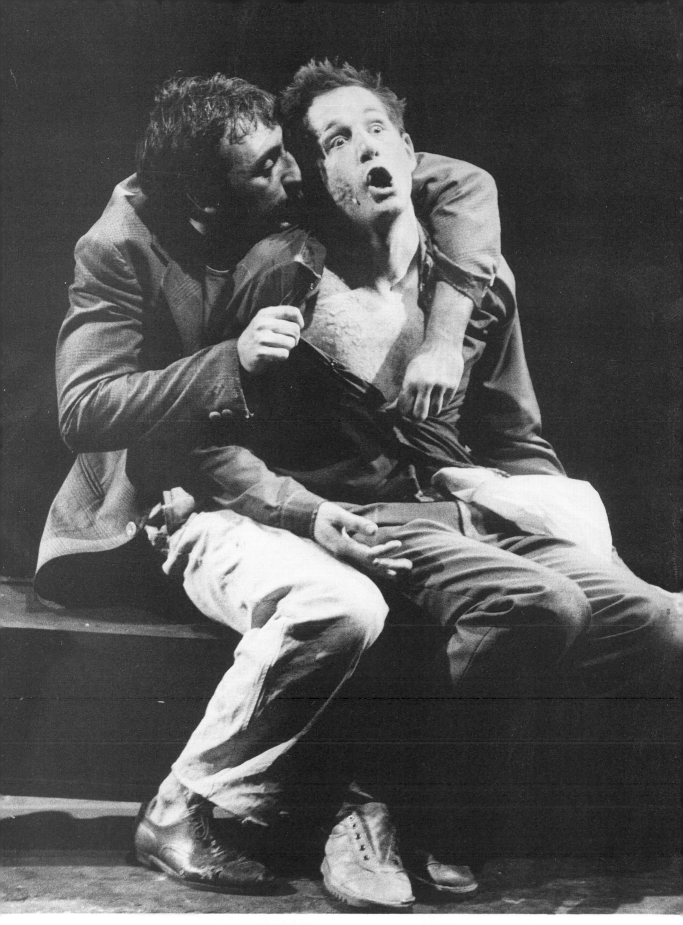

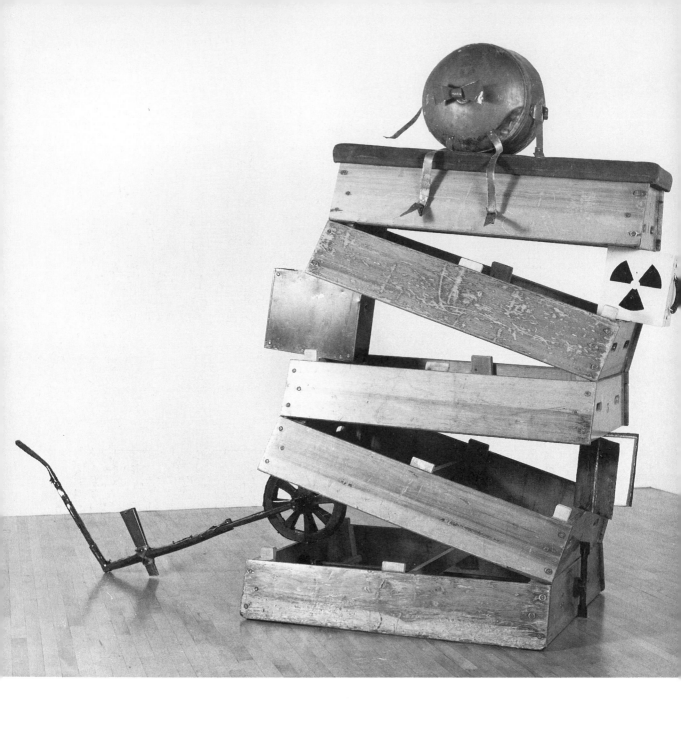

Pebbles (1988) consists of an arrangement of sea-worn fragments of polystyrene, to which Cragg has added his own polystyrene carving of an outsize ketchup bottle: the natural world working on the unnatural world, to create a new version of pebbles on the beach. **Minster** (1987) assembles cogs, rubber tyres, concrete, plastic and wooden rings into a serene sequence of dreaming spires.

Minster

The industrial scrap and urban rubbish that is transformed by Woodrow and Cragg into articulate sculpture in other hands becomes a source of music. The group Test Department began in 1981 by hammering out rhythms on the heaps of abandoned containers and wrecked piping in Docklands, finding a means to protest at the waste land that the economic policies of the 1980s were creating. They have developed into a performance group constructing events in sites such as an abandoned car factory in Cardiff, where they collaborated with the Welsh theatre group, Brith Gof, in a realisation of the seventh-century epic poem *Gododdin*. For Test Department, who were passionately involved in the miners' strike, the defeat of a tiny Welsh force by a mighty English army has political resonances that they were only too glad to hammer out on the wrecked cars in the derelict Rover works.

The Bow Gamelan Ensemble, formed in 1983, are more whimsical in their approach than the militant Test Department, but they have the same roots in the riverside dereliction of East London, and as both musicians and sculptors have the same appreciation of its possibilities, finding metal and industrial waste more natural to the environs of Bow than bamboo or stone. The ensemble is an interdisciplinary trio: the percussionist Paul Burwell, the sculptor Richard Wilson and the performance artist Anne Bean. They contrast the work of the 'junk sculptors', where the emphasis is on transformation, with their own aim, 'to release the hidden potential of things'.[22] They began by constructing 'sound sculptures' musical machinery that would function by itself, but as with Test Department, performance and spectacle has developed as their ideas have become more ambitious. Their most recent project, *The Navigators* (1989) involved the recovery of an old munitions barge from Bow Creek, and its transformation into a floating platform for a

The Bow Gamelan Ensemble

series of noisy sound and light displays at chosen sites along the Thames. As former members of the artists' colony at Butlers Wharf, they saw these performances as an attempt to recover the spirit of the river that the new Docklands is destroying.

The work of Bow Gamelan strays from percussion, to sculpture in light and smoke, to the lost *ballets mécaniques* of nineteenth-century theatre. Their response to a chosen site, its discovery and the process of transformation long before any performance, is an important conceptual part of their activity. There are striking correspondences with the sculptor David Mach, who constructs deliberately temporary, site-specific works out of unregarded materials such as rubber tyres (a temple, a submarine), furniture and tides of magazines and books. Mach has said, 'I am particularly interested in working "on site" like this. I consider this kind of work, given its temporary nature, not as an "installation" at all, but more of a kind of "live" performance of the piece, making it a bit like a piece of music performed by a band or orchestra.'[23]

The correspondences and crossovers between performance and the creation of objects and environments indicates a desire to escape the limitations of both by exploring the contradictions between them, by slipping between the established conventions of forms and disciplines. Photographers like Keith Arnatt, Matthew Dalziel and Tim Head have made lustrous, painterly colour images from subjects of pollution, waste and decay, but the Edinburgh photographer Ron O'Donnell has developed a unique art practice (notwithstanding comparisons with the painter/photographer Calum Colvin) to overcome the technical limitations of both painting and photography.

His medium is the large format colour photograph familiar from glossy magazines (a format which lends credibility to his images), but his subject matter is composed, as in a still life, from found objects, made objects and painted surfaces that he lights and then photographs. Much of the material is scavenged from rubbish, because, he has said, 'sometimes you can give it a new life – rediscover its spirit.'[24]

The resulting photograph is intended as a comment. **The Antechamber of Rameses V** *in the Valley of the Kings* has

The Antechamber of Rameses V

an Iain Sinclair-like appreciation of the curve of time as Egyptian wall paintings reappear on the walls of an Edinburgh tenement. **The Great Divide** is an emblem of contemporary Britain: the torn wall paper traces the outline of the east coast, with a bottle of HP (Houses of

Parliament) sauce at the crossing of the Thames. The rich anecdotal material of the impoverished left side of the frame is contrasted with the empty values of the appeals to consumption on the right. The comment is social, rather than political, though O'Donnell has described it as, 'Thatcher's Britain. I want it to be Surrealist – but in a social way.'[25]

The Great Divide

Anyone who has visited the abandoned upper rooms of the former synagogue in Princelet Street, Spitalfields will experience a Surreal frisson on seeing O'Donnell's work. Once he has completed and photographed an installation in a derelict building he is happy to abandon it to its fate. Revisiting the site later, he has sometimes found his work rearranged by other hands. In the case of *The Antechamber of Rameses V* the former tenement building has been converted into an up-market apartment block. But lurking somewhere behind the new wallpaper are the Egyptian paintings he created for the site.

The common theme of these varied practices is the reappropriation and transformation of the detritus of the contemporary environment. The fragments of a broken civilisation are reconstituted in an urban poetry. But it is not merely the discarded and the abandoned, with its all-too nostalgic appeal, that is reclaimed. Ironic quotation from the mass media has been part of the repertoire since Pop, but the technology of the media, photography, photocopying, video can also be reappropriated. The painter Conrad Atkinson has mocked the information industry in such works as the screenprints *The Wall Street Journal* (1985), *The Financial Times* (1987) and the *Daily Consumerica* (1988), all re-presentations of the front pages of newspapers, in the case of the latter, printed and distributed as a page of the *Guardian*.

The American Jenny Holzer and the Polish-Canadian Krzysztof Wodiczko have developed new ways of intervening in the blizzard of signs and symbols in the city streets. Wodiczko uses light projectors to impose images on public buildings which alter or challenge their architectural symbolism – most notably with the projection of a swastika onto the neo-classical façade of South Africa House in Trafalgar Square. Jenny Holzer uses the technology of the light-emitting diode screens that flash advertising messages on illuminated advertising hoardings, in order to insert more disturbing messages of her own.

Many of her statements have a banality that seems calculated to

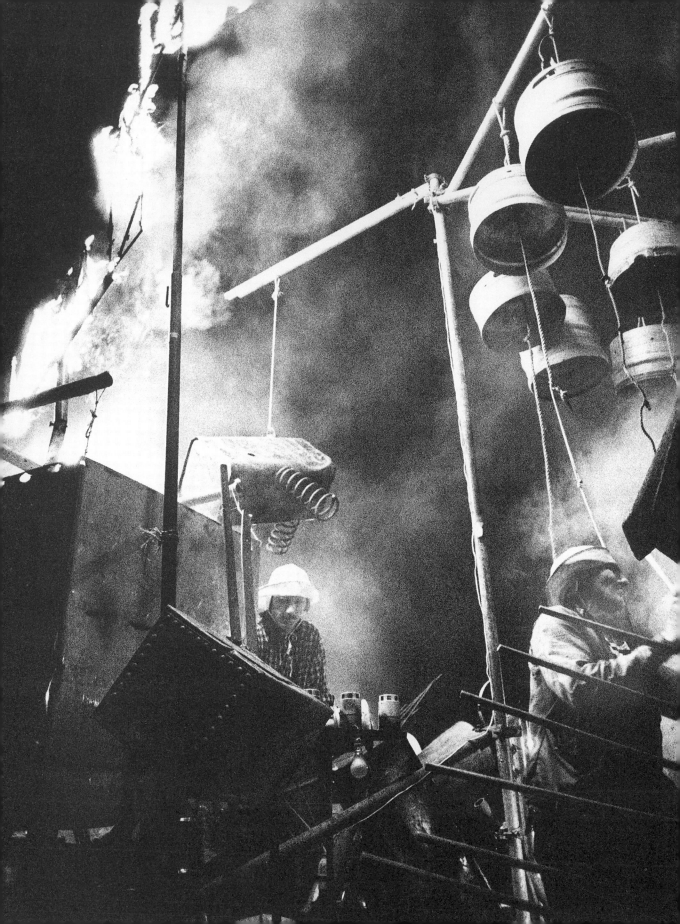

parody the banality of advertising slogans: 'Laugh hard at the absurdly evil'; 'The beginning of the war will be secret'. But the extraordinary nature of the interruption, 'Slipping into madness is good for the sake of comparison' comes from what it interrupts. Given space on a display screen high above **Piccadilly Circus**, such statements are inserted into cracks in the signage extolling not just consumer goods and British Airways but appeals from Westminster City Council to sponsor a tree for their Soho Project, and warnings from the police to keep an eye on your handbag. The familiar is made strange in a process that exposes the surreal text of the everyday.

Piccadilly Circus

The most striking example of the reappropriation of technology has been in pop, with the development of dub, scratch and hip hop. Afro-Caribbean blacks born in Britain have no 'heritage', except the double diaspora of slavery and immigration. In a sense all their culture, from cricket to carnival, has had no choice but to be a form of reappropriation. But as the critic Angela McRobbie points out, 'the ransacking and recycling of culture, the direct invocation to other texts and other images, can create a vibrant critique rather than an inward-looking second-hand aesthetic. What else has black urban culture in the last few years been, but an assertive re-assembling of bits and pieces, "whatever comes to hand", noises, debris, technology, tape, image, rapping, scratching, and other hand me downs?'[26] Black DJs began by talking over the instrumental 'dub' version of a popular hit, creating a kind of oral poetry. To this was added the mixing and scratching of records in a musical collage that made turntables and sound systems into a form of percussion. With the addition of drum machines the result has inevitably become a new source of recorded material. Dick Hebdige has described the refinement and philosophy of this process:

The hip hoppers 'stole' music off air and cut it up. Then they broke it down into its component parts and remixed it on tape. By doing this they were breaking the law of copyright. But the cut'n'mix attitude was that no one owns a rhythm or a sound. You just borrow it, use it and give it back to the people in a slightly different form. To use the language of Jamaican reggae and dub, you just *version* it. And anyone can do a 'version'. All you need is a

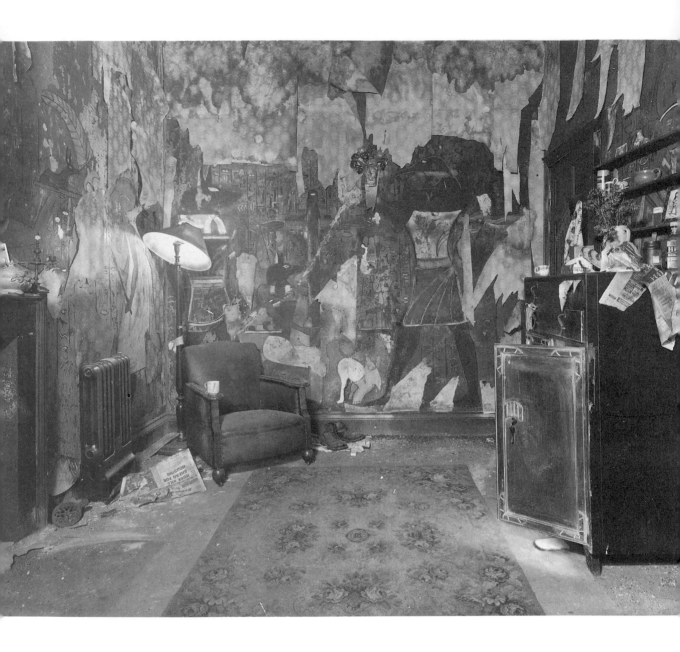

cassette taperecorder, a cassette, a pair of hands and ears and some imagination.[27]

From hip hop, developed in New York's South Bronx in the mid 1970s, has grown a witty and ironic approach to the language and material of pop which was easily transmitted to Britain. Significantly, its practitioners have called it 'scavenger music' because it is partly built out of scraps of earlier musics, and 'the last music' because its irony is derived from a reworking of these earlier materials. It has articulated a specific attitude to urban living, through the content of the raps, which celebrate black identity, through popularising a patois, a style of dress, and finding further expression in break dancing and graffiti art. Tower blocks have become ideal sites for illegal broadcasts that return the stolen music to the airwaves.

Scratch'n'mix is no longer confined to a particular sub-culture: Malcolm McLaren has produced his own cross-cultural mixes in his LPs *Duckrock* (African drumming, Appalachian folk), *Fans* (opera and drum machines), and the extraordinary blending of Strauss waltzes and disco in *Waltz Darling*. A white British group has made their own witty comment on the creation of collage music by taking the name, Pop Will Eat Itself.

Hebdige makes the point that a musical form may be generated within a particular sub-culture – punk, or hip hop – but that those boundaries are soon transcended once it is recognised that they offer a means of expression that has not been imposed, or turned into a commodity, however quickly the music industry then seeks to turn revolt into style:

As the pressure in the cities has mounted, the old national culture and national identity have started cracking at the seams. More and more people are growing up feeling, to use Colin McInnes's phrase, 'english half-english'. There is an army of inbetweens and neither-nors out there who feel they belong to no given community. They realise that any community they might belong to in the future will have to be *made by them* or it won't get made at all.[28]

In Social Surrealism what began as the dramatisation of a crisis becomes a potential instrument for resolving it. Reappropriated, recycled, remixed, both the detritus and the new technologies of post-industrial civilisation may yet form the basis for a new urbanism. The

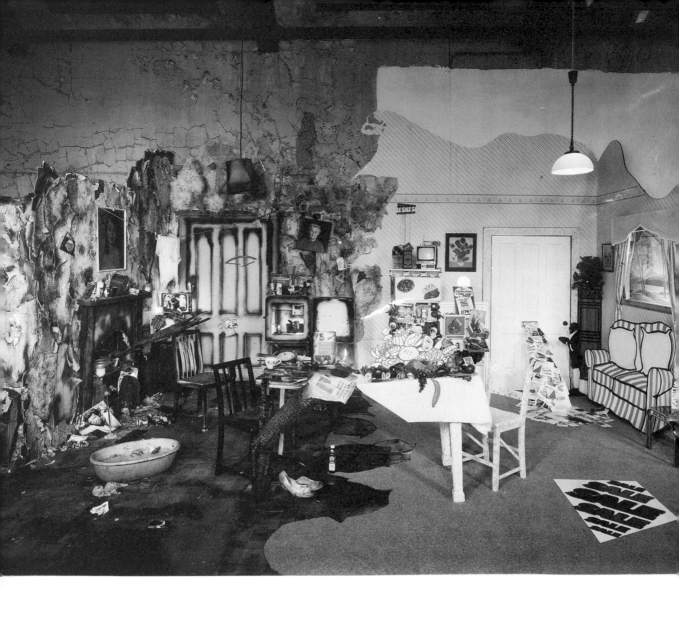

architect Nigel Coates is the most articulate spokesman for a philosophy of city living that, surrealistically, has set out to emphasise the 'absurdity of the ways things are'.[29] The programme of the NATO group (Narrative Architecture Today) has been to work, 'with a programme of signs and processes which, unlike those of postmodernism, embrace the idiosyncrasies of modern life with pleasure.'[30]

NATO was launched in 1983 with an exhibition at the Architectural Association mounted by Coates and his students in the school's Unit 10, which Coates had inherited from the visionary Modernist architect Bernard Tschumi. The show and accompanying publication featured a joint project – '**Albion**' – for the reconstruction of the Southwark and Bermondsey Docklands area – including Butlers Wharf. The freewheeling designs and their presentation, which carried over into NATO's publications, nearly caused the participating students to be failed by their external examiner James Stirling. But then NATO set out to reverse all the usual principles governing urban planning.

Albion

Start from the way things work, what they feel like. Instead of using plans Albion builds on incidents, sometimes pulled from the underculture of the city as it stands, sometimes culled from the mind . . . the city grows outwards from the action that fires it, not inwards from the planners' city of numbers method.[31]

NATO saw itself developing the space between home and work, between private, interiorised space and the commodified space of public architecture. The assemblage used to create the designs and models deliberately left gaps for creative misuse, and whatever the combination, 'it was put through further stages of distortion. Everything would bend even slightly, or be too big, or disguise its real functions under mountains of the unnecessary. It wasn't pretty, but it wasn't meant to be. Much more important, could it stimulate the instincts of its inhabitants? Could the city truly be an active partner to the experiences it contained?'[32]

NATO flourished in the urban decay of the 1980s. Coates acknowledges with delight the tarpaulin and mud exterior of Malcolm McLaren and Vivienne Westwood's shortlived World's End Shop in

St Christopher's Place (1982–83) as, 'a sort of NATO prototype . . . a critical *bricolage*'.[33] Coates' crude models of city environments, such as his satirical scheme for the redevelopment of King's Cross constructed from found objects, recall the work of the Situationist urban planner Constant. Appropriately, the firm of Branson-Coates designed the 1989 Situationist exhibition, and NATO's magazine was included in the exhibits.

The purpose of NATO was not to plan creativity, but to create conditions in which creativity might take place, with full participation:

We have adopted the artificial in place of the real, and learned to make use of this new 'reality'. Now we can all make TV programmes and handle computers. We assemble and recontextualise the spare parts of culture to suit our own expressions of identity. The old cultural compartments, patterns and processes have been deprogrammed from the constraints of a manufacturing based society towards one which manipulates excess. Resources are available to all by accident – whether in the form of the city wasteland or the computer console.[34]

To that end, NATO has not regarded a finished design or a completed building as the necessary end of the process – magazines, drawings, furniture, videos, arguments, clothes – are all means towards learning from, 'the psychological schisms, signs and patterns – the social narratives – of the times.'[35]

Yet in spite of the evident 'lifestyle' concerns of NATO, they should not be confused with the commodified versions of style, be it a particular type of architecture, or the fashionable streetstyle in the shops. NATO member Carlos Villanueva, in an allusion to Breton's projected resolution of the states of dream and reality in 'absolute reality', warns,

The fashion stereotype [style] is an object of production that fits smoothly into commercial praxis and abides by the rules of industry, technology and economics. The antagonistic stereotype [NATO] is not itself a consumable product, it is a catalyst in a cultural system that demands constant change. Its intention is not to replace the old with the new, but to influence the creative process directly, to radicalise the initial concepts and to encourage the

development of experimental phases. Architecture today should allow this ideological state of flux to exist and to accept experimentalism in the same way that it does practicality. If ideas are as influential as facts then the realm of dream begins to merge with reality.[36]

What is striking about NATO's attitude to city life is its optimism. The totality of the city's surroundings, 'from the city's moments of exquisite high culture to its backyards of decay,' are recognised as being in a state of constant flux that is a source of creative potential, not menace or uncontrolled disorder.[37] The wildness, the distortion, the deliberately rough edges and freestyle drawings of NATO schemes have an element of parody and the grotesque in them that is to be found in the spirit of carnival. Following the ideas of the Russian social theorist Mikhail Bakhtin (1895–1973) the American critic Robert Stam has defined the spirit of carnival as

more than a party or a festival; it is the oppositional culture of the oppressed, the official world as seen from below; not the mere disruption of etiquette but the symbolic, anticipatory overthrow of oppressive social structures . . . it is ecstatic collectivity, the joyful affirmation of change, a dress rehearsal for utopia.[38]

It is a dramatisation of change, not its fulfilment, but it expresses resistances and finds openings for celebrations of identity – most especially for the marginalised – in the gaps in public culture.

Since 1968 the group Welfare State has used theatre as a means towards this communal self-discovery. Calling themselves 'engineers of the imagination', they see performance as only the end result of a process of recovery and transformation. Michael White of Welfare State has written:

The celebrations and ceremonies we devise are not imposed upon a community but proceed from the creation of a common culture and shared belief. And in a humorous, ramshackle sort of way it is possible on occasion for a necessary, relevant, and accessible art to touch upon sacred things. In terms of resources, words and materials used, celebration is something produced through constant negotiation with its intended participants – negotiation as both political process and an epic journey to rebuild the necessary

MARTIN DESIGN

bridges between the domestic, the social and the mythic. It is a living theatre created not for an audience but for a community.[39]

Welfare State have carried out projects all over the world; since 1983 they have had special links with Barrow-in-Furness, and in 1988 began a three-year project at the invitation of Barrow Council that involves making television and radio programmes, pantomime, fire-shows, music and performance workshops, beach and street festivals. The intention is to leave Barrow with a thriving community arts network of its own.

The spirit of carnival, however, is only a temporary interruption in the official structure, and since the middle ages authorities have sought to limit the forces that it threatens to unleash. The Notting Hill Carnival has grown from an indoor event in 1959 into a huge celebration that attracts more than a million people, the majority of whom are white. But Notting Hill has been a contested area since the race riots of 1958, and the threat of violence has been present since the fighting that ended Carnival in 1976. In the 1980s what had been a run-down area (hence its attraction to immigrants) came under pressure from the process of gentrification that has pushed up land values and pushed down on the black inhabitants, many of whom by then had been born there. Drug dealing in the area has been used as a justification for heavy police surveillance, but the real conflict is over a minority culture whose values and pleasures do not correspond to those of the majority (at least, in the eyes of the police). Carnival is its cultural expression: changes, for instance, have made Jamaican sound systems as important an element as the Trinidadian steel bands. (Incidentally, themselves based on the recycling of waste oil drums.) But when the 1988 carnival lost £133,000, amid accusations of fraud, a coup was engineered that brought in a new committee, who set out to implement the recommendations of the accountants Coopers and Lybrand that the subsidised event could be made profitable. Even the spirit of carnival, it seems, must be accommodated to the enterprise culture.

To regret that the *laissez-faire*, chaotic, but genuinely communitarian celebrations of what is now an Anglo-Caribbean identity should be turned into another product of the leisure industry is not to call for the continuation of the violence and crime that has been associated with it. The heavy police presence is menacing enough in itself. There is a

danger, when releasing the energies of the ecstatic and the irrational in whatever form that the detonation will be destructive, and only that. The melancholy associated with the apocalyptic mode can itself be a despairing, and therefore reactionary genre. But the violence of Social Surrealism, often directed against the self, is in part an attempt to challenge the indifference of the public culture. As an expression of crisis, it is bound to have violent and repellent characteristics, and will deploy them to defeat the 'repressive tolerance' of the authorities.

Yet, living in the cracks of a managed public culture, recycling its waste and reappropriating its technology, the provisional culture of Social Surrealism shows that it is possible to 'release the hidden potential' of even the most disregarded things. Marshall Berman argues that the fruitful dialectic between the changing urban environment and the development of Modernist art and thought came to a halt in the 1950s, and that while Modernism continued, it became detached from its social context: 'The environment is not attacked, as it was in so many previous modernisms: it is simply not there'.[40] In the 1980s the city has once more been an inspiration, but it is not its modernisation that releases the imagination, it is its decay.

The object is not to romanticise the lives of the marginal, or to aestheticise squalor. The true poetry in the culture of collage and bricolage is the recreation of patterns, the rediscovery of the spirit and potentiality of things and ideas. As practitioners of an (until now) unrecognised genre, the artists quoted here have had very varying success. Tony Cragg won the Turner Prize in 1989, and has work in the Saatchi collection, as have Bill Woodrow and Richard Wilson. Derek Jarman is considered a marginal figure by the film industry and has extreme difficulty in financing his work. Howard Barker, Jim Cartwright and Gregory Motton depend on the shrinking budgets for new writing of the subsidised theatre. Members of the NATO group have put theory into practice, but Nigel Coates's work in Britain has been, for the most part, designing the interiors of shops, while the larger commissions in Japan have been for bars and nightclubs.

In the shadow of the Festival Hall and the other fortresses of culture on London's South Bank – their Modernist brutalism about to disappear beneath a skin of post-Modernist scenography to provide more space for shops and restaurants to support their cultural consumerism – is Cardboard City. Some of London's 75,000

homeless have taken up almost permanent residence here, recycling the discarded packaging of consumer society into a dreadful parody of NATO's bricolaged architecture. From the concrete crevices in the monuments to the public culture, the inhabitants of this anti-city can see across the Thames towards the real city, where, at night, Richard Rogers' Lloyds Building glows like a giant illuminated cash register. Neither culture on the South Bank, nor commerce on the North, is concerned about the future of these wasting lives.

'The body is, after all, the most readily available territory of expression'

NIGEL COATES

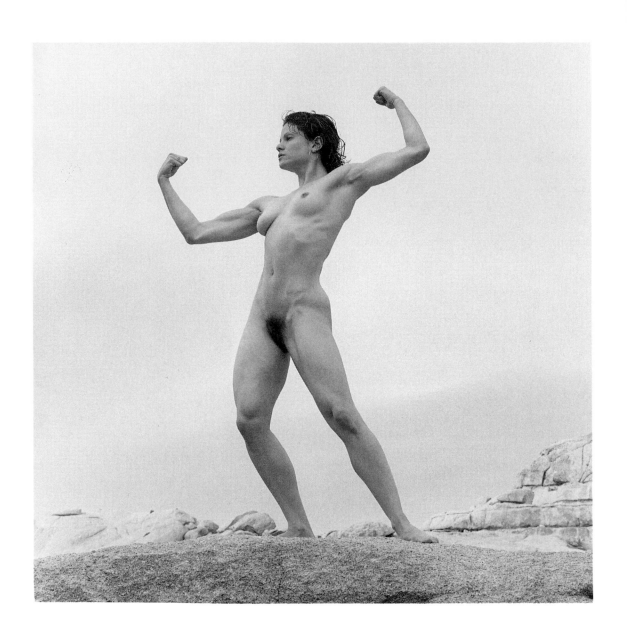

However much the creations of the cross-cultural bricoleurs of Social Surrealism are a source of pleasure – and therefore hope – there must come a time when the possibilities of the junk and detritus produced by a society even as prolific as ours will have been exhausted. This is true both of the artists who have found means to transform their material in an imaginative way, and of the retro-stylists of the information industry. The graphic designer Neville Brody knows the limits to the commercial consumption of culture: 'In the end design will eat itself. Culture is not a bottomless pit that can be infinitely ransacked – it needs a purposeful present, *lived* experience with which to nourish its context and vocabulary.'[1]

For a living culture to survive into the twenty-first century, that experience must be of more than a precarious existence in the cracks or on the margins of a completely commodified, imaginatively dead, public culture. There has to be an argument for transformation of some kind: social surrealism offers only a first stage towards Breton's as yet unknown 'absolute reality'. It is not enough to exploit the cracks in the dominant culture, a new space has to be created, one where it may yet be possible to make ourselves whole.

The Social Surrealists, nonetheless, have found the openings. The very sense of crisis and fracture brought about by the collapse of Modernism into the abyss of post-Modernism presents an opportunity. Post-industrial society, which has helped to provoke the crisis by exchanging the linear production models of nation states for the over-reaching armatures of multi-national corporations has created a new landscape of possibilities. As Iain Chambers argues,

It produces a space (in both the physical, temporal, and symbolic sense) in which previous social relations, economic organisation, and established knowledges and expertise are thrown into question, crisis, and movement; in which work may become discontinuous; in which ecology may not be of peripheral concern to the economy but part of the same social budget; in which the gender of power and politics can no longer be assumed or ignored; in which the exhaustion of the post-war consensus and the hardening of ideological discourses may, paradoxically, encourage the creation of transversal connections over previous political divisions.[2]

While the Right still clings to the comfort of corporate hierarchies, the Left spins in the void. The post-Modern pessimism of the Left derives from the collapse after 1968 of those progressive ideals that were expected to inspire mass movements to overthrow both corporate capitalism – as in Paris – and state imperialism – as in Prague. These twin debacles disenchanted radicals with communism and while confirming that the way forward was not through mass, bureaucratic parties, seemed to close off the possibilities of cultural revolution, or revolution of any kind. Such failures contributed to the post-Modern suspicion of mass movements in general (Baudrillard's argument that the obedient silent majority does not exist) and of what might be called the intellectual equivalent of the mass movement: the grand narrative – the totalising explanation, be it economic, philosophical or sociological, that contributes to the construction of some closed and hierarchically disseminated political programme.

Yet in the rubble of the broken monolith of total revolution there were new ideas to be discovered, new strategies to be explored. As Dick Hebdige has written,

Feminism, molecular and micro politics, the autonomy movement, the counter culture, the politics of sexuality, the politics of utterance (who says what how to whom on whose behalf: the issue of the politics of power and discourse, the issue of discursive 'space') – all these 'movements' and 'tendencies' grew out of the cracks, the gaps and silences in the old radical articulations. Given their provenance on the 'other side', as it were, of the *enoncé* it is hardly surprising that the new politics was more or less centrally concerned with the issue of subjectivity itself.[3]

Subjectivity begins with the body. The body is the missing term in the reconstruction of society under the dominance of transcendent capitalism, the term which NATO's 'narrative' architecture has tried to reintroduce in order to re-humanise the relationship between the individual and the city. Control over social space may largely have been surrendered to the corporations, but the body remains a means of expression. Confronted by an architecture of domination, something as apparently trivial as a hairstyle becomes an urgent matter. As the hair-designer Simon Forbes has remarked, 'We are all packed into London like sardines and the need to make a statement about yourself seems to intensify.'[4]

Much of mass culture is paradoxically concerned with individual self-presentation and identification, and as Iain Chambers points out, 'the concern with the body – both female and male – in fashion, pop music and dance, can lead into ambiguity, an escape from previous roles and an assumption of new ones.'[5] If only in fantasy, the shifting styles of pop culture offer a chance to try out new subjectivities. Dick Hebdige has described the fans who imitate David Bowie as, 'attempting to negotiate a meaningful intermediate space somewhere between the parent culture and the dominant ideology: a space where an alternative identity could be discovered and expressed.'[6]

But as the punks remind us, personal appearance can be a matter of fierce contestation: a statement of rejection and aggression. The designer Vivienne Westwood's concept of 'confrontation dressing' exploits a disruption of all previous codes, celebrating the risk of inviting or provoking rejection and harassment. In their self-mutilation, punks have parodied an economic order which, as Raymond Williams argued, looks on both the world, and people, simply as raw material:

There is now a major interpretation of sexual relationship as finding, in another person, the raw material for private sensations. This has been profitably institutionalised in pornography, but there are much more serious effects in the actual physical treatment of others, with women and children especially vulnerable. Failure in such versions of relationship is wholly predictable since relationship is precisely an alternative to the use of others as raw material. But what is most totalitarian about this failure is that it extends not only the cruel punishment of others . . . but also to the cruel punishment of self: in alcoholism, in addiction to damaging drugs, in obesities and damaging asceticisms. For the very self is then only raw material in the production of sensations and identities.[7]

The body, just as much as the city, is a site of struggle. But unlike the city, it remains open to the control of the individual. It is still possible to make a choice, even if the choice proves fatal. It is here, where the physical meets the metaphysical, that it is possible to construct new meanings and make new relationships. Feminism, in particular, has developed since 1968 as a critique of the politics of the body, and feminists have had the most experience of negotiating the fissures in the prevailing order. Indeed, as the French psychoanalyst Luce

Irigaray has argued, women have always been forced to exist within the cracks of the ruling structure, experiencing themselves, 'only fragmentarily as waste or as excess in the little-structured margins of a dominant ideology.'[8]

The experience and arguments of feminists are important not only because they are concerned with constructing a new order out of the fragments of the old, but because they have brought into question the way in which both the old and the new are contained within the same system of signification. That interrogation begins with the way the body itself is represented. As Rozsika Parker and Griselda Pollock explain in their introduction to *Framing Feminism*, 'The central question is about looking. Structures of looking and especially pleasurable looking have been identified and shown to establish meanings and gender positions for accepting those meanings. In a sexually divided and divisive society dominance in looking is accorded to and secures the masculine position, while the feminine is placed as the passive object of that gaze.'[9]

This division has important consequences for the entire iconography of culture, which has the male as concrete, active, and dominant, the female as abstract, inactive and subordinate, an iconography that feeds back into and reinforces the ideology from which it emerged. But the male as well as the female body is caught in the coils of representations. The looking subject has power over the regarded object, whatever the sex, and technology has vastly expanded the facilities for surveillance, be it visually, through the lenses of the cameras peering along the arcades of Tobacco Dock, or digitally through the array of credit and identity cards we are required to carry. Photography turns all of us into images, objects of control, in the case of pornography, of commodity exchange. Assisted by computerisation, photography, and by extension film and television, has become the pervasive technology of the twentieth century, and the principal reason for the emergence of an image-culture. For this same reason, photography has become a key medium of post-Modern art.

From the debate about representation we learn that the body is held within a frame of ruling definitions. It is not merely a question of appreciating representation as the replication of already constituted meanings, but understanding that representation is the process by which meanings are made. These meanings are ideological: they create images, ideas and values that lead to acts and utterances that define our social and sexual relations: relationships of power.

Representation, in this sense, is not confined to image-making, it extends to the whole way in which we name, describe and discuss the external world and speculate about its possibilities. All communication (even with ourselves) is mediated by images, signs and sounds which include language, but which extend far beyond it, in the all-embracing web of discourse. And, as the artist and critical theorist Victor Burgin points out, 'discourse is itself a determinate and determining form of social practice; discourse does not *express* the meanings of a pre-existent order, it *constructs* those meanings and that order.'[10]

A prisoner of imagery, language and ideology, it is no wonder that the case of the post-Modernist artist seems hopeless. It is not so much that the game is over. Rather, we are chess players, trapped into an endgame by a superior opponent through the classic strategic impossibility known as *zugzwang* – still in the game, but in a position from which there is no escape, for the only moves open are suicidal.[11] By the rules of chess, we should resign. But we cannot resign: the rules of reality are written by the ruling ideology, and without the use of representation and discourse we have no means of defining ourselves except as players in the game. That which does not enter into the ruling ideas and imagery of that ideology is invisible, does not exist, has no hand to play.

That, metaphorically, was the position in which women writers and artists found themselves in the aftermath of 1968. They had somehow to disengage themselves from male-defined artistic and critical practices, including Modernism, and somehow resite themselves in a position from which a new discourse could begin and a new artistic language expressing female consciousness could be made. In 1978 the art historian Lisa Tickner set out a possible agenda:

The female image in all its variations is the mythical consequence of women's exclusion from the *making* of art. It is arguable that, despite her ubiquitous presence, woman as such is largely absent from art. We are dealing with the sign 'woman', emptied of its original content and refilled with masculine anxieties and desires. Nowhere is this more evident than in the area of eroticism, and women see themselves reflected in culture as through a glass darkly. Yet paradoxically the tool for objectifying their experience *is* culture, *is* the process which already distorts it and which is not itself value-free. The only solution is to grasp and reconstruct it,

through the exposure and contradiction of the meanings it conveys. We cannot pull out of thin air a new and utopian art – or a new and utopian sexuality: both must be arrived at through struggle with the situation in which we find ourselves. Art does not just make ideology explicit but can be used, at a particular historical juncture, to rework it.[12]

Rosemary Betteron describes the strategy for its implementation: 'We need to look at those areas where struggles over representation are taking place, if only because by seeing what is denied or outlawed by dominant ideology, we can find the fragments to reconstruct femininity in new ways.'[13]

Rose Garrard

The process was two-fold: one was simply to return to the historical record the women artists who have been excluded from the masculine canon, a scholarly pursuit matched by the artist **Rose Garrard**'s 'reclaiming' the work of forgotten women artists – such as her reworking of Artemesia Gentleschi's self-portrait at Hampton Court – in order to bring them back into contemporary consciousness. The second was more provocative to the masculine order: to introduce into art those aspects of the female which had been previously excluded from that regarded as decorous and acceptable.

The source and subject matter of this art is the body, but not the colonised and eroticised female body of male representation; it is the female body as lived in its own quiddity, involving all its aspects of fertility, menstruation and sexuality. Depiction of the menstrual cycle breaks a long held taboo, few works of art have done so more provocatively than Judy Chicago's bloody tampon in *The Red Flag*. The exhibition and documentation of the previously unmentionable physical aspects of the female body is one challenge to the accepted discourse. Another means of asserting a female identity is to celebrate those myths and mysteries associated with pregnancy and child-rearing which are traditionally regarded as a female preserve, and to promote a cult of the mother, rather than the patriach.

Some of the most sustained work in this area has been done by Mary Kelly, whose *Post-Partum Document* (1973–1979) does not so much celebrate motherhood, as interrogate its nature by recording the first six years of her son's life. A six-part, 165-item piece, it is both an

archive – featuring her son's nappy linings – and a critical account of post-Freudian psychoanalytic theory concerning the relationship between mother and son. In 1983 Mary Kelly began a second series, *Interim*, which like the first is intended for display in galleries, though here the material consists of plexiglass panels of photographic screenprints paired with diary extracts. Mary Kelly explains:

In *Post-Partum Document*, I asked myself what the woman feared losing beyond the pleasure of the child's body and concluded that it was the closeness to the mother's body she experienced in being 'like her'. Now, in *Interim*, I am asking how the woman can reconstitute her narcissistic aim and consequently her pleasure, her desire, outside that maternal relation.'[14]

Significantly, Mary Kelly describes *Interim* as suggesting, 'a state between, in the middle, medial, midway . . . a gap, a space of possibility or a metaphorical "change of life".'[15] She also sees her work as, 'impelled to fill in, or perhaps I should say widen, the gaps in the Freudian thesis' on hysteria.[16]

The cool, gallery presentation of Mary Kelly's work is in the mode of conceptual art, but the emphasis on the body strikes a resonance with the use of the body in performance. As an art form virtually without a history, performance art has particular possibilities, because it escapes the academic (masculine) prescriptions of what is or is not suitable in terms of content and materials. The direct communication between performer and audience implies an open-ended, shared experience that tries to avoid the domination of either one or the other in a collective event. The choreographer Elizabeth Dempster notes that in dance (as in all other established art forms) the conventions are male, excluding the female body from the possibility of defining its own 'speech'. But, 'sometimes in an unguarded moment a fissure opens in a once silent body and from it flows an unstoppable, uncontainable speaking as we cast our bodies without thinking into space.'[17] The dancer Gaby Agis says that her choreographic ideas come through the body, rather than the mind, as she looks for 'a positive way of showing women's bodies, and skin and sexuality.'[18]

For Elizabeth Dempster, 'postmodern dance directs attention away from any specific image of the body and towards the process of constructing all bodies. If postmodern dance is a "writing" of the body, it is a writing which is conditional, circumstantial and above all transitory; it is a writing which erases itself in the act of being written.

The body, and by extension "the feminine" in postmodern dance is unstable, fleeting, flickering, transient – a subject of multiple representations.'[19] Such evanescent impressions evade the fixing of the dominant gaze. As Parker and Pollock argue, feminist art offers a new kind of pleasure to the viewer:

Rejecting the conventional gratifications of the successful, complete, finished art object and the voyeuristic spectacle, feminism explores the pleasures of resistance, of deconstruction, of discovery, of defining, of fragmenting, of redefining, all of which is often still tentative and provisional. Feminism constantly questions the identifications of popular and high culture and their pleasures – of being the artist, the special and select, the refined sensibility or inspired or driven creator, as well as the identifications for the viewer, of voyeurism and imaginary suspension from time and place, escape from the banal and real to the fantasies of other personalities, classes, races or genders. Feminist practice entails a collective production of radically different views of the world, different kinds of knowledge and accounts of experience and its determinations.[20]

The American critic Alice Jardine has theorised this practice as a tracing of 'possible new intersections for modernity and feminism through explorations in gynesis. *Gynesis*: a new kind of writing on the woman's body, a map of new spaces yet to be explored, with "woman" supplying the only directions, the only images, upon which Postmodern Man feels he can rely.'[21] The demolition of secure ideas of the self, of reality and representation, she argues, 'has left modernity with a *void* that it is vaguely aware must be spoken differently and strangely: as woman, through gynesis.'[22]

It would be inaccurate – and probably masculine – to present feminist explorations in search of a new space as a mutually agreed and coherent project. Some feminists argue that it is not simply a matter of making spaces that can be filled by a specifically feminist discourse: others have argued for the existence of a 'wild zone' or 'no-man's land' of female experience entirely inaccessible to men. (By definition, a male author has difficulty in speculating where that zone might be, and what it might contain.)[23] Alice Jardine argues that the new spaces of feminism are bound, in a sense, to be

unnameable, so long as narrative remains part of male-dominated discourse:

Because it is preeminently narrative whose function is to assure communication between two or more paternally conceived egos, narrative is seen as that which must be disturbed first so that the creation of new breathing spaces in language may be affirmed and valorised. Along with narrative, those systems that support it – from the linguistic sign to the image, from the Cartesian subject to Truth – must also be dismantled if modernity is to accomplish its parallel task: to name the unnameable.[24]

What Jardine says of narrative might also be applied to technology. Technology is the male drive of progress, seeking to control and exploit the world of nature (traditionally conceived of as feminine, 'Mother Nature'). The assertion of the feminine principle through gynesis might disrupt the narrative of technology, open new spaces within it – if only within the messages of the information industry – and so produce an as yet unnameable change.

What is to be learned from feminist critiques of representation is that men, as well as women, are the product of social and historically produced codes that determine identity. This binary code works to the advantage of men, as the critic Kathy Myers points out: 'One of the oppressions of patriarchy is to constrain female sexuality through a system of binary oppositions: e.g. masculine as opposed to feminine, passive versus active, emotional and sexual, sexual receptiveness as opposed to sexual drive, etc. This binary system works to perpetuate unacceptable ideologies about the nature of sexual relations.'[25] But this structure equally limits men. As the American critic Craig Owens points out, 'the representational systems of the West admit only one vision – that of the constitutive male subject – or, rather, they posit the subject of representation as absolutely centered, unitary, masculine. The post-modernist work attempts to upset the reassuring stability of that mastering position.'[26]

The feminist project to dismantle the unified subject – that is, to break up the idea of the single, unitary individual whose given identity is male, over against an 'other', the dispersed female – is as important for men as for women if new spaces and forms are to be discovered. For one thing it would be a means to escape the binary definitions of

sexuality, and indeed sex as a defining role altogether. As the French editorial collective of *Questions féministes* declared in 1978,' Up to now, only the masculine is allowed to be neuter (nonsexual definition) and general. We want access to the neuter, the general. Sex is not our destiny.'[27]

The difficulty attached to moving beyond sexual identification, as with the difficulty in evading representations or discourse, is that the sexual difference can only be transcended *through* the body, just as images and words are needed to escape the definitions that they have been used to construct. But there are ways in which the body has been used to confuse the binary categories, to blur their edges and render their images ambiguous. The collaboration between the bisexual American photographer Robert Mapplethorpe and the performance artist **Lisa Lyons** is a case in point. Mapplethorpe's images of the body-building

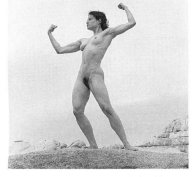

Lisa Lyons

Lyons suggest, as Rosetta Brooks has said, 'a form of cross-dressing on the body itself.'[28] The 'feminine' is denied by the hard musculature of the body-builder's pose (though possibly resurfacing in the homoerotic allusions to physique magazines); the masculine is denied by the evidently female body, above all in those images where hats or veils or other feminine signs are deployed. This analysis is not intended to reproduce the binary stereotypes male/female – particularly when it comes to homosexual eroticism – anymore than the object of bisexuality is to annul difference. Rather, it perceives gender as ever more fluid and ambiguous. On a completely different level, the notion of female display is delightfully parodied and enjoyed in the completely asexual costumes and make-up worn by the Australian designer **Leigh Bowery**.

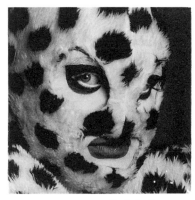

Leigh Bowery

The study of sexuality by the French social theorist Michel Foucault led him to conclude that the category 'homosexual' is as much socially constructed as 'male' or 'female'. Male and female homosexuals have been long accustomed to living between the 'straight' and the 'gay' worlds, but after 1968, like feminists, homosexuals have sought means to assert their particular subjectivity. The English writer and performer Neil Bartlett has followed a feminist strategy through the imaginative recovery of earlier homosexual artists: Oscar Wilde, in the case of his

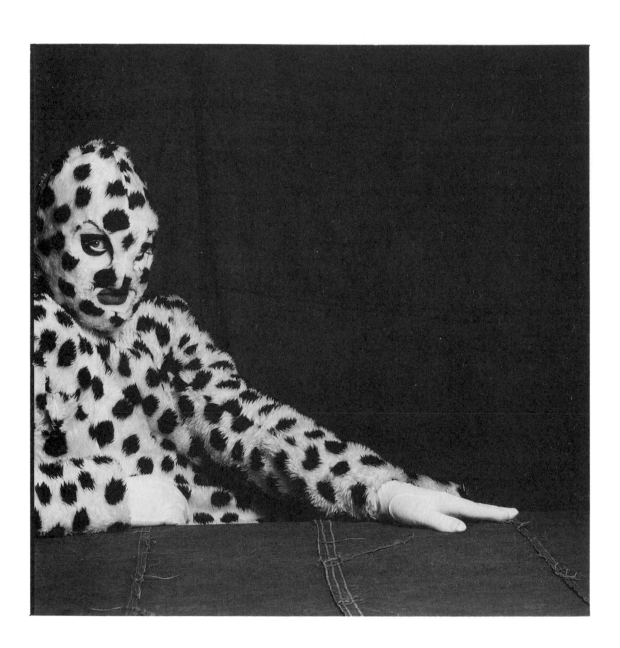

book, *Who Was That Man?* (1988); the painter Simeon Solomon, in the case of his performance piece, **A Vision of Love** *revealed in Sleep*, whose complete version was first shown in 1989. The performance centres on the vulnerability of Bartlett's own body, for he is nude throughout, shaved of all body hair except for an Edwardian moustache. His presentation of Bartlett/Solomon is assisted by three drag queens – one a transsexual – whose artifice and vulgarity introduce the totally ambiguous category of camp.

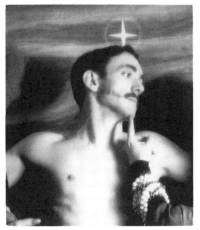

A Vision of Love

In both performance and text the recovery of the homosexual artist is paralleled and interleaved with Bartlett's own self-discovery as a homosexual. His investigation of Oscar Wilde is also an investigation of the city whose territory, metaphorically, he and Wilde share on the curve of time. For his body in performance, in the narrative Bartlett substitutes autobiography. The positioning of homosexual identity is crucial: Bartlett writes of his own sexually constructed desires for a 'female nature' within a masculine exterior, but points out that gay pornography is phrased, 'in terms of a masculinity, a maleness which is hardly under our control.'[29] There are 'straight ideas and straight desires waiting to surprise even those of us who really thought we knew what we were doing.'[30]

Bartlett writes that, 'We want the pleasure of saying what we mean.'[31] But words fail him and Wilde. Wilde's importance to Bartlett is that his exposure and trial in the 1890s drove an emergent homosexual consciousness underground once more. (It is not difficult to see a parallel with the moral panic caused by AIDS, and its relation to Clause 28.) Wilde, in a sense, was already post-Modern, in that he had to rely on the 'forged' nature of camp. Bartlett argues that the homosexual identity may be whatever the homosexual wants it to be – but only as a reconstruction of other constructions: 'There is no intrinsic value to homosexuality. There is no "real" us, we can only ever have an unnatural identity, which is why we are all forgers. We create a life, not out of lies, but out of more or less conscious choices; adaptations, imitations and plain theft of styles, names, social and sexual roles, bodies.'[32]

This bricolage of sexual identity, as an act of theft, has been treated as a form of transgression. Transgression of boundaries is the countersign of exploiting interstices. Bartlett says of the extreme example of

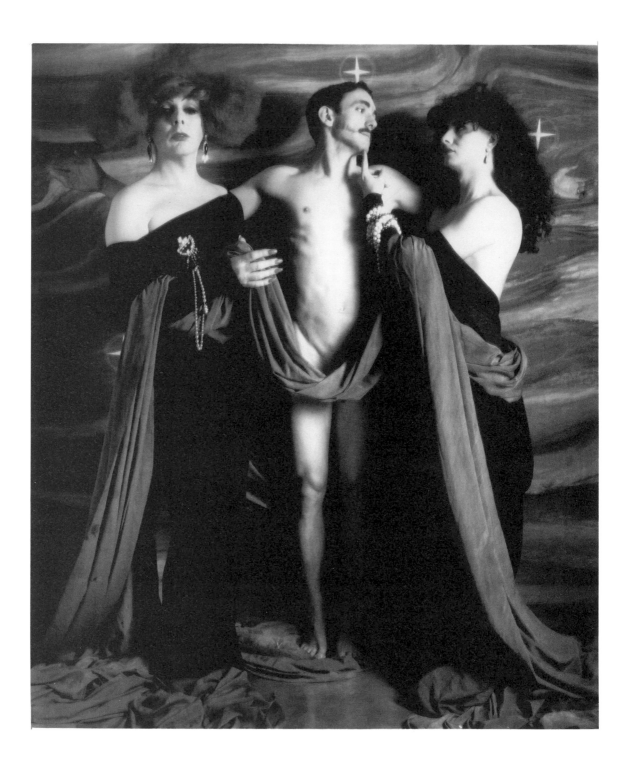

drag queens, 'It's not exactly what they do that is so moving (in fact they are ludicrous almost all of the time); it's the fact that they have crossed, in fact have dramatised, parodied, illuminated, erased, forgotten or made forgettable so many important and well-defended boundaries.'[33] The crossing of boundaries between art forms is a common theme to most of the works discussed in this book, but some also cross boundaries laid down by social convention, even, potentially, the law. The double transgression of a homosexual relationship across the racial barriers in the Frears/Kureishi film *My Beautiful Laundrette*, proved capable of giving particular offence, not least because it was within the conventions of a popular form of entertainment.

The critic Scott Lash sees political potential in the ambiguities of identity set up by the pluralistic attitudes to sexuality that are evident even in the popular imagery of entertainment and advertising:

'The deliberate ambiguity in gender and sexual preference built into images problematises reality and the normative in a sense not dissimilar to the way that Surrealism and pop art . . . operate. The effect is a much more ambivalent and less fixed positioning of subjectivity. If subjectivity is less fixed, then space is left for the construction of identities, and collective identities, which deviate from the norm. That is, space is left for difference.'[34]

The question remains as to whether the loosening of the conventional ties on identity could release the potential of female identity sufficiently for some 'wild zone' to be identified and articulated. By 1987 Lisa Tickner had revised her views on such a possibility:

What may have to be abandoned is the idea of a uniquely feminine painting (or writing) untainted by patriarchal imagery or language – exhilarating though that is – but if it is the context of our discourse which produces meaning we are not obliged to mimic our master's voice as the only alternative. We are constantly engaged in producing new meanings through metaphor, parody and interpretation: the task is to secure them and carry them onto the terrain of the dominant discourse.[35]

In the process, the dominant discourse would have to concede and adapt to the new ambiguities.

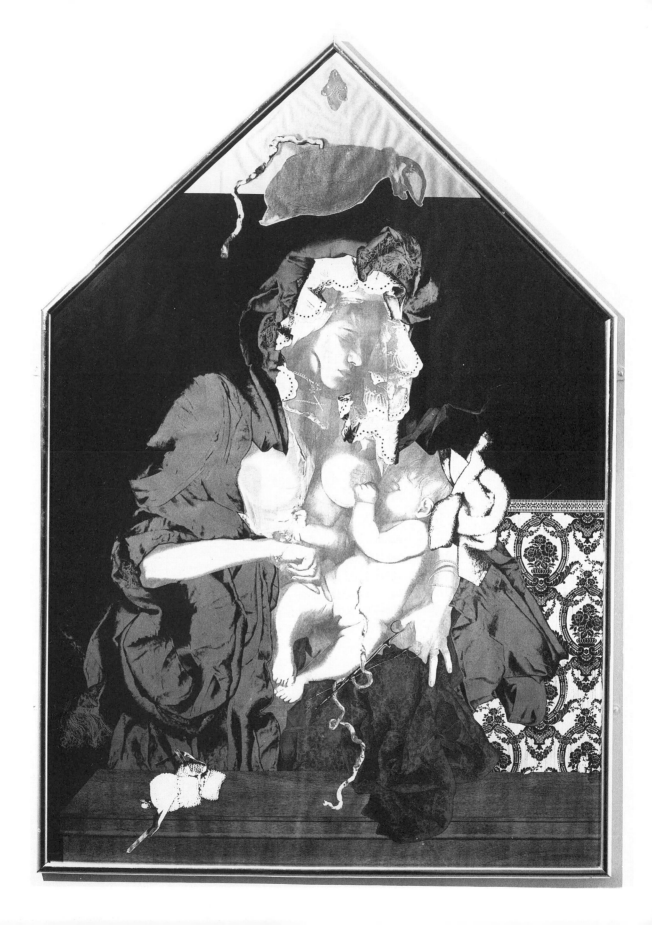

In the work of the British artist Helen Chadwick many of the themes involved in the search for a new methodology and a new space are brought together, and transcended. Chadwick, like others, begins with her own body, and like others uses photography as a principal medium, except that in her case she has developed a technique for using images made directly by a photocopier, simply by putting an object – most tellingly, her own body – in the place of a pre-existent image on the photocopier's screen. Because of the problems of the screen's limited surface area, the resulting image has to be collaged together with similar others, producing a combination of post-Modernist surface and cubist collage. The use of her body as subject evades associations of exploitation-through-representation (the sculptor Anthony Gormley makes casts from his own body in similar fashion.)

One Flesh

A work such as **One Flesh** (1986), constructed in this way, clearly reclaims the Christian iconography of mother and child for the feminist cause. The mother pointedly reveals the sex of the child as female, the associated imagery of scissors and umbilical cord recalls the physical reality of birth. Most daringly, the penumbra above the 'Madonna's' head is formed by the vital link between mother and daughter: the placenta.

In the same year Chadwick created an installation for the ICA that opens up yet wider aesthetic and philosophical possibilities. As an installation, **Of Mutability** extended the range from image, through sculpture, to environment, and deployed fresh technical resources by using a computer to generate the 'salomonic' columns that lined the walls of the larger of two rooms. In the smaller room a square column of glass, titled 'Carcass', held vegetable and animal matter, including material used to create the photocopies at the centre of the piece, that was freshly added to each day, rather like a transparent compost heap. The ecological reference is exact, for it was a demonstration of the mutability of matter as it slowly compressed into mulch at the base of the column.

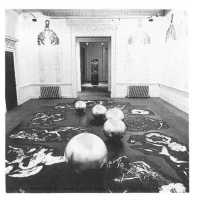

Of Mutability

In the main room the paper columns lining the walls were topped by photocopied images of the artist weeping. Metaphorically, her tears flow through vines down the columns and across the floor to fill the

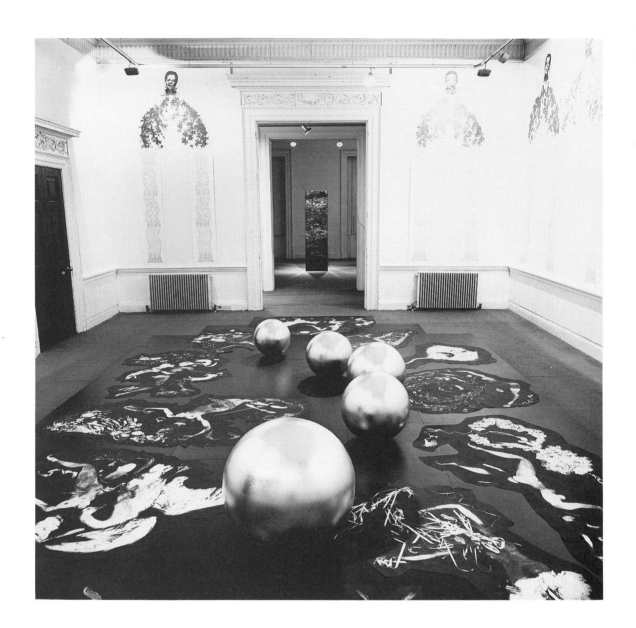

blue pool (the principal colour of the piece is blue), raised a few inches above the floor, that occupied the centre of the room. On the surface of the pool lay twelve groups of xeroxed images derived from the artist's body, animals, birds, fish and fruit. To this horizontal dimension, however, was added the emblem of five gold spheres placed across the centre of the piece. When remounted at the Victoria & Albert Museum in 1989 as *The Oval Court* ('Carcass' having been destroyed in an accident) the whole work could be seen in a convex mirror on the wall, adding another dimension of reflection, surface and reproduction.

The imagery of the surface of the pool is infinitely suggestive. The gold spheres represent both gold as an immutable substance, and the touch of the five fingers of a hand. The imaged animals are dead, even rotten, evoking the whole art historical tradition of *nature-mortes* and their symbolisation of decay. The constellations of figures also recall the classical imagery of star-maps, and there is a sense in which the female body is returned to its traditional iconographic significance and matriarchal nature. The artist is blindfolded, bound, hooded in various ways, and her posture sometimes repeats that of the dead nature around her. In some images she has more than one head and extra limbs, in others, limbs have been severed.

The effect is both sinister and sensual. Chadwick has said that the piece presents 'probability patterns for desire', to begin with, her desire, which is neither exclusively body nor mind, but imagination: 'It's my potential – it exists as potential of me.'[36] There is in this the theme of 'Vanitas' (which she has adopted for the title and subject of another piece deploying mirror and photocopying). The potential narcissism is undermined by the warning presence of decay. But then the figures do not seem aware of themselves, only the severed limbs appear conscious of loss. The totality of the piece suggests a cycle of passion that leads from melancholy to ecstasy and back again in an emotional and ecological harmony.

Significantly, this great achievement is virtually impossible to reproduce photographically. It only makes sense when it is directly experienced. To that extent it has acquired a particular autonomy. Chadwick has found that the piece is most quickly appreciated by bisexuals who apprehend more easily the polymorphous nature of desire. But now she is moving in her work beyond questions purely of female identity to those of androgyny or even, she has suggested, towards a 'hermaphroditic' art. More recent work has used computers

to develop patterns from her own cell structures which are then presented in relation to computer-processed photographs of landscape: a 'green' art that bypasses all questions of sexual difference or ambiguity by reflecting on the common ground between the 'natures' of all bodies and all landscapes. In her installation at Woodbridge Chapel, Woodbridge Street, in 1988, **Blood Hyphen**, she used a laser beam of blood red light to slice across the interior space of the chapel vault and fall onto a translucent slide, creating an image of 'healing light passing through body space'.[37]

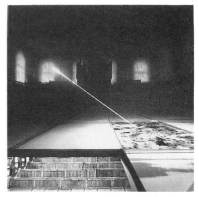

Blood Hyphen

The body is not sexed, the blood and implied pain is something the sexes experience in common. The light heals the wound between them.

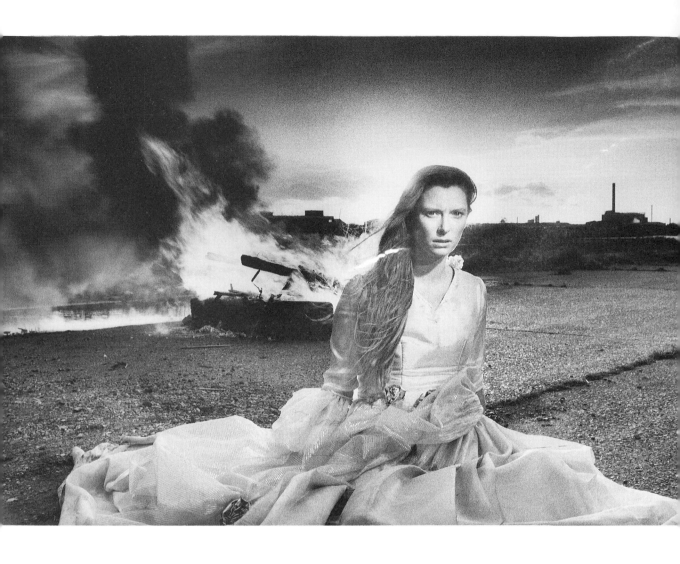

'A post-
modernist
artist or writer
is in the
position of a
philosopher
. . . working
without rules
in order to
formulate the
rules of what
will have been
done.'

JEAN FRANÇOIS LYOTARD

The debate about sexual identity and its consequences for the relations between the sexes – particularly power relations – is part of a wider issue: is it possible not only to make spaces for new concepts, but also to maintain an equable relationship between them, so that no one idea, or its manifestation in discourse, representation or social structure, dominates over another? Is it possible to have more than one set of 'truths'? To some extent this is the position in which we already find ourselves, following the collapse and fragmentation of intellectual certainties in the post-Modern condition. As the sociologist Zygmunt Bauman argues, 'the main feature ascribed to "postmodernity" is thus the permanent and irreducible *pluralism* of cultures, communal traditions, ideologies, "forms of life" or "language games".'[1] This is the nightmarish condition of loss and uncertainty described in chapter one:

Things which are plural in the postmodern world cannot be arranged in an evolutionary time-sequence, seen as each other's inferior or superior stages; neither can they be classified as 'right' or 'wrong' solutions to common problems. No knowledge can be assessed outside the context of culture, tradition, language game etc. which makes it possible and endows it with meaning. Hence no criteria of validation are available which could be themselves justified 'out of context'.[2]

With 'common sense' exploded as an ideological invention, and 'reality' no more than a set of ruling representations, the prospect is frightening. But it is only through the demise of a theoretical universalism that an actual pluralism can be made to work. The 'grand narratives' of the twentieth century have not produced the benefits expected, rather, they have led to overt or covert systems of oppression.

What is proposed is a constantly shifting field of cultural languages and ideas, relating one to another, sometimes complementarily, sometimes oppositionally, in a dialectic of dissonance and convergence that allows no single term either monopoly or domination. It is tempting to argue that this is how things are anyway, but it takes courage to launch out onto such a sea of apparent uncertainty.

One refuge is the immaculate perfection of a critical theory that does not engage in the contingent and the sensuous, the uncomfortable

textures of exceptions and contradictions that constitute experience of everyday life and material culture. But, as Dick Hebdige argues, the acknowledgement of an unstable state of flux frees artists and their allies to engage more directly in the 'moving equilibrium' of competing forces:

Within this model, there is no 'science' to be opposed to the monolith of ideology, only prescience: an alertness to possibility and emergence – that and the always imperfect, risky, undecidable 'science' of strategy. There are only competing ideologies, themselves unstable constellations, liable to collapse at any moment into their component parts. These parts in turn can be recombined with other ideological formations to form fragile unities which in turn act to interpellate and bond together new imaginary communities, to forge fresh alliances between disparate social groups.[3]

In the field of culture, the distinction between 'high' and 'low' art forms, between mass and elite audiences becomes unimportant; what matters is the way people take part selectively in all of them. It also matters that this participation should be active, indeed interactive, that people should be imaginatively and creatively involved, for the relentless drive of commodification threatens to turn them into passive consumers of a universal, 'public' culture.

It is important, however, that pluralism should not simply be another kind of sameness, that the acknowledgement and toleration of difference should not lead to the conclusion that nothing matters. Craig Owens warns that pluralism, 'reduces us to being an other among others; it is not a recognition, but a reduction to difference, to absolute indifference, equivalence, interchangeability (what Jean Baudrillard calls "implosion").'[4] Rosetta Brooks fears that the disruption and fragmentation of life in Britain in the 1980s has created a form of 'collective isolation':

In doing so, British society is following the model not only of immigrant groups, forced by legal and social constraints into physical and cultural ghettoes, but also of the art world, which in modern times has always been relegated to the periphery of society. By remaining outside of accepted class hierarchies, artists have gained a measure of freedom, but by the same token they

have been shunted into a marginal cultural role, unknown outside their community except as fictionalised mass-media celebrities.[5]

In this condition not only can new work be easily incorporated, ghettoised as 'the avant-garde' and sealed off for sale as a separate commodity: the apparent freedom to do whatever one likes may prove an illusion, and the deep structures of domination and exploitation remain in place. The potential for change in new work and new ideas is absorbed and neutralised by an apparently liberal pluralism which deflects potential antagonism by the simple acknowledgement of difference. The apparent liberalism of such pluralism may only be a gesture that masks new drives that will eventually make such gestures redundant.

The acknowledgement of difference *in itself* can prove to be a strategy for control. As *Questions féministes* argued,

The very theme of difference, whatever the differences are represented to be, is useful to the oppressing group: as long as such a group holds power, any difference established between itself and other groups validates the only difference of importance, namely, having power while others do not. The fact that blacks have 'a sense of rhythm' while whites do not is irrelevant and does not change the balance of power. On the contrary, any allegedly natural feature attributed to an oppressed group is used to imprison this group within the boundaries of a Nature which, since the group is oppressed, ideological confusion labels 'nature of oppressed person'.[6]

Almost as dangerous as the assumption of a 'natural' difference is the celebration of 'unnatural' disruption (a tendency among some artists in this book) where anything that is seen to offend or interrupt the *status quo* is welcomed, regardless of its purely destructive or self-destructive potential. It is not always true that change is productive in itself, and there are instances where resistance to change (as in the modern city) is necessary. Nor should the excluded and the marginalised be romanticised for *being* excluded and marginalised. The important thing is to celebrate the identity that they have developed for themselves (as opposed to have had forced on them) as a means of coping with the dominant ideology, and to use it as an argument for

altering the dominant. Only thus will we become a truly multi-cultural society.

We must learn, argues Craig Owens, 'how to conceive difference without opposition.'[7] In place of the grand narratives we need what might be called a Grand Dialogue. This dialogue can be achieved both at the macro and microlevel. The new technology of communications, once wrested from the grip of competing would-be monopolies, could make mutual access and exchange easy, without reducing differences of culture. On the individual level, the perception of the word or image not as text, but as 'intertext', where meaning is made both by the writer and the reader, the image-maker and the viewer, opens up possibilities for a new relationship with representation and discourse. At both the macro and micro level, the present emblems of fragmentation, isolation and competition could be exchanged for the image of the network, a chain of communication with many centres, many arms, and a plurality of links between them.

To exchange network for hierarchy, communication for domination, and to accept the condition of flux, it will be necessary to come to terms with the fact of change itself. The only constant state is change, whether we appreciate its consequences or not. This is not an argument against resisting change when – as pointed out earlier – change appears to be for the worse. But it must be acknowledged that even resistance to change is a form of change, in that it alters the relations and perceptions of what is to be preserved. The principle of pluralism necessarily involves acceptance of the changing and the incomplete, in the mobile alignments and linkages that constitute the net. The acceptance and comprehension of change would produce a vital shift in the balance between the past and the future. No longer would history be something that is over, but something *in the making*.

A recognition of change, of the necessary impermanence within pluralism, is a threat to the dominant order. The rewriting of history into Heritage is calculated not only to deny the pluralisms of the past, by converting the conflicts, contradictions and false turnings of events into a single narrative that leads remorselessly up to the powers that be of the present day: it is a means towards denying change in the present, where the only destiny is that already constructed from the past. Pluralism is a danger to any power structure, because to accept pluralism is to acknowledge 'the other'. To acknowledge the other is

to accept that you yourself are an other, and that the possibility exists that your truth might indeed be false.

This has received practical demonstration in Britain during the 1980s, in the conflict between central government and local democracy. The tentative attempts by the Greater London Council to encourage flexible and pluralistic cultural activities by emphasising the rights of minorities and decentralising its system of accountability towards those who used its services was met by the abolition of the GLC and the five other metropolitan counties. The democratic claims of the Conservative government have been matched in reality by its steady limitation of the powers of local authorities, or indeed any institutions, from the trades unions to the universities, that present an alternative case.

It is for this reason that London is the only capital in the world that has no common organisation for the planning and distribution of services. The 'pluralism' of the London boroughs is deployed precisely as a system for preventing opposition to central government, and of not acknowledging individual needs. The only answer offered to potential anarchy is increased surveillance from the centre. The inner cities have been on the government's agenda for reform since election night in 1987, but such policies that have been put into action – as, for instance, the extension of development corporations – are designed to override or ignore the wishes of the people who are most affected.

The government's policies on the inner cities have so far turned out to be a reshuffling of existing programmes and budgets. Now, it appears, both the arts and the problems of the environment are to be subjected to the same window dressing. At the beginning of 1989 it was made known that the Prime Minister intended to take a greater interest in the arts, as part of the general problem of the 'quality of life'. The 'greening' of the government is in line with this new policy. Mrs Thatcher's own enjoyment of the arts appears to be limited to a (disputed) appreciation of Henry Moore, the Turners at the Tate Gallery and Placido Domingo at the Royal Opera House, but the government's readiness to reverse all its previous policies on arts spending in an attempt to entice Baron Thyssen-Bornemisza to site his collection of Old Masters in Britain (preferably in Docklands) is evidence of a new seriousness of purpose in this direction.

In spite of the intervention of the Prince of Wales the collection went elsewhere, but the affair is an indication that culture is being

considered as another area for closer control. In the meantime arts organisations, which are expected to operate on much narrower margins of error in forecasting than the government itself, are held in check by the simple procedure of starving them of funds and prodding them into the hands of business sponsors. The Arts Council responds with such empty gestures as its pamphlet *An Urban Renaissance* and voluntarist proposals such as 'Per Cent For Art'.[8]

The long-term question, however, is whether or not the new pluralistic culture proposed here can resist the process of commodification that cast such a fatalistic shadow over the opening chapter of this book. As Victor Burgin has acidly pointed out, even criticism eventually turns into cash, as do the works that critics praise for resisting commodification: 'No matter that the work "does not sell" – at the very least lecture fees and airplane tickets will be generated, and if enough critical writing is produced to make the work "historically important", a National Endowment for the Arts grant may be forthcoming, or even a museum acquisition.'[9] (It is to be hoped that in one way or another this book has been paid for.) Even the 'uselessness' of art, it has been argued here, makes it useful as a source of shared values that can be promotionally associated with commodities.

Part of the answer to this objection is that new meanings generated by artists (and disseminated by critics) are not entirely susceptible to the manipulation of the market. There is a grain of authentic need even in the artificial desires stimulated by the information industry. New meanings can and do challenge the old. The crisis of values in culture turns on the plural meanings of value itself: the value of art is not exclusively monetary, nor is it, in that sense, useless: its value lies in use, not exchange; uses that are social, in terms of pleasure, emotional release, identity and self-expression. In the face of the commercial structures which exist to turn these things into commodities, the quality of a way of life still resists cost-quantification.

For all of the daunting circumstances, artists must still think of themselves as at least relatively free to influence events, however much they are circumscribed by questions of ideological or capitalist determinism. Their work still has a redemptive function. Even someone as apparently despairing and fatalistic as Derek Jarman can write

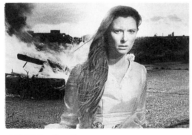

ART is the key

ART is the key. Those who don't know it simply don't

live, they exist. It, of course – is an approach to existence, an inner approach to the outer world; it's not just words and music, but gardens, sweeping, the washing-up; it needs no money, this archaeology of the soul, tho' the powers grab it and run it through the projector to blind you.[10]

To resist, if not defeat, the relentless process of commodification, however, it is clear that the artist or writer must adopt certain strategies. One of those immediately to hand is irony. Critically deployed, the post-Modern devices of fragmentation, sampling, collage, of pastiche and parody can be turned against the commodified culture of style to take apart its imagery and reclaim its elements. The Situationist practice of *détournement* involved an elaborate irony, conveying satirical meanings by words and actions whose literal meanings were the opposite of the original intention. They turned the instruments of the spectacle against the spectacle itself to discover the 'holes' that Malcolm McLaren has so profitably explored. Such irony can be playful, and play is a form of resistance. But irony's ambivalence is an emblem of the shifting meanings in the new network of pluralistic exchange. Irony accepts a measure of contradiction. Marshall Berman argues that, 'ambivalent irony will turn out to be one of the primary attitudes toward the modern city . . . the more the speaker condemns the city, the more vividly he evokes it, the more attractive he makes it; the more he dissociates himself from it, the more deeply he identifies himself with it, the clearer it is that he can't live without it.'[11]

Irony disturbs reality by conveying meaning through its opposite: but ruling definitions of reality must constantly be disputed. This has always been a function of art. As Bertolt Brecht argued, 'Realism doesn't consist in reproducing reality, but in showing how things really are.'[12] The art critic John Berger has pointed out the relativism within the realist tradition: 'Realism can only be defined with a given situation. . . . The only thing shared by all Realists is the nature of their relationship to the art tradition they inherit. They are Realists in so far as they bring into art aspects of nature and life previously ignored or forbidden by the rule-makers.'[13] Those undiscovered aspects are to be found in the gaps in the ruling definitions of reality, not only material, external reality, but the psychic reality of pain, pleasure, beauty, horror, the emotional truths that Social Surrealism seeks to add to Social Realism.

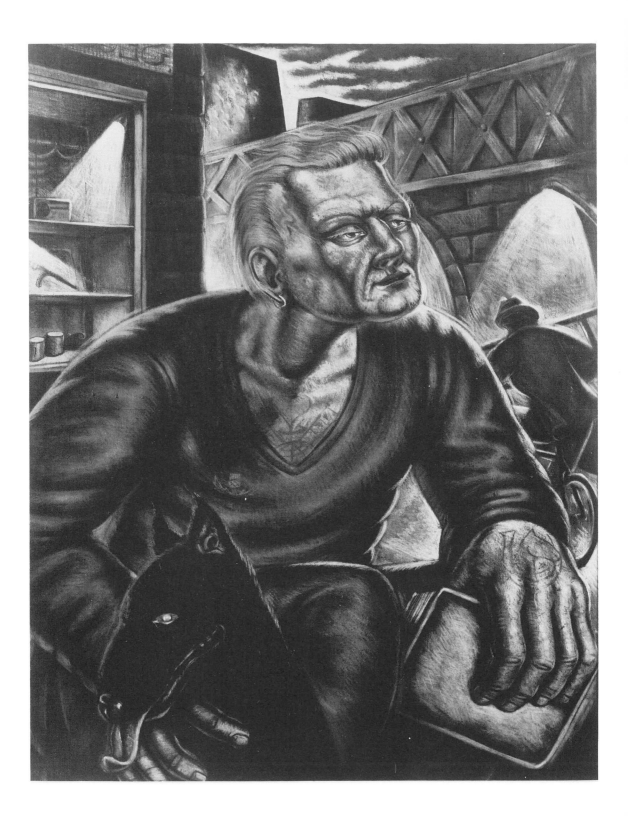

The acknowledgement that reality is constantly shifting, and that it is always necessary to reach beyond reality, opens the way to the sublime. Jean François Lyotard has written that, 'it is in the aesthetic of the sublime that modern art (including literature) finds its impetus and the logic of avant-gardes finds its axioms.'[14] Modernity cannot exist without the breaking of beliefs, the revelation of the lack of reality in reality, and the attempt to name new realities that are necessarily unknowable, or as yet unarticulated, 'ideas of which no presentation is possible.'[15] Being unrepresentable, such ideas can only be defined by their absence, by marking the gaps through which a new reality may appear. A faith in the opportunities of the sublime is necessarily a utopian view, a faith in the possibility of transfiguring and transcending reality that risks dismissal as romanticism, but which nonetheless – as in the paintings of **Peter Howson** or **Ken Currie** – displays courage and a commitment to the future. But as Marshall Berman argues, it takes courage to live at all. To be modern, 'is to experience personal and social life as a maelstrom, to find one's world and oneself in perpetual disintegration and renewal, trouble and anguish, ambiguity and contradiction: to be part of a universe in which all that is solid melts into air. To be a Modern*ist* is to make oneself somehow at home in the maelstrom, to make its rhythms one's own, to move within its currents in search of the forms of reality, of beauty, of freedom, of justice that its fervid and perilous flow allows.'[16]

Ken Currie

To overcome the loss and fragmentation in post-Modernism, we need to recover, not Modernism, but a sense of modernity, the consciousness of a new epoch, but one where the past is a source of positive connections, not negative comparisons. And as the art historian Brandon Taylor argues in his case for what he calls a 'critical realism':

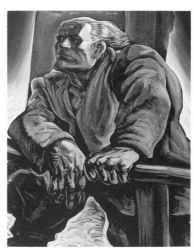

Peter Howson

It seems clear that any retrieval of modernism from its position of post-modern collapse must answer to the interests of more than just a minority specialist population. A far wider constituency of persons must come to feel themselves part of this renewal of artistic effort. They must be enabled to identify with the process of making, selecting, evaluating and conserving that

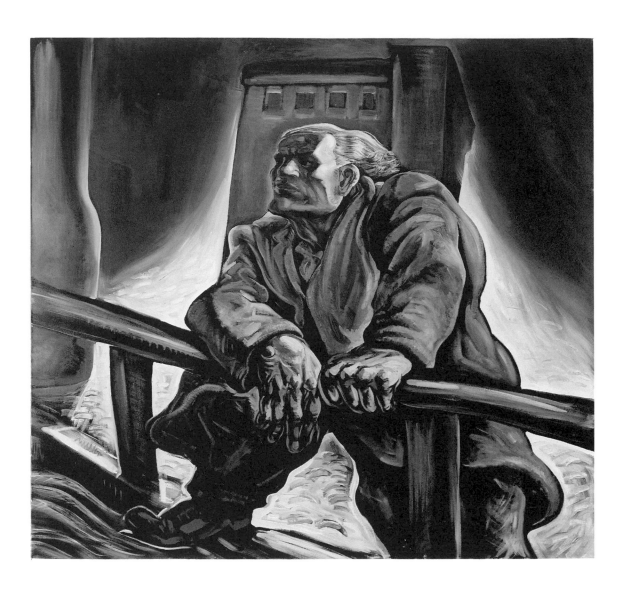

which is deemed valuable in the cultural process; and this must mean something other than reverting to the 'popular' culture of crafts, hobbies and sentimentalia – this version of popular culture . . . having been impoverished and endlessly diluted by the passivising proccss of TV.[17]

The sublime, whether beautiful or terrifying, has been described as unrepresentable, but intimations of its existence have to be conveyed in some way, over against the official reality defined by such institutions as 'the passivising process of TV'. We are once more confronted by the problem of representation, but this time at the level of institutions. The architectural critic Richard Bolton suggests what by now will be a familiar tactic: 'If the corporation controls the means of representation, then the audience can exist only as the corporation allows. This state of affairs can only be countered by finding the disjunctions within corporate reality, and by turning these disjunctions into disruptions. In this way can opposition be formed. The public may indeed be an institutional formation; we must then strive to change the institution.'[18]

To that end, the institution which is the primary source of cultural definitions, the information industry, must be halted in its seemingly inexorable drive towards world monopoly. Professor Levitt's law of dominance (p. 46) must be made inoperable. It must no longer be the case that competition is reduced to a trio of would-be monopolies of which only the larger two are profitable. Within and between countries, the ownership and cross-ownership of the information industry by a few all-powerful corporations must be broken up, and a network substituted in which no one institutional form – multinational corporation, national commercial interest, local business, state corporation, co-operative or non-profit distributing enterprise – is dominated by any other, with commercial advantage balanced by statutory obligations and controls.

As far as the more specific field of the arts is concerned, it is necessary to adopt a far wider definition of the arts themselves, beyond the aristocratically-established forms of the nineteenth century, to embrace the urban cultures of the twentieth. As Geoff Mulgan and Ken Worpole argue, 'Concentrating on pre-twentieth-century forms inevitably means concentrating on cultural products that were originally created for a wealthy, minority audience. It should hardly be surprising that it remains a wealthy, minority audience that has

both the cultural competences and the resources to enjoy these forms.'[19]

The intention is not to exclude such forms, but to add to them the new mass, electronically-based forms of music, broadcasting and video and the extensive field of design that are sometimes called the 'cultural industries'. But in that term lies the danger that cultural activity is considered only in its instrumental aspect, specifically as a means of economic regeneration. If we concentrate on culture purely as an economic force – as in the Policy Studies Institute's *The Economic Importance of the Arts* (1988) – there is a real danger that the arts will only speed the process of commodification that drains them of meaning.[20] It may have become necessary to argue for the cash benefits to society of 'investment' in the arts, because money is the only language that the Conservative government understands, but such instrumental arguments provide a justification for everything associated with cultural activity *except* art itself. The economic case for subsidising the arts may be a necessary one, but it is far from sufficient. As the managing director of the English National Opera, Peter Jonas, has said of the battle to increase public subsidy, 'if society is important, it must have basic tenets by which it lives, and one of those tenets must be the civilised aspect by which art influences society – and that to me is the only argument that will win.'[21] These sentiments are echoed by the director of the National Theatre, Richard Eyre, who argues that there must be

visible support from government, a visible approval of the arts not because they justify themselves as secondary sources of income, from VAT recovered and because they create job opportunities, simply for themselves, because the arts are perceived to be something that have value. And they are always, by definition, going to be subversive. The arts are never going to endorse the *status quo*, they are always going to be looking at the *status quo* from an oblique angle.[22]

Much will be made of the urban regeneration achieved by Glasgow in its successful campaign to become cultural capital of Europe in 1990. The real test will be in 1991. Will the benefits to the city's centre have been felt in Easterhouse or the Gorbals? Will Glasgow still be a cultural centre after the circus has moved on?

Whatever the arguments that are deployed as to the benefits of the

arts (benefits which defy cost quantification), the dispersal of ownership of the information industry should be matched by a far greater institutional variety in organisations concerned with promoting the arts. All should be subjected to far greater accountability and democracy than at present. To begin with, the fraud of the 'arms length principle', by which a mythical independence from government interference is guaranteed by the distribution of government money by government appointees, should be abandoned, and the Arts Council of Great Britain replaced by a proper Ministry for the Arts.

Education plays a key role at all levels in the perception of the arts, and must adapt to the new pluralism. As far as the training of artists is concerned, there is a profound paradox that has to be resolved. As Brandon Taylor (who teaches in an art school, and is well qualified to speak) points out, 'At the completion of his training, an artist in British society is turned out onto a labour market in which unfortunately there are no jobs – as artists, that is, as opposed to important ancillary professions like teaching or the service industries. These expensively trained people continue to survive, as artists, strictly on the margins of society.'[23] The instrumental arguments that treat people as 'product' make artists fit only for the service industries of the arts. Only by restoring a range of opportunities, *including* economic self-sufficiency, can we offer the graduates of any form of arts education proper prospects.

These reforms, though necessary, are concerned with the distribution of cultural funds, with the ownership and control of facilities that disseminate the 'given' of an artistic inheritance and its contemporary expression. The problem remains that, as Donald Horne has argued, '"Art", if it happens at all, is something that for many citizens is done *for* them and *to* them. The idea of actually going so far as to *make* art could seem impertinent. Indeed a great deal of art is presented in such a way that it is done *against* the citizens.'[24] It is not only a question of education and distribution, but of access to the policies of arts institutions, and to the facilities which they control, other than as consumers, passive constituents of the market. Horne advocates, 'a declaration of cultural rights . . . rights of access to the human cultural heritage; rights to new art; rights to community art participation.'[25] But for these to be effective, access to the cultural tradition must include the right to reinterpret and remake that tradition; new art must involve the reinterpretation of contemporary society; community

participation must mean not passive receptivity, but the right to exercise the interpretations that new art offers.

The transformation of the information industry – particularly in the use of computer technology – from competing hierarchies to an open network would open access to the exercise of those rights. But the example of the cultural bricolage already taking place shows that the guardians of the gates to access, artists, intellectuals, must themselves be prepared to undergo transformation and refunctioning, so that they no longer merely serve the production process. As the critic Edward Said argues,

we need to think about breaking out of the disciplinary ghettoes in which as intellectuals we have been confined, to reopen the blocked social processes ceding objective representation (hence power) of the world to a small coterie of experts and their clients, to consider that the audience for literacy is not a closed circle of three thousand professional critics but the community of human beings living in society, and to regard social reality in a secular rather than a mystical mode, despite all the protestations about realism and objectivity.[26]

To that end, critics especially – although the habit has spread to contemporary artists – must break out of the ghetto whose walls are constructed from an obscure technical language – a language which this book has been forced to use from time to time because that particular discourse has constructed the meanings with which it is necessary to engage. Critics have to abandon their own grand, masterly narratives, and engage in the difficulties, limitations, con-tingencies, specificities, anecdotes and contradictions of raw material experience. A few jokes would help to open up the absurdity of the way things are.

Cultural activity of whatever kind will only escape commodifi-cation if it is conceived of, not for a market, but for an audience. The significance of performance art is that it requires an audience of some kind to have any existence at all. But it is not merely a question of audience as witness: there has to be a dialogue, along the dispersed network of a new receptivity that ends the separation of artist and audience and includes both in the making of meanings. This is both a new theoretical and a new material relationship, founded not on value in exchange, but value derived from a common use.

From this grand dialogue will emerge, not a commodified, but a critical culture. Only a culture that is alert and self-aware can resist the seduction of commercialisation and the oppression of political domination, and sustain the principle of plurality without allowing difference to sink into indifference. Within the uncertainties of post-Modernism, argues the critic Hal Foster, it is possible to develop a critique which questions both Modernism and reactionary post-Modernism: 'In opposition (but not *only* in opposition), a resistant post-modernism is concerned with a critical deconstruction of tradition, not an instrumental pastiche of pop- or pseudo-historical forms, with a critique of origins, not a return to them. In short, it seeks to question rather than exploit cultural codes, to explore rather than conceal social and political affiliations.'[27] A critical culture is not a perpetuation, but a transmutation of the avant-garde. It moves beyond Modernism by engaging its audience in the self-critical process of making art, and so makes audience and artist aware of the shaping of experience. The critic Charles Russell describes this practice: 'Insofar as we become conscious of how meaning is both prefigured by the structure of discourse and how it is articulated solely by our participation within language, we potentially become critics and shapers of discourse. Instead of modernist transcendence of the social milieu, we are offered active participation in its being and potential transformation.'[28] With its broader perspective, a critical post-Modernism operates across the field of cultural activity, not denying the difference between elite and mass forms, but not privileging the former over the latter.

A critical culture is not solely concerned with the former province of the avant-garde. The current debate about tradition is a sign of the struggle for an authentic identity, which cannot be achieved through the pastiche of past styles, but can only be reached through a critical understanding of how traditions have been formed and what they have excluded. The present passion for the past must be recognised as the desperate need for a *past of some kind*. The critical culture is as much concerned to renew history – or rather, histories – as to engage in the future. Even the search for autonomy of the respective art forms, which proved a dead end by the 1960s, can have a value in that part of the process of art which consists in criticising its own formation and tradition. As the designer Neville Brody argues, 'design has to encourage a critical perspective; it should challenge perception, and not deprive us of it.'[29] To that extent art, literature and music do not

lose their responsibility or capacity to be formally interesting in themselves: by challenging existing formal norms and expectations, by using parody or ironic quotation, it is adopting a critical attitude to the social and cultural conventions that shaped them.

Above all, a critical culture will be critical of itself. It must constantly and self-consciously interrogate its own critical practices: this is the difference between the evolution of critical theory and the practice of reviewing. A self-critical approach is the equivalent of the investigation by artists of art's formal possibilities. Its objects will change as it affects the social structure and cultural economy it criticises, so its contents cannot be specified in advance. The process of criticism, which is a discovery of meaning, involves an active engagement with the material, be it reading, or seeing or listening, that opens up the work, revealing the gaps, creating new spaces. A critical culture stands between the cultural tradition that perceives the present as a culmination of the past, and the tradition of the avant-garde, which sees contemporary work merely as the precursor of some achievement yet to come. The achievement is now, in the living moment; it is critical of the culmination it offers, and yet looks forward. The critical culture performs the reformatory role of the avant-garde, but necessarily moves towards the centre and the mainstream – except that there no longer is a centre, in the democratic distribution of the net.

It will be an arduous task to sustain a critical culture, for decisions will have to be taken issue by issue, case by case. Its practitioners will have to be constantly alert, for it will no longer be possible to make choices by reference to established cultural conventions, or to the orthodoxies required by the need to conform to one mass movement or another. These certainties have gone, and it will require constant vigilance and self-reflexion to cope with the plural possibilities that their disappearance has opened up. The evolution of a genuinely multi-cultural society, where national and racial identities are recognised as interdependent, not mutually exclusive, will make further demands on the ability to sustain a many-sided dialogue.

However tentatively, a critical culture must be brought into being. The project of the Conservative government is to abolish the possibilities of a plural society by silencing all the alternative sources of authority: the church, the universities, the press and broadcasting, local government; so too the individual institutions of culture: the Arts Council, Regional Arts Associations, the British Council, the national museums and galleries and their regional equivalents. Only

the *ersatz* voice of the market will be heard. In these circumstances artists and the contemporary culture they practise must resist, as a source of alternative opinion and authority. In the cracks, if need be.

The effect of the evolution of a critical culture will be to change our view of art, in all its forms, from one of achievement-in-place to one of process, we will appreciate it as activity, not object. It then becomes possible to see art as a constant hypothesis, a means towards imagining the as yet unimaginable. Art dramatises the process of change, and thus for all of the pessimism attached to the prefix *post-*, even post-Modernism cannot be said to be simply something that is over. Victor Burgin sees it not as an ending, but as a beginning:

The category of the 'postmodern' is our first glimpse of the historical emergence of a field of *post*-Romantic aesthetics. The cultural theory of the 1970s . . . demonstrated the impossibility of the modernist ideal of art as a sphere of 'higher' values, independent of history, social forms, and the unconscious; this same theory has undermined the modernist dogma that 'visual art' is a mode of symbolisation independent of other symbolic systems – most notably language; modernist pretensions to artistic independence have been further subverted by the demonstration of the necessarily 'intertextual' nature of the production of meaning; we can no longer unproblematically assume that '*Art*' is somehow outside of the complex of representational practices and institutions with which it is contemporary – particularly, today, those which constitute what we so problematically call 'the mass media'.[30]

The distance between 'art' and 'life' begins to close once more, assisted by the expansion of cultural activity in spite of the self-interested pressures of commerce.

Bearing in mind Marx's dictum that history repeats itself as farce, there may yet be a case for comparing the 1990s with the 1890s. The Aesthetic movement and Art for Art's Sake involved an intense, self-absorbed interest in the autonomy of art, in style, fashion, and post-medievalist pastiche; sexual identity was being placed in question and feminism was in a radical phase. The term 'decadent' can be applied as easily to the consumerism and addictions which afflict the contemporary world as it can be to the Victorians' *fin-de-siècle*. The turn of the

nineteenth century brought in technological and social revolution, and an unprecedented flowering of artistic activity.

It is not possible to foretell – though it is possible to hope for – such an out-turn to the arrival of the twenty-first century. But within the gaps and cracks of the present culture there are possibilities for renewal. Join up the cracks, and a network forms; follow the lines, and a new map appears. It points the way past the post-Modern.

Outside the Institute of Contemporary Arts, on the night of the Situationists' private view, there were other Situationists, protesting at the incorporation and commodification of Situationism. It may be that it is possible to create a situation that turns around the situation, after all.

Introduction
1 S. Gablik, *Has Modernism Failed?*, London, Thames & Hudson, 1984, p. 17.
2 A. Huyssen, *After the Great Divide: Modernism, Mass Culture, Postmodernism*, London, Macmillan, 1986, p. 182.

A Parable
1 A. Huyssen, *op. cit.*, p. 166.
2 G. Debord, quoted in *An endless adventure . . . an endless passion . . . an endless banquet: a Situationist Scrapbook*, Iwona Blazwick (ed.), London, ICA/Verso, 1989, p. 95.

1. Commerce and Culture
1 Eric Hobsbawm, 'Farewell to the Classic Labour Movement?', *New Left Review*, Number 173 (Jan/Feb) 1989, p. 72.
2 Dick Hebdige, *Hiding in the Light: On Images and Things*, London, Routledge, 1988, p. 210.
3 Julia Kristeva, 'Post-modernism?', in H. R. Garvin (ed.), *Romanticism, Modernism, Postmodernism*, Toronto and London, Associated University Presses, 1980, p. 136.
4 Beuys is quoted first in S. Nairne, *State of the Art: Ideas and Images in the 1980s*, London, Chatto & Windus, 1987, p. 95. His later comment was made in a television interview on 'Arena' BBC2.
5 Performance by Gaby Agis & Company of *Don't Trash My Altar/Don't Alter My Trash*, November 1988.
6 D. Bell, *The Coming of Post-Industrial Society*, New York, Basic Book, 1973, p. 53.
7 Quoted in Griel Marcus, *Lipstick Traces: A secret history of the twentieth century*, London, Secker & Warburg, 1989, p. 44.
8 Quoted in Derek Jarman, *Dancing Ledge*, London, Quartet, 1984, p. 170.

9 J. F. Lyotard, *The Post-Modern Condition: A report on knowledge*, Manchester University Press, 1984, p. 5.
10 Placard at the LDDC visitors centre.
11 P. Bürger, *Theory of the Avant-Garde*, Manchester University Press, 1984, p. 58.
12 S. Gablik, *Has Modernism Failed?*, *op. cit.*, p. 56.
13 C. Joachimides, 'A New Spirit in Painting', in *A New Spirit in Painting*, London, Royal Academy/Weidenfeld & Nicolson, 1981, p. 15.
14 C. Owens, 'The discourse of others: Feminists and Postmodernism', in H. Foster (ed.), *Postmodern Culture*, London, Pluto Press, 1985, p. 67.
15 D. Cameron, 'The Tyranny of the Avant-Garde', in M. Allthorpe-Guyton (ed.), *Edge 88*, London, Edge 88 & Performance Magazine, 1988, p. 8.
16 Quoted in I. Fallon, *The Brothers: The Rise and Rise of Saatchi and Saatchi*, London, Hutchinson, 1988, p. 342.
17 Charles Jencks, 'The Post-Avant Garde', *Art & Design*, Vol. 3 No. 7/8 (1987), p. 16.
18 R. Hughes, 'On Art and Money', *Art Monthly*, No. 82 (Dec/Jan 1984/5), p. 9.
19 R. Hughes, *ibid.*
20 R. Hughes, *op. cit.*, p. 11.
21 P. Harrison, 'Towards the Nineties', in P. Owen (ed.), *Publishing – The Future*, London, Peter Owen, 1988, p. 58.
22 Transcript of Mrs Thatcher's speech at the Design Museum, 5 July 1989.
23 S. Bayley, *Commerce and Culture*, London, The Design Museum, 1989, p. 7.
24 Bayley, *op. cit.*, p. 5.
25 Bayley, *op. cit.*, p. 8.
26 Two page advertisement for the Butlers Wharf development,

Blueprint, No. 61 (October 1989), pp. 42–3.
27 D. Jarman, *Derek Jarman's Caravaggio*, London, Thames & Hudson, 1986, p. 40.
28 N. Brody & J. Wozencraft, 'Protect the lie', *Guardian*, 2 December 1988, p. 25.
29 Bayley, *op. cit.*, p. 113.
30 Bayley, *op. cit.*, p. 9.
31 R. Betterton, *Looking On: Images of Femininity in the Visual Arts and Media*, London, Pandora, 1987, p. 13.
32 Bayley, *op. cit.*, p. 7.
33 Bayley, *op. cit.*, p. 116.
34 M. Amis, *Money: a suicide note*, (Cape 1984), London, Penguin, 1985, p. 361. See also M. Amis, *London Fields*, London, Cape, 1989, p. 55.
35 J. Hegarty, interview in part one of *Three Minute Culture*, BBC2, January 1989.
36 D. Horne, *The Public Culture: The Triumph of Industrialism*, London, Pluto Press, 1986, p. 184.
37 R. Bolton, 'Architecture and Cognac', in D. Thakara (ed.), *Design after Modernism: beyond the object*, London, Thames & Hudson, 1988, p. 87.
38 Quoted in Sharon Zukin, 'The Postmodern Debate over Urban Form', *Theory Culture and Society*, Vol. 5 Nos 3/3, (June 1988), p. 437.
39 *The Independent*, 22 October 1988.
40 *The Times*, 3 February 1989.
41 A. McRobbie, 'Postmodernism and Popular Culture', in L. Appignanesi (ed.), *ICA Documents 4/5*, London, ICA, 1986, p. 56.
42 S. Sontag, *On Photography*, London, Penguin, 1978, p. 179.
43 Quoted in I. Fallon, *op. cit.*, p. 161.
44 Quoted in I. Fallon, *op. cit.*, p. 165.

45 D. Hebdige, *op. cit.*, p. 159.
46 Quoted in C. Butler, *After the Wake: an essay on the contemporary avant-garde*, Oxford, Clarendon Press, 1980, p. 100.
47. Quoted in C. Butler, *op. cit.*, p. 87.
48 J. R. R. Christie and Fred Orton, 'Writing on a text of the life', *Art History*, Vol. 11 No. 4 (December 1988), p. 556.
49 F. Jameson, 'Postmodernism, or the Cultural Logic of Late Capitalism', *New Left Review*, No. 146 (July/August 1984), p. 83.
50 F. Jameson, *ibid.*
51 F. Jameson, *op. cit.*, p. 84.
52 *Dimensions*, Summer 1989, p. 38.
53 J. Baudrillard, *Simulations*, New York, Semiotext(e), 1983, p. 146.
54 J. Baudrillard, *A L'Ombre des Majorites Silencieuses: ou La Fin du Social*, Paris, Editions Denoel/Gonthier, 1982, p. 87.
55 Said in an interview, February 1989.
56 J. Baudrillard, *Simulations, op. cit.*, p. 11.
57 J. Baudrillard, 'The Ecstasy of Communication', H. Foster (ed.), *Postmodern Culture*, London, Pluto Press, 1983, p. 126.
58 J. Baudrillard, *op. cit.*, p. 127.
59 J. Baudrillard, transcript of interview in 'The Shock of the Neo', *Signals*, Channel Four, 1988.
60 S. Beckett, *The Unnamable*, in *The Beckett Trilogy*, London, Picador, 1979, p. 382.

2. The Last of England

1 D. Jarman, *The Last of England*, London, Constable, 1987, p. 170.
2 D. Jarman, *op. cit.*, p. 196.
3 D. Jarman, *op. cit.*, p. 188.
4 Transcribed from the soundtrack of *The Last of England*.
5 *ibid.*
6 D. Jarman, *op. cit.*, p. 54.
7 D. Jarman, *op. cit.*, p. 211.
8 Transcribed from the soundtrack of *Jubilee*.
9 D. Jarman, *op. cit.*, p. 235.
10 S. Rushdie, *The Satanic Verses*, London, Viking, 1988, p. 320.
11 Report by House of Commons Committee of Public Accounts, *Urban Development Corporations*, 17 May 1989, p. v.
12 *The Times*, 31 October 1989.
13 Wall placard at the LDDC Visitors Centre.
14 'Classicism, the rejected alternative', BBC2, 6 November 1988.
15 P. Hoyeau, 'Heritage and "the conserver society": the French case', in R. Lumley (ed.), *The Museum Time Machine*, London, Routledge, 1988, p. 30.
16 R. Cornwell, 'Inside Out', *Artscribe*, May 1989, p. 9.
17 LDDC promotional video.
18 C. Leadbeater, 'In the land of the dispossessed' in L. McDowell, P. Sarre, C. Hamnett (eds.), *Divided Nation: Social and Cultural Change in Britain*, London, Hodder & Stoughton, 1989, p. 49.
19 M. Amis, *Einstein's Monsters*, (Cape, 1987) London, Penguin, 1988, p. 75.
20 For an excellent description of the synagogue and Spitalfields, see P. Wright, 'Rodinsky's Place' *London Review of Books*, Vol. 9, No. 19 (29 October 1987), pp. 3–5. In October 1989 the upper rooms were temporarily cleared so that repairs to the fabric could be carried out, but it was the intention to return the contents of rooms, as far as possible in their original state, when the work was completed.
21 W. Jahn, *The Art of Gilbert and George*, London, Thames and Hudson, 1989, p. 9.
22 Quoted in W. Jahn, *op. cit.*, p. 486.
23 W. Jahn, *op. cit.*, p. 196.
24 Introductory statement to *Gilbert and George, Pictures 1982–86*, Hayward Gallery, 1987.
25 W. Jahn, *op. cit.*, pp. 478–9.
26 P. Ackroyd, *Hawkesmoor*, London, Hamish Hamilton, 1985, p. 27.
27 I. Sinclair, *White Chappell: Scarlet Tracings*, (Goldmark, 1987) London, Paladin, 1988, p. 112.
28 I. Sinclair, *op. cit.*, p. 128.
29 I. Sinclair, *op. cit.*, p. 129.
30 M. Moorcock, *Mother London*, London, Secker & Warburg, 1988, p. 263.
31 M. Moorcock, *op. cit.*, pp. 343–4.
32 M. Moorcock, *op. cit.*, p. 495.
33 S. Rushdie, *op. cit.*, p. 49.
34 S. Franklin, catalogue note, *The London Project*, Photographers Gallery, London, 1988.
35 M. Berman, *All That Is Solid Melts Into Air*, London, Verso, 1983, p. 171.
36 *ibid.*

3. Social Surrealism

1 M. Berman, *op. cit.*, p. 171.
2 A. Breton, 'Manifeste du Surréalisme', in *Manifestes du Surréalisme*, Paris, J.-J. Pauvert, 1962, p. 27.
3 H. Barker, 'The triumph in defeat', *Guardian*, 22 August 1988.
4 *ibid.*
5 M. McLaren, conversation with the author, 15 June 1989.
6 M. McLaren, 'Antihero', *Spin Magazine*, November 1988, p. 80.
7 D. Hebdige, *Subculture: the meaning of style*, London, Methuen, 1979, p. 87.
8 I. Chambers, *Urban Rhythms: Pop Music and Popular Culture*, London, Macmillan, 1985, p. 183.
9 I. Chambers, *op. cit.*, p. 185.
10 Quoted in Rick Poynor, 'Brody on Sign Language',

Blueprint, No. 46, April 1989, p. 50.
11 D. Jarman, *Dancing Ledge*, London, Quartet, 1984, p. 164.
12 D. Jarman, *op. cit.*, p. 172.
13 D. Jarman, *op. cit.*, p. 176–177.
14 D. Jarman, *op. cit.*, p. 172.
15 Forced Entertainment, programme note to *200% and Bloody Thirsty*, ICA, London, February 1989.
16 Quoted in S. Constant, 'Giving birth to dead dreams', *Dance Theatre Journal*, Vol. 6, No. 4, (September 1988), p. 5.
17 J. Cartwright, *Road*, London, Methuen, 1986, p. 7.
18 J. Cartwright, *op. cit.*, p. 35.
19 G. Motton, *Chicken and Ambulance*, London, Penguin, 1987, p. 43.
20 Transcribed from soundtrack of D. Jarman, *The Last of England*.
21 T. Cragg, extract from *Art Forum*, March 1988, reprinted in *Tony Cragg*, London, Tate Gallery and Patrons of New Art, 1989, p. 18.
22 Conversation with the author, 30 June 1989.
23 Quoted in *The Vigorous Imagination: New Scottish Art*, Scottish National Gallery of Modern Art, 1987, p. 86.
24 Conversation with the author, 8 May 1989.
25 *ibid.*
26 A. McRobbie, 'Postmodernism and Popular Culture', *ICA Documents 4/5, op. cit.*, p. 57.
27 D. Hebdige, *Cut 'n' mix*, London, Comedia, 1987, p. 141.
28 *op. cit.*, p. 158.
29 N. Coates, 'Street Signs', in *Design After Modernism, op. cit.*, p. 100.
30 *ibid.*
31 Editorial in 'Albion', *NATO Magazine*, No. 1, London, Architectural Association, 1983, p. 5.

32 N. Coates, 'Albion', *op. cit.*, p. 10.
33 N. Coates, 'Street Signs', *op. cit.*, p. 109.
34 N. Coates, *op. cit.*, p. 98.
35 N. Coates, *op. cit.*, p. 103.
36 C. Villanueva, in 'Gamma City', *NATO Magazine*, No. 3, p. 22.
37 N. Coates, *op. cit.*, p. 100.
38 R. Stam, 'Mikhail Bakhtin and Left Cultural Critique', in E. Kaplan (ed.), *Postmodernism and its Discontents*, London, Verso, 1988, p. 135. See also D. Edgar, 'Festivals of the Oppressed', *New Formations*, No. 3 (Winter 1987), pp. 19–32.
39 M. White, 'Resources for a Journey of Hope: the Work of Welfare State International', *New Theatre Quarterly*, August 1988.
40 M. Berman, *op. cit.*, p. 309.

4. The Body Politic

1 N. Brody & J. Wozencraft, 'Protect the lie', *Guardian*, 2 December 1988.
2 I. Chambers, 'Narratives of nationalism: being "British"', *New Formations*, No. 7 (Spring 1989), p. 100.
3 D. Hebdige, *Hiding in the Light*, *op. cit.*, p. 188.
4 Quoted in C. McDermott, *Street Style*, London, The Design Council, 1987, p. 29.
5 I. Chambers, *Popular Culture*, London, Methuen, 1986.
6 D. Hebdige, *Subculture*, *op. cit.*, p. 88.
7 R. Williams, *Towards 2000*, (Chatto & Windus, 1983), Penguin, 1985, p. 263.
8 L. Irigaray, 'This Sex Which Is Not One', in E. Marks and I. de Courtivron (eds.), *New French Feminisms: An Anthology*, Brighton, Harvester Press, 1981, p. 104.
9 R. Parker and G. Pollock (eds.), *Framing Feminism: Art and the*

Women's Movement 1970–1985, London, Pandora, 1987, p. 73.
10 V. Burgin, *The End of Art Theory: Criticism and Postmodernity*, London, Macmillan, 1986, p. 181.
11 The image is used with particular force at the close of M. Amis, *Money, op. cit.*, p. 379.
12 L. Tickner, 'The Body Politic: Female Sexuality and Women Artists', *Art History*, Vol. 1, No. 2 (June 1978), p. 247.
13 R. Betterton, *Looking On: Images of Femininity in the Visual Arts and Media*, London, Pandora, 1987, p. 10.
14 M. Kelly, 'Invisible Bodies: Mary Kelly's *Interim*', *New Formations*, Vol. 1, No. 2 (Summer 1987), p. 11.
15 M. Kelly, *op. cit.*, p. 7.
16 M. Kelly, *op. cit.*, p. 10.
17 E. Dempster, 'Women Writing the Body: Let's Watch a Little How She Dances', in S. Sheridan (ed.), *Grafts: Feminist Cultural Criticism*, London, Verso, 1988, p. 52.
18 Speaking in *Imaginary Women*, Channel Four, 13 July 1986.
19 E. Dempster, 'Women Writing the Body', *op. cit.*, pp. 48–9.
20 R. Parker and G. Pollock, *Framing Feminism*, *op. cit.*, p. 54.
21 A. Jardine, *Gynesis: configurations of woman and modernity*, London and Ithaca, Cornell University Press, 1985, p. 52.
22 A. Jardine, *op. cit.*, p. 154.
23 See L. Williams, 'A Jury of their Peers: Marlene Gorris's *A Question of Silence*' in E. Kaplan (ed.), *Postmodernism and its Discontents*, London, Verso, 1988, p. 107.
24 A. Jardine, *op. cit.*, p. 230.
25 K. Myers, 'Towards a Feminist Erotica', in R. Betterton (ed.), *op. cit.*, p. 200.

26 C. Owens, 'The Discourse of Others: Feminists and Postmodernism', in H. Foster (ed.), op. cit., p. 58.
27 'Variations on Common Themes', in E. Marks and I. de Courtivron, New French Feminisms, op. cit., p. 222.
28 Rosetta Brooks, 'The Body of the Image', ZG, No. 10 (Spring 1984), p. 1.
29 N. Bartlett, Who Was That Man? A Present for Mr Oscar Wilde, London, Serpents Tail, 1988, p. 83.
30 ibid.
31 N. Bartlett, op. cit., p. 86.
32 N. Bartlett, op. cit., p. 169.
33 N. Bartlett, programme note, A Vision of Love revealed in Sleep, 1989.
34 S. Lash, 'Discourse or Figure? Postmodernism as a "Regime of Signification"', in M. Featherstone (ed.), op. cit., p. 334.
35 L. Tickner in Nancy Spero, exhibition catalogue, ICA, London, 1987, p. 15.
36 Conversation with the author, 20 June 1989.
37 Catalogue note, Edge 88, London, Edge 88 and Performance Magazine, 1988, p. 32.

5. Looking Forward
1 Z. Bauman, 'Is there a Postmodern Sociology?' in M. Featherstone (ed.), op. cit., p. 225.
2 Z. Bauman, op. cit., p. 226.
3 D. Hebdige, Hiding in the Light,

op. cit., pp. 206–7. The phrase 'moving equilibrium' is Gramsci's.
4 C. Owens, 'The Discourse of Others' in Foster (ed.), op. cit., p. 58.
5 R. Brooks, 'Through the Looking Glass, Darkly', in Mark Hawarth-Booth (and others), British Photography: Towards a Bigger Picture, New York, Aperture Foundation, 1988, p. 50.
6 'Common Themes' in E. Marks and I. de Courtivron (eds.), New French Feminisms, op. cit., p. 219.
7 C. Owens, 'The Discourse of Others' in Foster (ed.), op. cit., p. 62.
8 An Urban Renaissance: The role of the arts in urban regeneration, London, The Arts Council of Great Britain, 1988.
9 V. Burgin, op. cit., p. 190.
10 D. Jarman, The Last of England, op. cit., p. 235.
11 M. Berman, All That Is Solid, op. cit., p. 201.
12 Quoted in T. Gallagher, John Ford: The Man and His Films, London and Los Angeles, University of California Press, 1986, p. 474.
13 J. Berger, Permanent Red: Essays in Seeing, (Methuen, 1960) London, Writers and Readers Co-Operative, 1979, p. 208.
14 J. F. Lyotard, The Post-Modern Condition, op. cit., p. 77.
15 ibid.
16 M. Berman, All That Is Solid Melts Into Air, op. cit., pp. 345–6.

17 B. Taylor, Modernism, Post-Modernism, Realism: A critical perspective for art, Winchester School of Art Press, 1987, p. 131.
18 R. Bolton, 'Architecture and Cognac', in J. Thackeray (ed.), op. cit., p. 93.
19 G. Mulgan and K. Worpole, Saturday Night or Sunday Morning?: From arts to industry – new forms of cultural policy, London, Comedia, 1986, p. 116.
20 J. Myerscough, The Economic Importance of the Arts in Britain, London, Policy Studies Institute, 1988.
21 P. Jonas, 'Third Ear', BBC Radio 3, 24 May 1989.
22 R. Eyre, 'Signals', Channel Four, 14 December 1988.
23 B. Taylor, Modernism, Post-Modernism, Realism, op. cit., p. 134.
24 D. Horne, The Public Culture, op. cit., p. 234.
25 ibid.
26 E. Said, 'Opponents, Audiences, Constituencies and Community', in H. Foster (ed.), op. cit., p. 158.
27 H. Foster, 'Postmodernism: A Preface', in H. Foster (ed.), op. cit., p. xii.
28 C. Russell, 'The Context of the Concept', in H. Garvin (ed.), Romanticism, Modernism, Postmodernism, Toronto and London, Associated University Presses, 1980, p. 192.
29 N. Brody and J. Wozencraft, op. cit.
30 V. Burgin, op. cit., p. 204.

The Naked City by Guy Debord, reproduced by kind permission of the ICA Galleries

Situationist Poster, 1968

Ronan Point, 1968, reproduced by kind permission of the Hulton Picture Company

PLIGHT by Josef Beuys, Collection Centre Pompidou, Paris, Courtesy Anthony d'Offay Gallery, London

Gaby Agis and Company in Don't Trash my Altar, Don't Alter my Trash, photographed by Jessica Shaw

The Saatchi Gallery (Bill Woodrow Installation), photographed by Helène Binet, reproduced courtesy of the Saatchi Collection

The Old Man's Boat And The Old Man's Dog 84″ by 84″, 1982, by Eric Fischl reproduced by kind permission of the Saatchi Collection and the Mary Boone Gallery, New York

Humanity Asleep by Julian Schnabel, reproduced by kind permission of the Tate Gallery, London

Pink Panther by Jeff Koons, courtesy of the Sonnabend Gallery, New York

The Design Museum, photographed by Phil Sayer, reproduced courtesy of the Design Museum, Butlers Wharf

The Breughel Series (A Vanitas of Style) by Pat Steir

Almanac by Robert Rauschenberg, reproduced by kind permission of the Tate Gallery, London and DACS Ltd

Jean Baudrillard on 'Shock of the Neo', an Illuminations (Television) production for Signals, Channel 4, reproduced courtesy of Illuminations Ltd

The Last of England by Derek Jarman, photographed by Mike Laye

The Last of England: Final Sequence by Derek Jarman, photographed by Mike Laye

Tobacco Dock, photographed by Ros Drinkwater, reproduced by kind permission of *Times Newspapers Ltd*

Quinlan Terry's Richmond Riverside Development, photographed by Martin Charles, reproduced courtesy of the Design Museum

Canary Wharf, courtesy of Olympia and York

Prince's Youth Business Trust Poster photographed by Nadav Kander, reproduced by kind permission of Young and Rubicam Ltd

Rodinsky's Room at Spitalfields Heritage Centre, photographed by Danny Gralton, courtesy of the Spitalfields Heritage Centre

Fuck by Gilbert and George, courtesy Anthony d'Offay Gallery, London

Gateway by Gilbert and George, one part of the triptych Class War, Gateway, Militant, 1986, courtesy Anthony d'Offay Gallery, London

Victoria Station, photographed by Stuart Franklin, reproduced by kind permission of Magnum Photos Ltd

Sex Pistols Record Sleeve for God Save The Queen, by Jamie Reid, courtesy of Virgin Records

Michael Clark, photographed by Richard Haughton

DV8, Dead Dreams of Monochrome Men, photographed by Eleni Leoussi, reproduced courtesy of DV8 Physical Theatre

Romance in the Age of Raygun by Sue Coe, reproduced by kind permission of the Museum of Modern Art, Oxford and The Broida Trust

Kevin McMonagle and Adam Kotz in **Ambulance**, written by Gregory Motton, and reproduced courtesy of the Royal Court Theatre

ENGLISH HERITAGE – HUMPTY FUCKING DUMPTY by Bill Woodrow, 1987, Vaulting Box and Mixed Media, Trustees of the Tate Gallery, London

Britain Seen From The North by Tony Cragg, reproduced by kind permission of the Tate Gallery, London

Minster by Tony Cragg, reproduced by kind permission of the Saatchi Gallery

The Navigators by the Bow Gamelan Ensemble, photographed by Ed Sirrs, courtesy of the Bow Gamelan Ensemble

The Antechamber of Rameses V in the Valley of the Kings by Ron O'Donnell, reproduced courtesy of the artist

The Great Divide by Ron O'Donnell, reproduced courtesy of the artist

Piccadilly Circus by Jenny Holzer, courtesy of The Artangel Trust

NATO's Albion Scheme by Nigel Coates, courtesy of NATO magazine

Lisa Lyon 1980 by Robert Mapplethorpe, Copyright © 1980 The Estate of Robert Mapplethorpe

Flaccid Guns from the Models Triptych by Rose Garrard, photographed by Edward Woodman

Leigh Bowery 1988, photographed by Fergus Greer, courtesy of Anthony d'Offay, London

Regina Fong, Neil Bartlett and Ivan in Gloria's production of Neil Bartlett's **A Vision of Love Revealed in Sleep**. Photo: Mike Laye

One Flesh by Helen Chadwick, photographed by Edward Woodman

Of Mutability by Helen Chadwick, photographed by Edward Woodman

Blood Hyphen by Helen Chadwick, photographed by Edward Woodman

Tilda Swinton in The Last of England, by Derek Jarman, photographed by Mike Laye

The Heroic Dosser by Peter Howson reproduced by kind permission of the National Gallery of Scotland

The Calton Activist by Ken Currie, reproduced by kind permission of the Raab Galleries

Every effort has been made to describe the subjects and attribute picture sources correctly and trace copyright owners. Apologies are made for any errors or omissions.

INDEX

Numbers in italics refer to illustrations